T0231154

HYBRID ANIMATION

HYBRID ANIMATION
Integrating 2D and 3D Assets

TINA O'HAILEY

LONDON AND NEW YORK

First published 2010
This edition published 2013 by Focal Press

Published 2017 by Routledge
2 Park Square, Milton Park, Abingdon, Oxon OX14 4RN
711 Third Avenue, New York, NY 10017, USA

First issued in hardback 2017

Routledge is an imprint of the Taylor & Francis Group, an informa business

Notices

Practitioners and researchers must always rely on their own experience and knowledge in evaluating and using any information, methods, compounds, or experiments described herein. In using such information or methods they should be mindful of their own safety and the safety of others, including parties for whom they have a professional responsibility.

Product or corporate names may be trademarks or registered trademarks, and are used only for identification and explanation without intent to infringe.

Library of Congress Cataloging-in-Publication Data
O'Hailey, Tina.
 Hybrid animation : integrating 2D and 3D assets / by Tina O'Hailey.
 p. cm.
 Includes bibliographical references and index.
 ISBN 978-0-240-81205-2 (alk. paper)
 1. Computer animation. I. Title.
 TR897.7.O42 2010
 006.6'96—dc22

 2009048178

ISBN 13: 978-1-138-40321-5 (hbk)
ISBN 13: 978-0-240-81205-2 (pbk)

CONTENTS

INTRODUCTION AND AN APOLOGY

Before we begin this journey together, I must apologize to you. My résumé says that I have worked at great places. I have. However, I have never served as a great artist. I rarely received much more than a "special thanks" credit on any film. I am one of *many* who worked on feature animation films and was only a small, small cog in the feature animation gear mechanism.

My cog, however, was a unique and special one. My cog was allowed to fit and morph and change as needed throughout the film. In a large production house, this is not usually the case. One is usually pigeonholed into one area. In this, I can say my experience was different than most. I was not confined to one area of animation. In fact, I was fortunate to have never been limited in my quest for knowledge as it applied to animation.

During my career as a trainer for two feature animation studios and one game studio, I have had rooms of computers where artists would come to learn what they needed to know to do their jobs. Those rooms were sometimes small, such as an old storage closet, and sometimes larger, such as a room with—gasp—windows! A unifier was that they were all warm, except for one; it was freezing!

The best unifier of all is that in all three of those studios, I was granted this one amazing gift: great artists who did great things and had amazing credits on movies came into those training rooms. I was able to teach them what they needed, and in return I asked them questions and learned how they thought and worked. I had my own personal education process for all of those years with the best professors I could have ever asked for.

If that weren't enough, when no one was in my training rooms, I was busy picking scenes out and watching them progress from rough animation to final composite. I followed them through the pipeline and saw how they were done. I concentrated on the problems that might require the problem solver to get some training in order to proceed better. I would question and poke, watch, learn, prod, and figure out how to teach to the artists' needs. I'm sure I wore out my welcome on occasion, because I questioned—often. I would pop into someone's office to ask how he or she did something, always trying to understand. I would try not to pick on the same person more than once in a row; I spread the questions around. For everyone who has been kind enough to entertain my questions, thank you. If I know anything, it is because of those patient friends who endured my enthusiasm for learning and my longing to know how everything worked.

It wasn't until I became a professor and started trying to put this education into practice via classroom assignments and my own group projects that I started to formulate everything into a cohesive thought. Luckily, I am not afraid to speak something out loud and sound like a complete idiot while formulating that cohesive thought. Those who have ever been in my classroom just as I have started down the journey of a given quest have been abused with these half-baked musings that usually work themselves into well-educated ideas in a few months or sometimes years. In the experimental, collaborative environment of classroom projects, I have been able to crystallize some of the concepts that are put forth in this book. It is just a beginning, however. The last chapter of the book guides readers to the online forum website that exists for us to continue our discussion and further hone these concepts, such as the honing I have done for the past four years in the classroom and the dozen years before that in animation training rooms.

This entire apology is to say that this book is composed of the methods of 2D/3D that I use in class and in my own group projects. They are based on methods that are applied in feature

animation films and published in papers and articles you can find in the ACM (Association for Computing Machinery) library. They are based on methods that we have come up with in class to help isolate the issues particular to 2D/3D. They are based on what I see as the underlying problems to solve.

Is this the end-all, be-all production bible in a book? No. It is an overview of 2D/3D problem solving. I hope it is helpful as you combine it with your already established method of creating this art we call animation.

I can't wait to see what questions we come up with.

—Tina O'Hailey

THE PAGE OF THANKS

Most humbly, I thank all of those who were there for me when I needed a second pair of eyes, an image, an idea, an ear to listen to my ramblings, help with software bugs (both perceived and real), a project, a rig, a model, an illustration, an idea, a quality tester, a tutorial checker, a sanity check, a high-speed Internet connection when I needed it on the mountain, a personal cheering section whenever I posted that another chapter was done, a reminder that the world outside of this project existed and I would see it again, and a hot meal when I couldn't fathom cooking and live where there is no delivery.

I will try to list names and hope I do not miss anyone.

Thank you to my editors, Katy Spencer and Graham Smith, for patiently listening to my monthly rambling progress updates.

Thank you also to my technical editors, Rob Bekuhrs and Gregg Azzopardi, for your patience, teachings, and all you have given.

Extra special thanks to the following:

- Chelsey L. Cline for amazing, thorough checking of the text from front to back and every button click and missed comma in between
- Daniel Tiesling for wonderful models and rigs, on time and exceeding expectations
- Jason Walling and Clint Donaldson for their overwhelming dedication to *Jaguar McGuire* and all of its challenges
- Claire Almon for her tireless and amazing work
- Dianna Bedell for work, on time and with a smile

Contributing students and alumni:

- Yossaya Aisiri
- Candice Ciesla
- Jennifer Chandler
- Chris Ellis
- Loraine Howard III
- Jessica Huang
- Alston Jones
- John-Michael Kirkconnell
- Brent Morris
- Dan Murdock
- Amanda Powell
- Jessica Toedt
- Shani Vargo
- John T. Vu

Contributing friends and peers:

- Marty Altman
- Jeff Dutton
- Joseph Gilland
- Troy Gustafson

- Matthew Maloney
- Jason Schleifer
- Alex Dukai
- Derald Hunt
- Todd Redner

Technical guides:

- Clark Stallworth, VSFX Professor, SCAD, Atlanta
- Matt Burge, Associate Chair BCST, SCAD, Atlanta
- Tan Tascioglu, VSFX Professor, SCAD, Atlanta

Personal cheering section:

- Chantal Bumgarner
- Patricia Hannaway
- Dianna Bedell

Those who reminded me that the world would be there when I returned:

- Carolyn McClendon
- Mark Ostrander

And, of course, heartfelt thanks to my family: Danny, Emma, and Mr. O'.

To anyone I have missed, I apologize. Your help has been most appreciated even if your name has not sprung to the top of this Swiss-cheese mind.

Thank you,
…tina

ABOUT THE AUTHOR

The author is a mild-mannered mother of two who seeks respite in the mountains with her family, on a bluff, overlooking a wooded valley. Her education includes a BFA in computer animation from Ringling School of Art and Design (though, it was called computer graphics at the time and the school is now called Ringling College of Art and Design, but the sentiment is still the same). She also holds an MSCIT degree in object-oriented programming from Regis University. When not wearing flannel and jeans, she can be found wandering the halls or teaching in the classrooms of Savannah College of Art and Design's Atlanta campus.

She currently is the Associate Chair of the Animation Department at the Atlanta campus, though still considers herself a professor who happens to want to schedule classes and see that the "pipeline" of learning for the students is streamlined and worthy. She enjoys being in the classroom, learning new things, and making the students laugh while they learn. Her current hobbies include silver fabrication (rings, specifically), caving, motorcycles, and baking. She rarely blogs except when working on projects and events; that blog is at http://blog.scad.edu/tohailey.

Tina O'Hailey, Photograph by Mark Ostrander

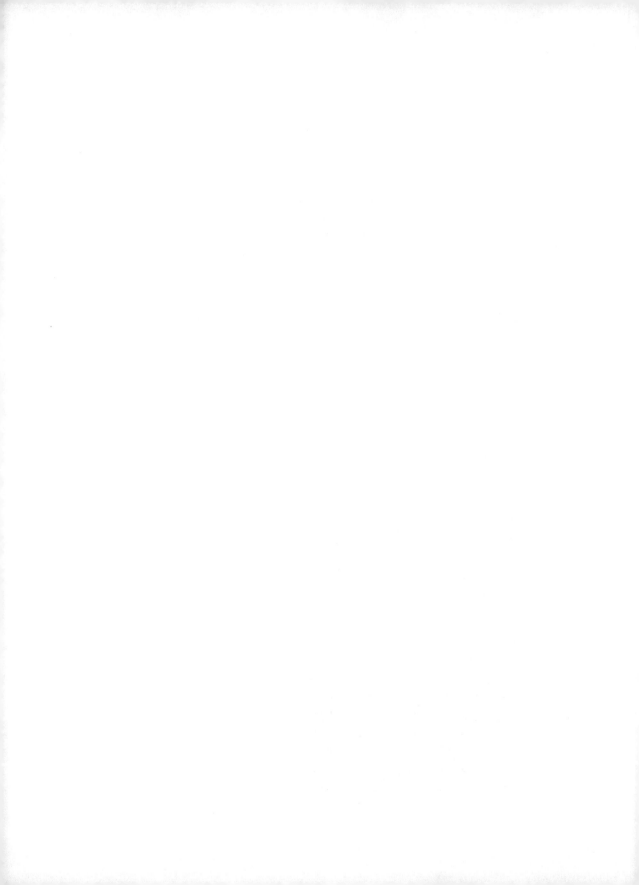

AN OVERVIEW FOR STUDENTS

The first two chapters are an overview of topics used in my classroom. Students will want to read these chapters to become familiar with the workings of storyboarding and previsualization of 2D/3D animation. Those in the industry may want to skim the following chapters, as a few of the ideas presented may be new to you. From techniques that I learned in the industry and have honed in the classroom, I have put forth a few ideas to help streamline a 2D/3D animation process. You can add these thoughts into your own pipelines.

The chapters are a short read and even include homework. I hope you brought your pencil and paper to class.

1

HYBRID ANIMATION: THE MAIN PROBLEMS

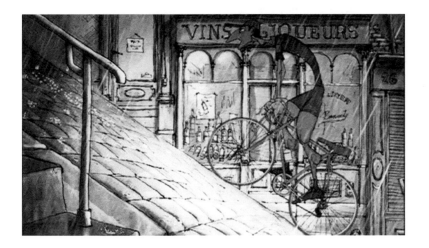

SUMMARY

What is 2D/3D animation? Why use one medium over another? What is the main problem of combining media, and how does one judge the success of this integration? This chapter addresses all of these topics.

To begin your journey toward creating 2D/3D animation, the hands-on exercise section of this chapter will have you create a short storyboard sequence using a given visual style, visual storytelling rules, and storybeats/beads. A short overview of using these three concepts is presented for those unfamiliar with the terms. Then, looking at the outcome of your exercise, we will contemplate what media might be used to execute the story.

DOI: 10.1016/B978-0-240-81205-2.00001-7

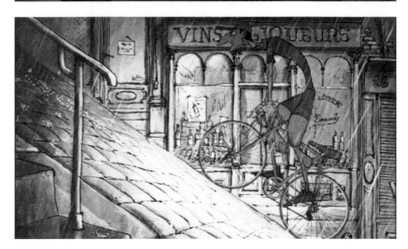

FIGURE 1.1, FIGURE 1.2, FIGURE 1.3 Hybrid or 2D/3D animation examples can be found in many films, such as *Iron Giant, Triplets of Belleville,* and *Treasure Planet. The Iron Giant* © Warner Bros., a division of Time Warner Entertainment Company, L. P. All Rights Reserved. *Treasure Planet* © Disney Enterprises, Inc.

WHAT IS HYBRID ANIMATION?

Hybrid animation is the combination of two-dimensional (2D) and three-dimensional (3D) animation media. 2D and 3D animation media can be used, and are used, independently of one another. Pixar's *The Incredibles* is an entirely 3D animated film. Disney's *Dumbo* is an entirely 2D animated film.

Yet ever since the first appearance of a 3D glowing bauble in a 2D animated film, Disney's *The Black Cauldron,* artists have been finding inventive ways to combine the animation media. The use of 2D/3D at Disney predates *The Black Cauldron* and can be seen in a short test done by John Lassiter titled *Where the Wild Things Are* (1983).

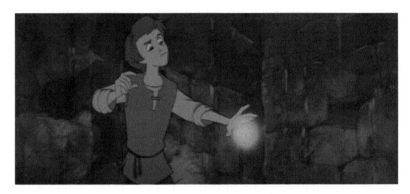

FIGURE 1.4 The bauble from Disney's *The Black Cauldron* was one of the first 3D elements to be combined with 2D animation. © Disney Enterprises, Inc.

> **Trench Note**
> Most attribute the first 3D element in a 2D animated film to the clock gears in Disney's *The Great Mouse Detective.* The first experiments with combining 3D with 2D in a feature animated film is the bauble in The Black Cauldron, animated by Barry Cook.

There have been many combinations of media. Some of the earlier examples can be found in the Academy Award–nominated short *Technological Threat* in 1998 and also in a wonderful short film produced at Disney's Florida studio called *Off His Rockers.* Both of these shorts can be found on YouTube. In feature animated films, probably one of the most memorable combinations of media is found in Warner Brother's *Iron Giant* where a young boy befriends an alien robot, the robot being 3D in a 2D animated film. However, characters themselves do not need to be completely rendered in one medium or another, as was the case with the character John Silver in Disney's *Treasure Planet* or the bicyclists in *The Triplets of Belleville,* as shown in Figures 1.1 through

1.3. In those films, 2D characters were drawn with 3D appendages rendered to match the 2D portions. Lastly, the most common use of combining media is for noncharacter animation assets or elements. This combination of 3D elements into 2D animation is seen in everything from Disney's *Mulan* to *The Simpsons Movie*.

To begin with, let's clarify exactly what 2D and 3D animation assets are and how they are created. You might be proficient with a few of these creation methods. The hope is that during the course of this book, you will find yourself experimenting with other methods. A large, looming goal of this book is to show you the path to fearlessness and flexibility with software.

2D animation assets are images that exist only in two dimensions during creation. There is nothing earth-shattering in that statement. How the 2D images are created is the interesting part. These images can be created in the birth tradition of animation using pencil and paper. In Figure 1.5, you see two artists' work. One artist animated the character in red pencil on traditional paper. Then another artist drew a cleaned-up graphite version on a separate piece of paper. Both images are shown composited together in Figure 1.5. Also, traditional animation artists have had great success in creating their images digitally using software such as Photoshop, Flash, or Animo, to name a few. The character depicted in Figure 1.6 is a 2D character drawn and animated directly in Flash. Other ways of creating 2D animation images include painting on glass, drawing in sand, scratching on film, or using other flat methods of creation. All of these methods fall under the 2D animation category.

> **Take Note**
> I found these terms for 2D and 3D art: "flaties" and "clumpies." I have not heard these terms used in the United States; perhaps they are used in the United Kingdom? Keep your ear out for these expressions. [Taylor p. 22]

3D animation assets exist in three dimensions during the creation process. Perhaps this is another not-so-earth-shattering statement, but look at the key phrase: *during the creation process.* Live-action film would come under this category, if we were not limiting ourselves to animation assets. 3D animation assets include digital and stop-motion animation. Digital animation can be created in 3D software packages such as XSI, Maya, Max, or a multitude of others. See the example of a 3D model in Figure 1.7. Stop motion is the process of animating tangible items in front of a camera; usually pose-able puppets made of clay, latex, or other

FIGURE 1.5 2D Traditional Character "M.E." Animation (red) by Tina O'Hailey. Cleanup by John O'Hailey.

FIGURE 1.6 Image from *How to Throw a Jellyfish Party*, drawn and animated in Flash by Dan Murdock, 2008, Savannah College of Art and Design (SCAD), Digital Cel I course.

materials. Figure 1.8 presents an example of a stop-motion character created by M.T. Maloney for his stop-motion short film *King Rust*.

Because we are focusing on animation and not live action, combining film or video with 2D or 3D animation is beyond the scope of this book. However, the same problem-solving concepts and compositing techniques covered in this book can be applied to combining live action and animation.

WHY USE ONE MEDIUM OVER THE OTHER?

Artists' imaginations continue to grow and stretch the boundaries of animation to tell stories. It can become difficult to decide which medium is best to tell the story. Sometimes, fad decisions are made based on the newness of a medium.

To take an objective look at the decision, consider the following five issues to determine why one medium might be preferred over another:

1. Visual target, not subject matter
2. Line mileage
3. Complexity
4. Team skills versus production schedule
5. Physical assets and budget

FIGURE 1.7 3D character modeled by Loraine Howard III, 2008, SCAD alum.

FIGURE 1.8 Character from the stop-motion animated film *King Rust* by M.T. Maloney.

Visual Target Not Subject Matter

The visual target or visual style of a film is a large factor in deciding which type of medium will be chosen. It is no longer the subject matter that is the deciding factor. The division between what medium is best for what subject matter has become so blurred as to be nonexistent. 3D software techniques have advanced so that humans, furry animals, and other warm-looking creatures are no longer out of their grasp. The question is, which medium will lend itself best to the artist's final vision? This question will be answered with strong art direction and experimenting during preproduction.

Let's look at an example of a visual style. Figure 1.9 is an example of a painterly visual style. It is easiest matched in 2D. Pixar ingeniously incorporated many visual styles, including the UPA style, into its short *Your Friend the Rat* (2007), included on the *Ratatouille* DVD release.

In Chapter 2 we will discuss experimenting with different media to find which best accomplishes your visual style and supports the emotion your story is trying to convey.

FIGURE 1.9 Visual style and frame of final 2D/3D animation by Claire Almon, 2007, SCAD.

Line Mileage

"Line mileage" is a term that means how much line you have to draw. If you were to take a traditional drawing and stretch out the lines end to end, you would see what your line mileage is. Every millimeter more of pencil or digital line takes more time to draw. Intricate character designs may look good as still images, but the reality of animating such a character is time consuming. A long, curly headed character wearing a wrinkly overcoat, multiple ammo straps over his shoulders, and a striped shirt has extra line mileage. It is difficult to keep so many lines moving well without them seeming to crawl, pop, or distract from the animation.

FIGURE 1.10 Line mileage refers to how much line must be drawn, shown here by stretching out the drawing end to end.

If a traditional medium is chosen and the animation is fully animated, line mileage is looked at very closely and characters are simplified to minimize the line mileage. For example, on the fully animated Disney film *Lilo and Stitch*, the T-shirt for the character Nani had a coffee cup design on the front. The design was simplified to a heart in order to lower the line mileage. This may not seem like a large simplification, but given that Nani was in much of the movie, the seemingly small simplification (along with many others) added up to less time spent drawing. Anime characters can be designed with more detail because the animation style dictates minimal inbetweening in the characters.

> **Trench Note**
> Readers may have noticed that the coffee cup T-shirt appears at the end of the film when Stitch is seen doing the laundry.

A common multiplier of line mileage is crowds. If a traditional animated film calls for crowds of people, that is a ton of line mileage. To simplify the line mileage, many 3D crowd techniques have been used. 3D crowds were rendered to match the 2D line style in Disney's *Hunchback of Notre Dame* and with the Hun charge in *Mulan*. Another method used is to procedurally populate a 3D world with 2D animated sprites; this method was also used in *Mulan*. *The Simpson's Movie* used a similar technique of moving a 3D camera move through a 2D crowd.

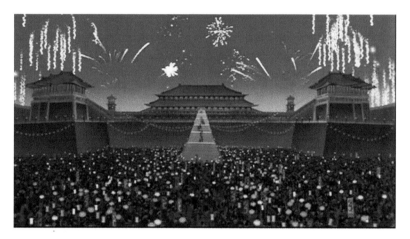

FIGURE 1.11 Disney's *Mulan*. The palace scene used 2D animation, crowd placement in Maya, 3D fireworks, and compositing software to create this hybrid shot. © Disney Enterprises, Inc.

Complexity

3D has successfully been used to animate complex elements that are difficult to animate *believably* using traditional methods. Objects shown in perspective or having intricate textures and details can become distorted when drawn in 2D. An early example is the magic carpet in *Aladdin*. The carpet was designed with an intricate texture that needed to bend and move as it animated. The carpet, needing to match a 2D style, was animated in 2D as a template and reanimated and rendered in 3D so that its texture moved believably. In Disney's *Brother Bear*, the moose's antlers proved to be difficult to draw in perspective.

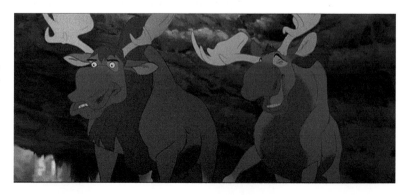

FIGURE 1.12 Broose Johnson and Tony Stanley animated the antlers in 3D to match their 2D moose animation. The 3D animation was then used as a template and redrawn in 2D. In Chapters 4 and 5, we will cover these techniques. © Disney Enterprises, Inc.

Team Skills versus Production Schedule

A reality is that you might have a team of artists that are not comfortable with the medium you want to use. If you do not have a production schedule that allows for training and retooling for different media, it will ultimately sway the medium choice. Students can relate to this as well. Often they find themselves up against a project deadline and opt for the medium they are most comfortable with instead of experimenting with new media. As a side note, this is a cyclical issue: the medium a student puts on his or her reel is more than likely the medium/industry where that student will find a job. Unless the student is on a project that has the budget and time to allow training in a different medium, he or she may find jobs scarce if a fad shows that animation studios are favoring one medium over another.

Physical Assets and Budget

Having or not having the budget to purchase the physical assets you need for a given medium will certainly sway what your production decisions are. What is the cost of a given medium? Is one less costly than another?

Physical asset costs for the different media, when compared, vary. The diminishing cost of computer animation software has steadily made the software more accessible to the general public; however, 3D studios are costly to set up and even more costly to maintain. Stop-motion or model animation costs are close to that of traditional 2D animation, and traditional animation's costs can be kept low with homemade light tables and self-punched paper. Just like with any business, physical asset costs can be as little or as much as one wants to spend.

Ultimately, the largest cost is the time spent on the project and the number of artists needed to complete it. Digital processes have tried to address this "time is money" issue. 3D studios, theoretically, can recoup part of their cost by having smaller crews. Paperless or digital 2D animation is slightly cheaper than 2D animation using paper, because the digital process saves time by allowing easy sharing of art assets and bypasses the scanning process.

Once a studio is set up and running in a given medium, adding another medium causes the studio to incur additional costs. For example, the small studio that creates *The Simpsons* television series (writing, story, and keys) in Los Angeles has small budgets and extremely quick turnarounds. However, the studio also created the larger-budget *The Simpsons Movie*, which included a large amount of 2D/3D animation. Naturally, after that exposure to 3D the crew began to incorporate 3D more into the television show. If a production has a traditional low-budget pipeline, the

producers may be extremely hesitant to take on any different and possibly expensive technique. Such a request can certainly concern the accounting department because of the extra expense.

WHAT IS THE MAIN PROBLEM OF COMBINING THE MEDIA?

Once a decision has been made to use multiple media, the problems of how to produce the shots loom largely. It is important to work out the following pipeline issues so that the production can be successful:

1. Style matching
2. Registration
3. Frame rate and image format
4. Timing
5. Image sizes

FIGURE 1.13 Pipeline test of 2D character walk cycle with 3D head, by Claire Almon, 2007, SCAD, 2D/3D course.

Style Matching

During the previsualization stage of production, experimentation will need to take place. Multiple software, drawing methods, combinations of the media, and post-processing effects need to

be compared to see which pipeline will most easily achieve the visual style set forth by the art director.

It is important that all experiments be well documented. What workflow was employed to get the artwork from the concept to the final render? Did the final project achieve the desired visual style? At times, a different visual style will be achieved, one not correct for the present project but useful for something in the future. At other times, a method will not work because the technology will not be completely advanced enough yet. Sometimes it only takes half a year for the technology to catch up, and for the next project you will have a half-developed technique that you can reapply and test.

Having a small team of enthusiastic risk takers who are unafraid to experiment with technology and artistic techniques with an eye toward creating stunning visual results is necessary. The techniques found in this book will help you become one of those enthusiastic risk takers.

FIGURE 1.14 Concept art for *Poison Tree,* 2008, SCAD, 2D/3D group project.

FIGURE 1.15 Final image from *Poison Tree,* 2008, SCAD, 2D/3D group project.

Registration

Registration refers to when one object touches another in the scene. For example, when the 2D character Hogarth climbs into the 3D robot's hand in the *Iron Giant*, where they contact is the registration line. In the past, having a 3D object contact a 2D object has been a large registration issue that was nearly impossible to overcome. 3D objects had to be printed out and pegged onto animation paper. This process is error prone the moment the printer spits out the first page. The printer itself does not print a well-registered image; the pegging process cannot be perfect

enough. The 2D animator must register 2D art to this wobbly image. This method was used on *Mulan, Lilo and Stitch,* and countless other animated films. With dedication to detail, it *is* possible to produce well-registered images this way, although this method is very difficult.

Technology has advanced, and now that Wacom tablets, Cintiq tablets, and paperless animation have arrived, the printing pipeline for registration is no longer necessary (unless you have budgetary issues). However, even with the introduction of the Cintiq and Wacom tablets, registration is still an issue that can belittle the 2D/3D compositing efforts. If the artists are careless in regard to the registration lines (in other words, if the artists have sloppy draftsmanship), all the technology in the world cannot save the shot.

Each combination of elements requires a different pipeline to obtain the best registration. Depending on which element "leads the movement" in each shot, the 3D element will have to be drawn first or the 2D element will have to be drawn first. In the coming chapters as we cover the common combinations of the media, we will also highlight the pipeline needed for proper registration.

FIGURE 1.16 Example of 2D character registering with 3D character, by Candice Ciesla, 2007, SCAD, 2D/3D course.

Frame Rate and Image Format

Frame rate and image format seem like small issues, and they are often overlooked in small studios or on student films. When combining different media, especially across multiple software packages, it is extremely important to agree upon the frame rate that will be used and in what format the images will go through the pipeline. For example, if a 2D character is drawn and pencil tests are done at 24 frames per second, the animation is approved

and a reference avi file is made. Then that animation is brought into a 3D software package for the 3D animator to create the octopus arms that are to attach to the 2D character. The 3D animator should, obviously, use the same frame rate as the 2D animator. Is the avi file that the animator is referencing actually 24 frames per second? Did the 3D animator remember to set playback settings to 24 fps, or are the settings on 30 fps? Pipeline tests need to check that image formats maintain constant frame rate and image size throughout the production. All of the topics we cover will help to make it unnecessary to redo scenes because the animation did not match properly.

Timing

Anyone who has ever animated a character holding a coffee cup (or something of the like), even in a single medium, knows that it is difficult to make sure that the coffee cup moves in sync with the hand. In traditional animation the cup is on a separate piece of paper and the animator has access to the timing chart or x-sheet and knows where the keyframes are and what type of timing was used. She can match similar keyframes and timing to the cup level. An example of this technique is depicted in Figure 1.17. If the same type of animation were to be done in 3D, then constraints could be used to help simplify the issue, as illustrated in Figure 1.18.

> **Trench Note**
> For those counting, this is the fourth coffee reference. There's a quiz at the end, so pay attention.

FIGURE 1.17 Example of 2D elements registering.

FIGURE 1.18 Example of 3D elements registering. 3D model and rigging by Amanda Powell, 2009, SCAD, 3D Character Setup and Animation course.

Any student who has tried to animate a handheld object in 3D without using constraints should instantly cringe at how difficult it is to match the timing. This is what happens when multiple media are combined—the timing must be matched frame by frame.

To do this, it is easiest to know where the keyframes (extremes) are and what type of timing is being used. In the case of a traditional character leading a digital character, is the 2D character's inbetweens on halves? Thirds? Held? This is not an issue if the animation is completely done on ones (every frame is drawn); however, this is not the common procedure. Maintaining an x-sheet and some style of timing chart is the solution to this problem.

X-sheets or dope sheets can be found in countless "how to animate" books. They are rarely used in 3D, which makes the inclusion of them in a 2D/3D animation process alien to the 3D animators.

The use of the timing chart, the chart drawn on a traditional keyframe that communicates to the inbetweener how to space the inbetweens he must draw, is another traditional technique that 3D animators do not use. Sadly, I see more traditional animation students coming through my classes who do not understand completely, nor use, timing charts. This might be the hardest concept to apply to your pipeline.

It is possible to combine 2D and 3D animation without timing charts and x-sheets; using them, however, will make the process less painstaking. As with all of the previously discussed concepts,

we will take care to address this issue and its variations in the upcoming chapters.

Image Sizes

The last concept that must be resolved for a 2D/3D pipeline is that of image sizes. Because scanned images, rendered images, digitally drawn images, maybe even still photography are to be combined, in order for them to register properly you will need to make sure that you are using the same pixel ratio and have agreed-upon res (resolution) and image sizes for your pipeline. Again, this issue might seem obvious to a solo artist. However, on a group project, nothing is too trivial to outline. Often, different file sizes are used throughout the production to speed up workflow. For example, in the rough stages of animation, reference images need not be at full resolution size, as that will only slow down the software package being used and the transfer of images between artists. Finding ways to use smaller res sizes (all at the correct ratio so that registration stays consistent) will increase productivity. In production, at least three file sizes can be used, and depending on the studio there may be more:

1. *Final res.* The final render of animation assets that are then composited together (for example, 1280×720, image ratio $1:77$, pixel ratio: 1).
2. *Mid res.* Used for double-checking registration and getting animation approved (for example, 960×540, image ratio $1:77$, pixel ratio: 1).
3. *Low res.* Used for initial scans and rough animation. This allows for memory savings and ease of use in 3D animation packages as reference (for example, 512×288, image ratio $1:77$, pixel ratio: 1).

To recap, once the pipeline for reaching a visual style is achieved, then it is decided how assets will go through the pipeline to achieve the best registration based on which asset needs to be created first. Then a test is needed to make sure that the image sizes, as well as frame rate and image format, all flow through the pipeline and end up as a final image that is successful. In Chapter 2, we will work on this process by working toward a visual style while iterating through pipeline issues.

JUDGING THE SUCCESS OF 2D/3D INTEGRATION

There are a lot of things to consider when combining 2D and 3D animation. After working through the chapters in this book,

you should be well on your way to having mastered some of those considerations. How do you know if you've done it successfully?

When researching for this book, students and colleagues brought example after example of 2D/3D combinations to add to my growing list of films. Looking through all of them, one might find that there is one measure that determines whether the 2D/3D combination was successful or not. As all hard-working visual entertainment specialists know (be they editors, VSFXs, compositors, animators, texture artists, lighters—any of us), *it is successful if our work is invisible.* If our visual style creates a homogeneous image that conveys the emotion of the story, if our registration is executed well and the contact points don't wiggle, if our animation timing is accurate and our media move well together, if our work is not visible and if the story is told without interruption, then our efforts have been successful.

FIGURE 1.19 Stop-motion test with digital head replacement, by Chris Ellis, 2006, SCAD 2D/3D course.

HANDS-ON EXAMPLE

The following exercise will allow us to go through a story creation process using the bull's-eye method, thus solidifying our use of these new glossary terms. Because we are working on a 2D/3D project as well, you might find the process slightly different from what you have read in other books. I have found breaking things down this way allows me to move students away from the very first way of setting up a shot that comes into their heads. It pushes them to look a little at their shots and how they relate to the story to dictate the setup. Basically, I'm throwing logic at the problem.

We'll actually start with the second ring of our bull's-eye first. The storybeads for your exercise are as follows:

1. It is a lovely night.
2. There are two people, in the city, in love.
3. Character A thinks that now is the right time.
4. On bended knee, character A asks the big question by presenting the ring.
5. Character B thinks over the question.
6. Character A waits for the answer.
7. Character B rejects the offer.
8. Character A is rejected in the city as the rain begins to fall.

Now let's look at the center of our bull's-eye: the emotion. We will start the story out by making the audience think this couple is in love, get their hopes up, then show the loneliness of the dejected lover at the end of our story.

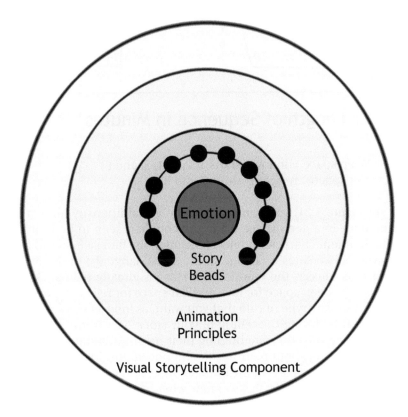

FIGURE 1.20 Exercise bull's-eye with central emotion and storybeads.

We know about the third ring in the bull's-eye, so let's move onto the fourth ring. To make the audience feel our story, we will use a visual storytelling component: space. We will use the contrast of flat and deep space for our story. If you haven't read Block's book, follow along with the imagery and you'll be able to

deduce some of the ideas of showing off space as an actor. You may miss the finer points, so make sure to read his text. The visual rule for our small story will be as follows:

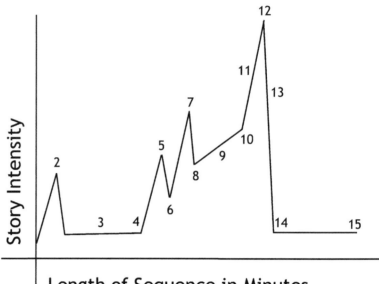

FIGURE 1.21 Story and visual intensity chart with visual storytelling components.

1. Deep space = in love (shots 1, 2, 3, 4, 5, and 6)
2. Flat space = rejected (shots 7 and 8)

In Figure 1.21, you can see that the visual intensity holds the audience in a deep space when the couple is seen to be in love. The moment character A rejects the offer, the film switches to flat space. This creates a change in the visual language of the story and thus plusses the emotion the story is already telling. Did it have to be deep space for love and flat space for rejected? No. You can set up any type of rule that you want, as long as you stay true to that rule during the telling of your story. Now, if my students are reading this, they are holding their breath thinking I'm going to start talking about neurons, the hippocampus, inhibitors, synapses, and other parts of the brain to prove how exactly this works. I'll just leave it at this: Pavlov knew what he was doing with those dogs. "Ding. Ding."

Random Note
Let out your pent-up breath, students. I won't discuss synaptic connections here. You can attend my three-hour lecture on the topic at your leisure.

Of course, that is not the only way to tell the story. What if our emotional intent was to show that the marriage proposal was doomed from the beginning, and the story is about two lovers who can never marry?

Flat space = single/rejected (shots 1, 2, 5, 7, and 8)
Deep space = hope for marriage (clueless character A's shots: 3, 4, and 6)

We keep the story in flat space and the only time we break into deep space is when we are showing poor, clueless character A as he or she hopes for a marriage acceptance.

If we put all of these elements together—the emotional center, storybeads, and visual storytelling components—we get a bull's-eye chart something like the one shown in Figure 1.22.

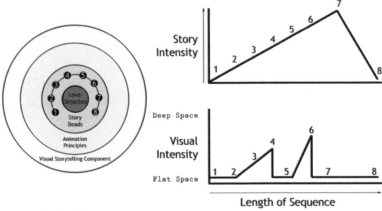

1. It is a lovely night
2. There are two people, in the city, in love.
3. Character A thinks that now is the right time.
4. On bended knee, Character A asks the big question by presenting the ring
5. Character B thinks over the question
6. Character A waits for the answer
7. Character B rejects the offer
8. Character A is rejected in the city as the rain begins to fall.

Flat Space = single/rejected
Deep Space = hope for marriage

FIGURE 1.22 Our story's intensity chart with visual storytelling components and bull's-eye with storybeads and central emotion.

You will note the animation principles ring of the bull's-eye. I remind my students that were they an actor on a stage, they would not give the Academy Award–winning crying speech in every scene. They would save those tears and all-out acting for the climax of the film. This ring reminds the animator where to pause, where to hold back, and where to let every trick out to hit that emotional center.

Here is an example of a thumb-nailed storyboard and the final storyboard for the first version of our story where everybody is in love until the final rejection. Note that all shots are in deep space with only the last two panels in flat space. This reflects what we set up as our visual storytelling component:

Deep space = in love (shots 1, 2, 3, 4, 5, and 6)
Flat space = rejected (shots 7 and 8)

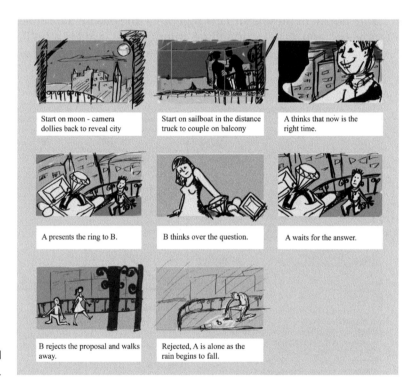

FIGURE 1.23 Thumbnail storyboard for version 1.

To following shows an example of using the visual storytelling components to change the emotion of the story to show the cluelessness of character A. Note that shots 3, 4, and 6 have stayed the same, as they were in deep space already. The camera movement changed in the beginning two shots to make them into flat space. Shot 5 was changed the most, and I reframed the final shot to make the character feel a bit more trapped near the center:

Flat space = single/rejected (shots 1, 2, 5, 7, and 8)
Deep space = hope for marriage (clueless character A's shots: 3, 4, and 6)

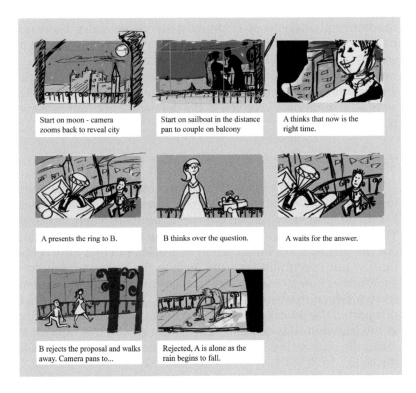

Start on moon - camera zooms back to reveal city

Start on sailboat in the distance pan to couple on balcony

A thinks that now is the right time.

A presents the ring to B.

B thinks over the question.

A waits for the answer.

B rejects the proposal and walks away. Camera pans to...

Rejected, A is alone as the rain begins to fall.

FIGURE 1.24 Thumbnail storyboard for version 2.

What have we done so far? We worked on our storybeats/storybeads first and focused on what emotion they are trying to portray. Then we decided what visual storytelling component we will use to visually support the intensity of the story. All of this was completed *before* we began storyboarding. Of course, complete books can be dedicated to the storyboard process and how to visualize the story, which is not the focus of this book. I will suggest that you read, along with Bruce Block's book, Francis Glebas's book *Directing the Story*. If you read the two books together, you will have a great understanding on how to tell your story.

VISUAL DEVELOPMENT

Before we can discuss what this book is about—creating a hybrid animation—we must research and design the style of our

film. A *little* research will help us expand our horizons and move beyond the first image that pops into our heads. Graduate students spend the bulk of their time toward earning their degree by researching styles that appeal to them and then formulating their own style. Undergrad students *should* spend the bulk of their time researching styles and mimicking them until they understand the fundamental makeup of each style. By visual styles I am not necessarily referring to animation only. We can find inspiration in sculpture, painting, illustrations, architecture—*any* art form. Do not limit yourself. For the beginning stages we will stay simple, and in this assignment we are going to use Frank Miller's graphic style as inspiration. I urge you to dig deeper during your research phase.

What Does It Mean to Research a Visual Style?

To me this is such a fun part of the process. At Disney, the training department would offer all sorts of classes and guest lectures. I sat in on most, because that was the department where I worked. The whole department (all five of us) set up the chairs and handed out the pizzas, and I would get an education out of it until it was time to put everything away, go back to the training room, and show artists how to use the software. One of those guest lecturers was a production stylist for *Hercules*, Sue C. Nichols. She described this part of the process as going into the candy store and looking at the isles and isles of shiny, tasty candy. At first it is difficult to make the choice. It is an inspiration process that artists should thrive in.

When timelines are involved, I see that students often fall back to a style they are comfortable with. My students know that I am constantly pushing them to move beyond having only one style of drawing or animation. I am sure it has not been easy for them; they have not liked it but worked through it anyway, and I thank them for their hard work. I liken it to actors who can get pigeon-holed into one type of character type versus actors who can move in and out of different characters seamlessly. It gives you a portfolio with much more breadth that allows you to expand into any type of role. Do not be afraid to try different styles of animation, different character looks, and different final compositing styles.

Take a look at the extra features on Disney's *Treasure Planet* feature animated film on DVD. You will find that the filmmakers used N.C. Wyeth and other illustrators from the School of Illustration as their visual inspiration for the art style of *Treasure Planet*. When researching for a visual style, aim high. If you think a Rembrandt painting captures the warmth that would best support the emotion you are trying to create, use Rembrandt as inspiration for your visual style.

How Much Research Is Enough?

You always want to complete more research than you need. Research should be an inspirational process. There are plenty of books on concept art and visual development to help you through this portion of the process. At Disney, we had a research librarian who stocked shelves with pertinent books, DVDs, slides, and so on that would be on hand in case an artist needed inspiration and guidance during the course of the project. Once she was even asked to please research "the meaning of life" (with no signs of Monty Python anywhere) for *Brother Bear*—and her results were due in two weeks.

My warning about the research previsualization step: often I have seen students who adore the previsualization stage and doing the concept art, but when it comes to the actual production of their short film, they either run out of time because so much was spent during the previsualization stage or they run out of passion.

What If I Work on This Step Later and Continue with the Story Development?

You can. If your team is made up of more than you, the jobs can be assigned to different individuals. However, when working on a small team project or a personal project, I urge my students not to put off the visual development stage, especially in the case of 2D/3D projects. Research early on helps the animator to work toward a visual style much earlier. This style can work itself into your final storyboards. With these more developed images you can begin to think about the media needed and other questions that we will look at shortly.

As a word of caution: when developing storyboards for 3D animation you must work out many issues completely (more so than you would for 2D animation) to aid in production. For instance, you do not have to model everything completely if it is not going to be seen. This can be visualized in your storyboard process early on and save production time. The same is true, even more so, for a hybrid animation. Planning in the beginning stages will save time, money, and the sanity of your art production manager (APM).

Now we are ready to focus on what this book is about: creating a hybrid animation from this story. We're going to work with the second treatment of the story where character A is absolutely clueless that he is about to be rejected.

The questions we need to ask are as follows:

- What medium or media would best tell this story?
- What are the technical challenges?

What Media Would Best Tell This Story?

In other words, how should the story look? We decided to use a flat space in most shots. Flat space does not have to be 2D; it could be 3D. Depth cues can be removed from 3D shots to create flat space fairly easily. However, if we look at our chosen style of Frank Miller, we see that a flat graphic style might be best depicted with 2D. The most important point is that the linework should be smooth and graceful.

To push the deep space aspect of our sequence, we will need to work with the camera. By having parallax between the buildings, characters, trees, and so on, we can push this naturally flat space to appear deeper.

In shot 4, we want to make sure that the ring box is shown in the deepest space of all. It is character A's hopeful moment. We might want to use 3D for that ring box and use tones and highlights to push the tonal range.

If we pushed shot 6, "Character A waits for the answer," to be in ambiguous space instead of deep space, it might up the intensity even more and cause the audience to feel on edge. If you've ever seen a horror film or *Citizen Kane,* you have seen ambiguous shots. The result is that the members of the audience aren't quite sure where they are. Composing an ambiguous shot can be tricky, so we'd have to make sure we do some tests on how to achieve the type of look we are aiming for.

What Are the Technical Challenges?

As we proceed in the next chapter, we need to keep in mind that the following technical challenges need solutions:

1. The flat 2D: traditional portions. Should they be pencil or digital vector line to achieve a smooth look?
2. For the deep space shot's parallax: Can we accomplish this with compositing only or all in 3D?
3. The 3D ring box: We'll need to test a cartoon rendering style and match it to the 2D style that we have accomplished.
4. The ambiguous shot: How will we achieve this shot? We better put this one into testing pipeline first and allow extra research and iterations so that we come up with the best look, not just the first one.

The final step in this stage: more research.

What Has Been Done Before?

It does not matter how old the film is or even how successful a film was. Research should include everything. Many lessons can

be gleaned from films that failed to pull off what they were trying to achieve. Perhaps the technology just wasn't ready at the time the film was made. How did the filmmakers go about pulling off the shot? DVDs and their great commentaries and supplemental information nowadays are an amazing resource. "Why, back in my day, we didn't have the Internet and DVDs with people telling us how they did things. We were all clueless and had to figure things out!" My students laugh when I go on my old lady rant, but it is the truth. It also made us all great problem solvers. We had to figure it out, most of the time without manuals. Those were the priceless printed tombs that the school only had one copy of and you did not have access to them. Start storing up your old lady stories. You'll be telling your own version in about 20 years. Research. You must do this. Nothing is too old. Nothing is too wrong. You can learn something from everything. So, now for our first assignment.

PROJECT: 2D/3D MOVIE ANALYSIS

Due: _____

Students and those who are studious, the following is your homework assignment, due before you read Chapter 2.

With this chapter's ideas fresh in your head, now it is time to research 2D/3D films. Review a 2D/3D film of your choosing. Refer to the list at the bottom of this project sheet for possible selections. Feel free to add your own film to the list. There are certainly more.

For students: Present to the class a PowerPoint presentation, keynote, html page, or other visual presentation of your findings. Utilize DVD players on the PC that do image grabs, or use a Mac.

Here are some questions to answer in your presentation:

1. What type of art direction was used in the film?
2. What were the film's artistic influences (i.e., artistic styles)?
3. Was the combination of media a success or a failure? Why?
4. What is your favorite scene? Why?
5. What technical information did you glean from the special features or commentary of the film? Site your sources.

You are assessed on the following skills:

1. Problem solving (getting images, putting the presentation together, testing that the presentation works properly)
2. Analytical abilities (depth of analysis, proper application of topics learned)
3. Aesthetic appreciation (ability to visualize art assets)
4. Technical appreciation (ability to present the technical concepts learned)

Here are some hybrid animation examples (to name a few):

Prince of Egypt, 1998
Mulan, 1998
The Iron Giant, 1999
Tarzan, 1999
Cowboy Bebop, 1999
Titan A.E., 2000
El Dorado, 2000
Osmosis Jones, 2001
Spirit: Stallion of Cimarron, 2002
Lilo and Stitch, 2002
Treasure Planet, 2002
Brother Bear, 2003
The Triplets of Belleville, 2003
Princess Mononoke, 2004
Steamboy, 2004
Mushishi (episode 1), 2005
The Simpsons Movie, 2007
Family Guy Blue Harvest, 2007
Futurama, 1999-2009
Waltz with Bashir, 2009

FURTHER READINGS

Block, Bruce. *The Visual Story Creating the Visual Structure of Film, TV and Digital Media,* Boston: Focal Press, 2008.
Glebas, Francis. *Directing the Story,* Boston: Focal Press, 2008.
Hooks, Ed. *Acting for Animators,* Portsmouth, NH: Heinemann, 2003.
Stanislavsky, Constantin. *An Actor Prepares,* New York, Theatre Arts Books: 1948, 1965.

STUDENT CONTRIBUTORS

Contributing students for this chapter, in order of contribution:

Dan Murdock
Loraine Howard III
Claire Almon
Candice Ciesla
Amanda Powell
Chris Ellis

Please refer to the Student Contributor appendix to read more about these students and to find out where you can see more of their work.

DERALD HUNT
CG Animation Supervisor

It has become commonplace in our industry to mix 2D and 3D disciplines. There are many benefits that come from having access to a diverse set of animation tools and the skill to make them work together. This is a fantastic case of "If the only tool you have is a hammer, all of your projects start to look like a nail." If all you know is 2D, you are missing out on the efficiencies that can be won by incorporating 3D into your pipeline. If all you know is 3D, you miss out on great traditional animation style and the speed that can come from 2D animation. It is important to choose that right tool for the job, and combine them whenever it makes sense.

I worked with a team of people on a series of Lara Croft animations where we used 3D environments that were shaded to exactly match Flash characters. The advantage to using 3D for the environments was obvious. Once a scene was built in 3D, it was very easy to move the camera to capture the scene from a variety of angles. Carefully planned camera moves added a lot of production value for very little effort. In many cases, we substituted 2D characters with 3D versions to make the scene more dynamic. In one episode, we had to animate hundreds of

crawling insects. In this case, it was far more efficient to use 3D versions of the bugs to populate the scenes.

Another way to enhance 2D animation is to leverage the power of 3D with difficult-to-draw changes in perspective. Our team was challenged to animate vehicles that were swerving, flipping, and spinning through several scenes. Using 3D to solve the difficulties of perspective allowed the animators to concentrate on motion and timing. Once the vehicles were shaded to match the Flash, integration was simple.

Occasionally we work with characters that are expected to look like they were produced in Flash but move in a more 3D fashion. When tasked with developing a new web personality, it was decided that we would build the new character in Flash and then match the 2D look in a fully rigged 3D version as well. In many cases, the animations that we were asked to produce were easy to achieve in Flash. However, some animations required the character to spin in circles and perform acrobatics that would be time consuming to draw. If the integrity of the character was maintained and the look was identical, the client didn't care which approach we used. We simply chose the most efficient tool for the job and saved our client a lot of money with our process.

We worked on a project where we were asked to repackage an entire network for a summer stunt. We were given fantastic character designs and asked to combine them with realistic-looking 3D environments. At first we tried fully modeling the characters in 3D but soon discovered that these designs didn't interpret well into dimensional characters. After several attempts, we decided to build and animate flat, 2.5D versions of the characters in a 3D animation package. This approach allowed us to match the character designs exactly while making it far easier to integrate them into the scene. Simple 3D rigs were built to give us animation control over the flat characters. It was an effective solution that yielded big results.

Using a mixed discipline approach can be an enormous time-saver while adding production value to a project.

ITERATIONS FOR DEVELOPING A PIPELINE AND NAILING THE MOMENTS

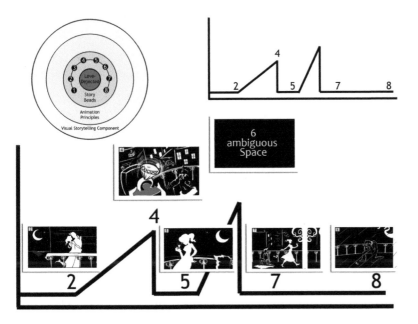

SUMMARY

This chapter covers how to isolate the most important and strongest emotional storybead/storybeat moments in a film. These "moments" are used to develop the visual target for the story. They are the frontrunners for working out the pipeline issues, isolating technical hurdles, and deciding what it will take to get the shot done and make it look good. It all starts with a visual target. Without it, the artist risks having images that have achieved something technically worthy yet lack any emotion or aesthetic principles.

DOI: 10.1016/B978-0-240-81205-2.00002-9

WHAT ARE ITERATIONS?

As an artist, you want to be able to quickly go through different looks, ideas, and concepts so that you can decide whether or not these looks, ideas, or concepts worked. An iteration is the ability to repeat the idea or concept until you get the desired results. What is key is that you are able to iterate *quickly*. You do not want to spend a lot of time working through one idea only to find out it won't work! Plus, it is a neat word. Iterations. Throw that one out at a cocktail party. You'll see the CS (computer science) people nod in approval. In Figure 2.1, you see a series of keyframes as an example of iteration. Each frame shows a different stage or iteration of the drawing process for the figure, from a simple gesture to a human with clothing.

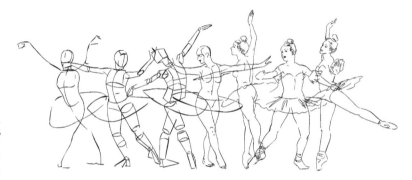

FIGURE 2.1 Iteration is key. Image from *Sugar Plum Fairy* by Claire Almon, 2007, SCAD, Drawing in Motion course.

WHAT IS A "MOMENT"?

As we use it in this book, a "moment" is composed of a style frame and a pipeline test(s) that tries to match that style frame. The term "moment" was used mainly at the Disney studio. I have not encountered it anywhere else. However, to me it is not about the style only, or else we would remain with the commonly used terms "style frame" and "research and development" (R&D). Instead, we use the term "moment" in my class and in this book because it emphasizes that the style frame and R&D are coupled. Together they should be a "moment." The emotional moment is something that I believe should be upheld from the beginning or else it gets lost in the technical details. If you forget to focus on the emotion you are trying to display (no matter what cool new tool or technique you are going to use to show it), you risk having an animation that does not elicit an emotional response from your audience. It would be a shame to miss the emotional target after all of your hard work.

CREATING A MOMENT IS A TWO-STAGE PROCESS

Step 1: Style Frame

First a single frame is created that depicts a key emotional moment in the story. We'll refer to this single frame as a style frame. Often, concept art has been developed in the previsualization stage and can be used as this visual target. This image is a visual guide and has been created to establish the visual style of the film with *any* artistic technique. It does not, and usually is not, created with the tools and pipeline that will be used in the film.

FIGURE 2.2 Style frame for *Three Magicians* by Claire Almon, 2008 SCAD thesis.

What medium should be used for the visual target concepts? Personally, I prefer anything but 3D: traditional painting, Photoshop, Painter, markers, pencil, pen and ink. An artist who starts with a 3D pristine image will end up with just that: a 3D pristine image. However, an artist who starts with an energetic marker comp, with bold shading and gestural lines, is forced to push his or her images further than the natural coldness that 3D lends itself toward.

Step 2: Production Techniques/Pipeline Tests

The second stage is to choose a scene and create an image from the scene (or multiple keyframes from the scene) using techniques that *could* be used in the film. The goal is to use the original style frame as a divining rod. The artist works with different tool sets, software packages, and pipelines to get as close to the visual target as possible while keeping an eye on the best way to achieve it.

FIGURE 2.3 Storyboard, style frame, and final moment from *Three Magicians* by Claire Almon, 2008, SCAD thesis.

The second stage is basically research and development. However, I cannot stress how important it is that we keep a look at the visual target as our goal. So, often it is the research and development—the technology—that leads the scene, instead of the desired look.

WHAT IS THE BEST "MOMENT"?

Let us take a look at that bull's-eye diagram again, shown in Figure 2.4. We have discussed that the inner circle represents the central emotion. Every scene should have some type of emotion that you are trying to get the audience to feel.

Note, I am not saying that the character feels it or that the shot has emotion. No. Your goal is to make the audience feel an emotion. You will need to employ every trick that you can think of to get their brains to call up a memory that causes the desired emotional response. Don't forget it. Every shot should have an emotion, even if it is only sustaining the emotion from the previous shots. Not every shot is an Oscar-winning performance. Sometimes shots are simply shots that get a character from A to B. However, all shots should maintain the current rings of the bull's-eye. Every frame in the shot should be targeted toward the center of the bull's-eye's emotion. But not all shots are high emotional conveyances.

When you choose what moment to put through your pipeline tests, you should make sure it contains the shots with the strongest, most pivotal emotions in your story. You want to make sure

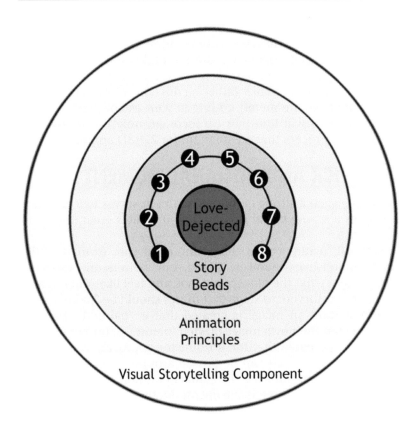

FIGURE 2.4 Bull's-eye diagram and its central emotion.

that you can display them correctly and uphold that emotion. What horror would it be if you couldn't visually pull off the shot where the prince finally kisses the princess?

You'll note that the second ring in the bull's-eye is for the storybeats that we developed in the previous chapter. It is important that all of these storybeats, of course, support the emotion of the story. If this is unfamiliar to you, please refer to the handout "Hitting the Emotional Target" found on the companion website.

A NOTE ON MOMENTS VERSUS VISUAL DEVELOPMENT

Students often ask the difference between moments and visual development. Visual development is a process whereby artists research and define what the visual style of the film might be. This happens during the previsualization stage. We talked briefly about this process back in Chapter 1. Creating moments in your animation piece comes after the visual development stage. What we create in this chapter are the first tries at production work, beyond

the previsualization stage. The final outcome of this moment can be a single frame. However, some studios push the whole shot through the pipeline so that at the end of this stage there is a finished piece of production work. It is assumed that you have many production process books gathering dust on your bookshelf, and in this book we are merely adding to your established methods. Therefore, you will find that we focus on only the areas in the production process that are different for 2D/3D animation.

WHY PICK AN EMOTIONAL MOMENT?

Picking such a strong emotional moment serves two purposes: it creates a strong visual glossary and it creates great images for you to use.

First off, using a compelling emotional shot from your film helps establish its mood by giving your viewers an image that shows them what the film should look and feel like. You might all agree at the storyboard stage that things should be "painterly and sad," but until an image is created that is "painterly and sad" everyone has their own image of what "painterly and sad" is. Once an image is created that the art director approves, then there is something visual that can be passed around, used as direction, and used to communicate the actual definition of "painterly and sad" that can be created using the production tools. These images should be posted in well-lit, highly populated areas so that *all* see them. As the film progresses, if the style focus changes, these images should be updated accordingly. Again, this is beyond concept art. This effect is created using production methods. This is very important. Oftentimes the concept art is great but the final look achieved by the production is far different and misses the emotional impact.

The second purpose of picking a high emotional point in the film is a self-serving one: advertising and promotion (to the outside world and to the team). Whether you need a few compelling images to create a press kit with and pass around to encourage someone to buy your project, to fuel an advertising department, or to inspire your team with what a great project they have signed up for, strong emotional style frames will provide the best images for this need.

HOW MANY DO YOU NEED?

For a film that poses few technical challenges, you would be free to pick any strong emotional moments. For a 2D/3D film, you will need to pick something that is strong emotionally but also highlights any of the pipeline or technical challenges that you are going to have to answer.

FIGURE 2.5 A completed moment used as a team promotion.

In the previous chapter, we created a story with an eight-panel storyboard. In a longer film, obviously, there would be a hundred times more panels, at least. Even in a short student film, you will have amassed large sum of panels.

In a longer film comprised of an exposition, conflict, climax, and resolution, there will be a certain defining story point. Perhaps it is the moment that Indy victoriously replaces a golden idol on its stand with a bag of sand. For just one moment, maybe half a second, he is convinced that he has beaten the booby traps.

You are also looking for shots that show the multiple media together. You want to firmly establish how those media are going to fit together seamlessly as early as possible in your production.

As outlined in Chapter 1, during the creation of these moments, the following technical pipeline issues need to be addressed:

1. Style matching
2. Registration
3. Frame rate
4. Timing
5. Image sizes

FIGURE 2.6 Image by Jason Walling, 2008, SCAD, Digital Cel I course.

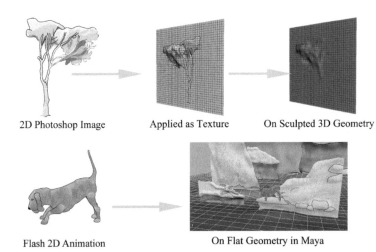

2D Photoshop Image Applied as Texture On Sculpted 3D Geometry

Flash 2D Animation On Flat Geometry in Maya

FIGURE 2.7 Example of art elements in a scene. Images by Jennifer Chandler, 2009, SCAD, 2D/3D course.

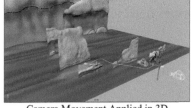

Camera Movement Applied in 3D Final Image

EMOTIONAL *AND* TECHNICAL MOMENTS

Because 2D/3D films have more than one medium, we are also looking to address pipeline and technical issues, not just the emotional moment. This can be tricky because we stray into technical areas. Remember, "iteration" is the key word. The more you can go through at this problem-solving stage, the more likely you are to uncover a better pipeline to create your image. Do not settle on your first try. The first try is probably only your most comfortable, easy method. It might not create the best aesthetic nor be the fastest. This is not to say that you can't have it look good and be fast. What's that quote? "You can have it: fast, cheap, and great looking. Pick two."

Moments can be made using any software program(s)—at first. Aim high. The goal is to capture the style and test out possible technical pipelines. Don't be concerned at first if the technical aspect is too slow or not developed enough: the "*exactly* how we do it" comes later. It might even be decided that the effect can't be done. However, you might find that what you thought would be an improbable way of creating the image is doable with a few tweaks and you still get the great image at the end! It is a test; failure is okay. From that failure you may uncover another way to approach the problem. We make a safe place to fail by only using one frame or one scene. By testing the technical pipelines in a safe environment of one shot or one frame, it allows the filmmakers to try things that they normally would have avoided. They might have not included a certain aspect of a story or a character design because they thought, "No, we can't do that, because …." It becomes especially necessary to have this process in a 2D/3D pipeline when it might be that no processes or pipelines have been established. This puts the production team into a high-risk category. The process of creating moments helps flush out those technical issues early while keeping focused on the overall aesthetic of the piece. Most important, do not stop a test with the roadblock of "We can't do that, because …." Just as in the rules of brainstorming, if you stop a test from happening, you also stop any branches of knowledge or problem solving that might have come from that test. Even if the experiment was going to be a failure, its branches might have led to a success.

Once when I was a student, a professor stopped a student's story idea that had sand in it by interjecting, "We can't do sand." The story pitch stopped, the student blinked a few times, sat down, and that was the end of it. It bothered me at the time for a reason I couldn't articulate. Now I understand. Sometimes it is the "we can't do" situations that spawn great ideas. Instead of "we can't do," you can ask, "How could we achieve the same look?" So to keep creativity from being stopped by "we can't do

its," we allow ourselves this step of testing and iterating to get a final image.

Students often are subject to many hours of art history classes. Animation students should make sure that they are receiving cinema study classes as well. In these studies they will find that these topics are core concepts in filmmaking. So that at that same cocktail party where animators are discussing Acting with a capital A, they should also be discussing Filmmaking with a capital F.

> As soon as the film-maker loses sight of this essence [emotional center] the means ossifies into lifeless literary symbolism and stylistic mannerism.
>
> —Sergei Eisenstein [2]

Hands-on Examples

Now we will go through the process of picking what is a good moment and discussing how to proceed with the pipeline tests to create that moment. Let's take a look at the story we created in the first chapter and find the high emotional moments. We will use these moments to discuss the technical challenges each shot illustrates as well the best medium to use for the art assets. In this example, we will not generate the art; the techniques for that will be covered in Part Two of this book. We are focusing on the method of selecting the correct shots to begin with and how to analyze them.

Picking the Moments

Our storybeads were the following:

Shot 1 It is a lovely night.
Shot 2 There are two people, in the city, in love.
Shot 3 Character A thinks that now is the right time.
Shot 4 On bended knee, character A asks the big question by presenting the ring.
Shot 5 Character B thinks over the question.
Shot 6 Character A waits for the answer.
Shot 7 Character B rejects the offer.
Shot 8 Character A is rejected in the city as the rain begins to fall.

We could argue about what are the highest emotional points in these eight storybeats, and at first blush it might be hard to discern which have the highest emotional intensity. They all are important shots and we would have a hard time cutting any. But some shots could be cut out. That thought can help us weed out what is *not* a high emotional point. What could you cut out and still be left with the same story?

Shot 2 A couple is in the city, in love.
Shot 4 Character A asks the big question.
Shot 5 Character B thinks over the question.
Shot 7 Character B rejects the offer.
Shot 8 Character A is rejected in the city as the rain begins to fall.

Some might be tempted to take out shot 5 and shot 8, the thinking and the resolution. It is possible. In my opinion, making those cuts would cause the scene to lose a lot of the overall emotional impact and empathy that the audience gains by the thinking and the aftermath.

Now we have been able to cut out some of the possible candidates for what shots to make moments of. Let's do another pass at this to weed down the scene even further.

Incidentally, this is a great idea I picked up at Electronic Arts: do not try to cut everything in one pass. Instead, try multiple passes. You end up getting where you wanted to be with less angst. Parallel ideas can be found in object-oriented programming (OOP) and, gosh, everywhere. There generally is logic to the suggestions I put forth here, but this approach is not the only way. Feel free to add and subtract as your methods develop, then tell us about your ideas on the forum www.hybridanimation.com.

To help, we can look at our storybeats and how they correspond to the visual rules we have set up. Then look for where the largest intensity should be. That can help us see where to focus our attention.

Shot 2 (a couple in love) is an establishing shot and really not that high on the emotional chart. Shot 5 (thinking it over) is a good shot but still not high on the intensity chart. With shot 6, cut out of our simplified sequence, the highest visual and emotional intensity is where the crux of this story is: the question (shot 4) and the answer (shot 7). At minimum, those are the two moments that I would push through first.

The two other bookend shots, even though they are not high on our intensity chart, do set and finish the mood: shot 2 (a couple is in love) and shot 8 (the final shot). For me, the first and last shots are very important. The opening shot should be the exposition of the film and tell what the story is going to be about. The last shot should tell the audience how they should feel about the story. (Of course, there are times to deviate from these types of thoughts. Not all stories need this type of visual setup.)

Using our analysis tools, we have picked the emotional moments from our small film. Because I have chosen two moments based on their intensity and importance to the film and two based on my ideas of opening and closing shots being important, I will label them as *high* and *medium,* respectively. I would work on the high shots first, before the medium shots. If I ran out of time, I could

skip this process on the medium shots, but I wouldn't be happy about it.

Shot 2 A couple is in the city, in love (medium).
Shot 4 Character A asks the big question (high).
Shot 7 Character B rejects the offer (high).
Shot 8 Character A is rejected in the city as the rain begins to fall (medium).

STYLE FRAME

The art director of the film (in this case, us) has gone off, looked at plenty of reference material, and created concept art depicting the visual style we would like to have. We will use this concept art as inspiration as we go through the two-step process of creating moments.

For your own productions you would have pages and pages of reference art and concept art. Please refer to the companion website.

Remember the visual rules that we set up in Chapter 1? We chose to use space:

deep space = love
flat space = rejection

From looking at the concept art and reference images I've added in a color visual rule as well:

red = hope for love
black and white = rejected

With those visual rules set, we'll work on the first step of creating our moments: creating the style frame. These images are created using any software. What we are going for is more the look than the actual production method. In our case, the Frank Miller style that we have chosen is very flat with plays of dark and light.

This goes in line with our storybeats and the queuing of the rain during the rejection and final shot. (In your experience, doesn't it always rain when you are sad?) Figure 2.8 shows us the correlation between the storybeats, the visual intensity chart, and the visual targets we have created. By now, it should be clear how these are developed together. We are missing shot 6, which earlier in this chapter we decided was going to be an ambiguous space shot. As the chart in Figure 2.8 shows, an off setting shot should cause the visual intensity to go up before we sharply return to flat space. You now have something to put into a work reel (edited together at the expected length of shot duration); add a scratch reel and soundtrack and you can see how the story plays out. Of course,

this all looks cut and dried with charts. At some point you can start to bend or break the rules as your intuition tells you.

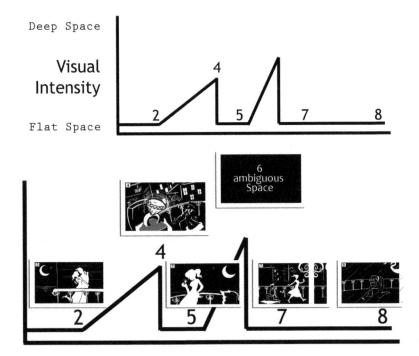

FIGURE 2.8 Visual storytelling component chart.

If this were a film in one medium, we would have already established a pipeline and would merely push these shots through the pipeline (assuming character design and so forth had been completed). However, our technically challenging film requires more diligence and development to establish the pipelines. The good news is that the more problems we solve and the more pipelines we work out, the easier it will be as the project goes along.

PIPELINE TEST USING THE STYLE FRAME AS YOUR GUIDE

With those style frames posted on our wall, passed out to our team, and tattooed on our foreheads, we can begin the second portion of creating a moment—pipeline tests. The question we ask for pipeline tests is, "How the heck are we going to match that look?"

What types of shots are we going to create? It looks like we mostly have flat and deep space shots. Let's add something to what we have, because we are early in the story stage and we won't

lose anything. What a great time to add things! Certainly, we *don't* want to pull these types of stunts later! (Tattoo that on your producer's forearm for me.) Let's add a sense of dread into shot 6, where character A is waiting for the answer. Instead of having it stay in flat space, let's change it to be ambiguous space.

Shot 2 A couple is in the city, in love (flat space).
Shot 4 Character A asks the big question (deep space).
Shot 6 Character A waits for the answer (ambiguous space).
Shot 7 Character B rejects the offer (flat space).
Shot 8 Character A is rejected in the city (flat space).

The second portion of this book is dedicated to going through common patterns of pipelines used for combining 2D and 3D elements. Software will come and go; buttons will change; some processes will streamline; some won't. However, at the core, the workflows will stay similar. It is important to not let changing software get in the way of solving the problem. To do that, you need to be able to ask the correct questions. We'll end this chapter by looking at an example of those questions before we begin with the button clicking.

Because we have established a visual storytelling component to emphasize our emotional intensity in the story outlined earlier, that should be the focus of our main question.

HOW DO WE BEST DISPLAY OUR VISUAL STORYTELLING COMPONENT: SPACE?

Flat Space Shots

Looks like our characters will best match the visual style we have chosen, if done in 2D. Should we use traditional pencil or digital vector line to achieve a smooth line look to match our visual target? How will that match up with any deep space shot?

Deep Space Shots

To get a good parallax of movement in this shot should we use compositing only to create the space or use 3D? If the camera moves, how close will we get to the 2D artwork? What is the best way to make sure the characters maintain resolution and we get the deepest parallax?

Ambiguous Space Shot

How will we best achieve that? We'll have to get someone started on that shot right away so we have time for multiple tests

on that until we get the best technique decided that fits in with the other shots and it brings a sense of limbo. Would this be a zolly shot, an interesting camera angle, or vantage point?

Another question that we can focus on for our testing is the art assets themselves as they relate to the types of space we have set up for each shot.

WHAT ART ASSETS NEED TO BE TESTED?

Ring Box

The ring box could be a complicated box. We'll want to push the perspective of that since it shows up in a deep space shot. That seems like a candidate for a 3D object. We'll need to do cartoon ("toon") line rendering tests to match the 2D style.

Cityscape

Shot 2 with the couple in love in the city has a cityscape. Even though that is a flat space shot and we won't have a lot of perspective to deal with, there still is a lot of line mileage in the buildings. Perhaps this could be a 3D asset?

This chapter has been created to help you, the reader, through the beginning stages of isolating a "moment" in a short film. That moment is picked due to its visual intensity in the story. Since the creating of a 2D/3D film can be overwhelmingly technical and leave behind the emotional core of the story, we learned to create a style frame in any means necessary to keep our artistic goal high. Using that style frame we then begin to ask questions that need to be answered in our pipeline tests. The bulk of this book will take us through the answering of those technical questions.

PROJECT: PICKING MOMENTS

Due: _____

Students and those who are studious, the following is your homework assignment; due before reading Chapter 3.

Choose a *sequence* from a 2D/3D film of your choice. Find the shots that you would have chosen as "moments." This is a shot or shots that depict the highest visual intensity and emotional intensity for the chosen sequence. Also look to find the shot(s) that is an example of the largest technical issues in the film. This may be in addition to the highest visual and emotionally intense scenes. It is also helpful if it displays the main character and main environment.

Identify the art assets that are in the shot and what methods could have been used to create them. Also highlight what an

important problem was that had to be overcome. Something that might have taken away from the moment: contact points, shadows, registered movement between 2D and 3D characters, and so on.

For students: present to the class a PowerPoint, keynote, html page, or otherwise visual presentation of your findings. Utilize DVD players on the PC that do image grabs, or use a Mac.

You are assessed on the following skills:

1. Problem solving (getting image, putting the presentation together, testing that the presentation works properly)
2. Analytical abilities (depth of analysis, proper application of topics learned, use of glossary)
3. Aesthetic appreciation (ability to visualize art assets)
4. Technical forethought (ability to conceptualize what methods might be have been used in creating the shots)

View the companion website for this chapter to see examples of presentations by the students below: www.hybridanimation. com.

FURTHER READINGS

Barshatzky, Kathy Kershaw. *The Art of Disney's Mulan, Visual Integration: The Hun Charge* SIGGRAPH, pp. 4b-2-4b-3, 1998 Course Notes Course 39. 25th Interactive Conference on Computer Graphics and Interactive Technique.

Eisenstein, Sergei, *Film Form: Essays in Film Theory*, p. 58, Houghton Mifflin Harcourt, 1949.

STUDENT CONTRIBUTORS

Claire Almon
Jason Walling
Jennifer Chandler
Daniel Tiesling
Chelsey L. Cline
John-Michael Kirkconnell

Please refer to the Student Contributor appendix to read more about these students and to find out where you can see more of their work.

PART TWO

TECHNIQUES

The largest section of this book is dedicated to covering the techniques of putting together 2D and 3D animation media. I've abstracted the combination of media down into common patterns of combination. We'll look at industry examples in each chapter, but mostly we want to push buttons, master software programs, and make some nice images, right? So the bulk of each chapter will consist of a tutorial that walks you through the techniques. Oh boy, put on your magic thinking hat. We're going to have some fearless fun with software.

3

3D CHARACTER LEADS 2D CHARACTER

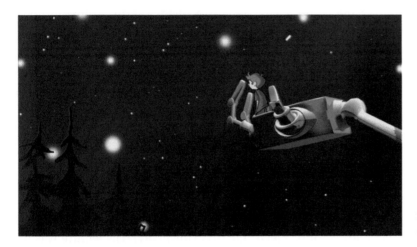

2D/3D compositing example by Candice Ciesla, 2008, SCAD.

LECTURE NOTES

This chapter explores having a 2D character and a 3D character interacting with one another. We examine the most important method of eliciting an emotional response from the audience, which is by including touch in our characters. The characters must touch both each other and themselves. The issues that need to be resolved are registration, timing, and line look. How do we make characters drawn in different media look like they are touching and make the line quality of the characters look like they match?

INDUSTRY EXAMPLES

Let's take a look at some memorable scenes that have shown the interaction between two characters who happened to be of different media.

Warner Brothers' *Iron Giant* is one of my favorites. It is one of the first films in my memory to successfully present two charac-

DOI: 10.1016/B978-0-240-81205-2.00003-0

ters interacting together who happened to be of different media. The giant was a natural for 3D given its rigid nature and complexity. Remember the ideas of line mileage and complexity from Chapter 1? The giant has a high amount of line mileage that would have been difficult to animate in 2D and keep the rigid nature as well.

Another example of many 2D/3D accomplishments is Disney's *Treasure Planet*. We will look at *Treasure Planet* more in this book, because so much was accomplished technically in that film. Figure 3.2 shows the main 2D character being picked up by B.E.N, a 3D character. "Hazaa!"

I've been accused of only looking at "old" films. That really makes me laugh. Okay, "old" is a relative term. Animation is a pretty young medium. The industry films we look at in these chapters had large budgets, lots of artists, and pulled off the combining of the media. We can learn a lot from the techniques that the animators had the time and money to come up with. However, you can look anywhere and come up with examples of 2D and 3D characters interacting, even modern examples that are not "old."

EMOTION

I spend a lot of time driving and keep a portable DVD player in my truck. While driving, I listen to movie commentary and lectures I have recorded at work. (I can stand no time being wasted—even driving.) One day I found myself listening to a lecture by Bob Nicoll (director of Electronic Arts University). His lecture was on "Emotions in Animation." He would play for the audience a clip from *Dumbo*, where Dumbo goes to see his jailed mother. It is a bittersweet meeting between mother and son, underscored by a mournful song. When the clip ended, Nicoll asked the audience what they remembered most from the clip. Most often someone would comment on the touching between the two characters. To see two characters touch strongly stirs emotions in us.

I'll take it even one step further. Just by *listening* to the clip, I was not even watching it (I was driving; I keep the DVD player nearly closed to avoid temptation), yet I could mentally *visualize* the sequence. While *listening* to the clip, I found myself thinking about my kids and wondering if I had been too harsh or too distracted with them the night before. I caught myself and wondered why was I thinking about the kids? I realized, of course, Bob Nicoll was right. The clip of Dumbo and his mom, punctuated by the touch, had connected in my brain to the strongest of emotions, which centers around my kids. Sure enough, I started thinking of them, which in turn stirred more emotions.

Bingo. That is the way we get audiences to feel emotions—we must connect to a memory they have in their heads. (My students

are cringing. They think I'm going to talk about neuroscience. I promise, I'll hold myself back.) You might have heard that a large memory trigger is smell. Well, that one is out for now. With smell-o-vision aside, we'll have to look to another large sense that we use—touch. We touch our faces, wring our hands, hug our bodies; we do all sorts of self-touch to convey to others how we feel [1]. We also, based on culture, touch others to convey friendship, intimidation, love, and a host of other emotions.

This is our first task to undertake when combining 2D and 3D animation. We have to master how to have our characters touch.

Dig Deeper

For those who made it to this footnote, you can indeed dig deeper into why and how emotions connect in our brains. My favorite book on this subject is Joseph LeDoux's *Synaptic Self.*

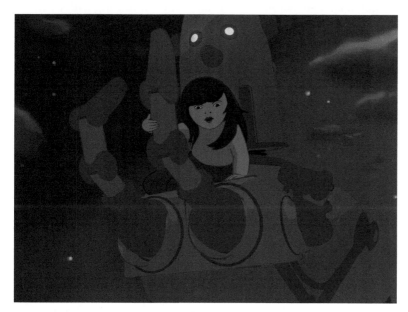

FIGURE 3.1 Touch between characters, by Claire Almon, 2007, SCAD 2D/3D Compositing course.

HANDS-ON EXAMPLES

The following section will finally let us get into putting together a scene. While going through this hands-on portion, we will cover some of the pipeline issues: registration, timing, and line look. We will also look at various ways to combine 2D animation on top of 3D images. From these methods you can find what fits your pipeline best or come up with one of your own. Remember to post

your findings on the forum at www.hybridanimation.com. You can read more information in the last chapter about the forum.

WHO LEADS?

In the first scene we will do, a small character climbs into the hand of a larger character and is lifted. You can use *Iron Giant* as your reference. The first question to ask then is, "Who leads?" In other words, whose movement is moving the other? In this case, the larger character will be lifting the smaller character; therefore, the larger character leads. Which one is which medium? The boy character will be 2D and the robot character will be 3D. So in this case, 3D will lead 2D. Please visit Chapter 3 in the Gallery section at www.hybridanimation.com for images displaying the pipelines that we will need to use.

This pipeline has 2D animation being done digitally. This means using Photoshop, Corel Painter Draw, Toon Boom, and so on: software. You can draw with a Wacom tablet or use a Cintiq tablet. It isn't advisable to think about 2D animating with a mouse. I'm sure it can be done, but I wouldn't want to do it.

What if you do not have a fancy Wacom tablet and needed to draw the 2D on paper? Then you would need to print the 3D animation, peg it up, and use it as reference for your 2D animation. It is a cheap pipeline, but it instantly causes registration issues at the printing stage. The 3D character is printed onto paper. That paper is hand-pegged, meaning someone sits at a light table, lines up crosshairs that were printed on the animation, and tapes a peg strip at the bottom of the page. One by one each page is pegged up. A pencil test is shot to see if the pegging process was acceptable. *Then* the animator can begin to animate using the 3D images as reference. Once completed, the 2D animation needs to be scanned back in to composite with the 3D animation.

Take Note

Beware. The printing and scanning process adds more time to your pipeline and most likely introduces bad registration between your 2D and 3D characters unless absolute care is given to the pegging process.

You might ask, "What if the order were reversed? What if the boy character was 3D and the robot character was 2D?" Then we would need to use a pipeline where 2D leads 3D. I've added the option of the 2D being traditional paper or digital. When traditional paper 2D leads, it isn't as problematic unless the last stage of tweaking 2D to 3D is needed. In that case, there would be a

printing and pegging of the 3D assets and possible registration issues.

In scenes where one character is definitively leading the other one, it is an easy pipeline. However, what if this scene was a dance or a fight between characters? What if they had to tango? That would take more coordination between animators. More than likely one animator would lead and rough in where he or she expected the other character to be. The second animator would then take over and match where the first animator indicated the character to be. If there were any discrepancies, there would have to be a back and forth between the animators.

Anytime the animation goes from one animator back to the other for tweaking, it can be considered a redo. It costs extra time and usually worries the art production manager. It is the first part of the pipeline to be avoided. That does mean that usually each animator has only one shot to get the acting, registration, and timing correct and hope it matches to the character's animation. However, if it is an "A" scene (a scene that is very important, like a moment scene with high emotion and story importance) or a scene where no discernable character leads the other, then the redos/tweaking should be allowed (within reason) to make sure the animation is acceptable.

Take Note

Remember, any tweaking between media means much more time will be needed to finish the scene. Factor that in when you are budgeting time for your personal films.

3D LEADS 2D: ANIMATING A 3D CHARACTER WITH A 3D STAND-IN USING MAYA

This hands-on tutorial will walk you through the technical steps of animating our robot rig, creating a stand-in 3D object for our 2D character, and constraining it to follow the robot's hand. Then, you will bring the levels into Photoshop as reference and animate in Photoshop.

1. *Create a project.* Start Maya and create a new project for this lesson. Select **File > Project > New …**. Save the project in a place where you will have plenty of disk space. Give it a name, click **Use Defaults** folder settings, and then click **Accept**. (Students, do not save directly to your flash drives. Use the local drive and back up to your FTP sites and flash drives at the end of your day.)

FIGURE 3.2 Our goal for this exercise, by Chelsey L. Cline.

> **Trench Note**
> You never want to think about losing data, and it happens to the best of us. A good rule that I use for important projects is to keep things local. Back up to a flash drive daily. Keep the flash drive *away* from your computer. Back up weekly to an FTP site in another state/weather pattern.

For instance, when I lived in Florida my FTP site was out of reach of hurricanes. I'm ultra paranoid. I also keep an external hard drive and back it up bimonthly. During my thesis, I most ungracefully poured a glass of water onto my laptop. Luckily, I was able to revive the old friend once it had dried out and only had to reformat the drive. I lost very little work because I had backups. I hope you have the same self-made luck.

> **Take Note**
> Maya will happily save your file even if your computer or home directory has run out of disk space. It will not even complain. You won't know you have run out of disk space (and have corrupted files) until the next time you open your scene. No amount of backups will save you from that!

2. *Open the file.* Open our robot rig. **File > Open Scene …**, locate the rig **Robby_3DLeads2D_1.ma**, and click **Open**.

3. *Select the character set mode.* In the bottom right-hand corner, select the character set for this rig: **Robby**. This allows you to set keyframes and not worry about having the controls selected. If you are familiar with animating without character sets, feel free to do so. We will use character sets in this book. When the red arrow is on, you are using character sets to animate.

4. *Animating to the camera.* Because we have a camera set for this scene, we will use it to check our silhouettes. In the perspective window, click **Panels > Perspective > Render_Cam**. *Do not move* this camera. It is important to keep the rendering camera still during the animation process. Instead, we will set it aside so that we can animate to the camera. Animating to the camera means animating in the perspective, top, front, and side window with the ability to orbit around and looking at the Render_Cam to make sure the poses read well. Choose **Panels > Tear Off Copy …**. Now you have a free-floating panel of your render camera. Resize it and place it so that it is out of the way but still visible. (For those fortunate animators, place the panel on your second monitor.) In the Render_Cam panel, choose the following items so that you can get a clean silhouette view:

 a. Under **Show**, hide everything but the geometry. Make sure to check off **Manipulators**.

 b. Press the **7** key on the keyboard. That puts you in lighting mode. Because we have no lights, your scene character should be in complete silhouette.

FIGURE 3.3 A torn-off Render_Cam Panel, which we will use to check our silhouettes as we animate in the Perspective view.

5. *Animate.* Now you are ready to animate the hand so that it starts at the bottom of the frame and lifts up to midchest level. Our animation lasts 18 frames. You can open **Robby_ 3DLeads2D_2.mb** for an already animated version of Robby.

6. *Set frame rate.* What frame rate will you animate in? You need to make sure the time is correct and stays constant throughout the production. In other words, right here is where you can mess things up! Take a moment and set the frame rate in the **Animation Preferences** window, under **Settings > Timeline > Playback speed**. Ours is set to **Real-Time [24 fps]**. At each step of the pipeline, we will need to make sure this is our frame per second.

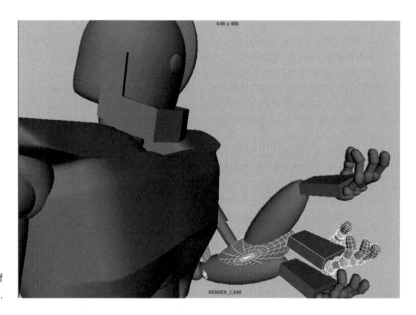

FIGURE 3.4 Keyframes of animated Robby hand.

7. *Import 2D's 3D stand-in.* Now, import in the 2D character's 3D stand-in. Click **File > Import...** and find the file **Roy_3DLeads2D_Standin.ma**. Click **Import**. Roy appears at the origin, beneath the robot. In the Perspective view, orbit around to see him.

8. *Constrain stand-in to follow the hand.* The stand-in character is a small rig itself, able to be animated in a limited fashion as reference for the 2D animator. You'll notice Roy has a few controls to move his arms, legs, head, hips, and chest. There is also a small ring at his bottom titled **PLACE_ME**.

 a. Go to frame **one**. Select Roy's "**Place_Me**" controller. Translate and rotate Roy into place in Rob Robot's open hand.

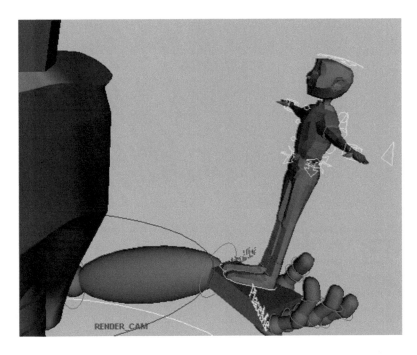

FIGURE 3.5 Roy stand-in put in Rob Robot's hand for frame 1.

b. To make Roy follow Rob Robot's animated hand, select Rob Robot's "**Attach_Here**" control (on the animated hand), hold **shift**, then select Roy's "**Place_Me**" control. Both controllers should be selected. "Attach_Here" will be white, and "Place_Me" should be green. This indicates that "Place_Me" was selected last.

📝 **Take Note**
When you constrain objects, which order you select things is very important. You select them as Driver—Driven. You can select objects to be constrained to other objects. In this case, we had rigs with attaching controls that we used.

c. In the **Animation** menu, select **Constrain > Parent** (option box).
d. The default settings are just fine (you can click **edit > rest settings** to get default settings). It is important that **Maintain Offset** is on.
e. Click **Add**.

FIGURE 3.6 Select "Attach_Here" and "Place_Me" (Driver—Driven), then parent constrain the objects together.

> **Take Note**
>
> If you selected everything correctly and the pivot point of Roy's "Place Me" control is matched to Rob Robot's "Attach Here" control, then Roy should sit in the palm of Rob Robot's hand and animate with him.

9. *See Roy move in Rob Robot's hand.* Scrub through or play the animation to see that Roy's 3D stand-in does indeed sit in Rob Robot's hand throughout the animation.

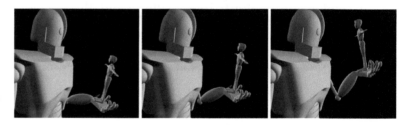

FIGURE 3.7a Roy now moves in Rob Robot's hand.

10. *To aid the 2D animator, add a few keyframes for Roy.* Remember to not overlap the robot overtop of Roy in this animation. That would complicate our composite. We'll get to that technique later.
11. *Save your file.* If you wish to see our completed file from this tutorial, view **Robby_3DLeads2D_3.mb**.

Ones or Twos?

3D animators might not think of this at first. 2D animators will ask this question immediately. 2D is normally drawn on twos. This means that every frame is held for two frames. Why? There is less to draw. Drawing something on ones, or a drawing for every single frame of film, makes for very subtle movement and it is difficult

to keep the 2D animating smoothly. It can be done. Certainly there are those who have used a style of animating on ones—Richard Williams, for example. There are also times when you need to put the animation on ones, such as when the movement is very fast. As a 2D/3D animator, you will want the ability to at least be able to put everything on twos and at most be able to control when things are on twos and when things are on ones.

There are many methods to convert your animation in 3D to be on twos. You can do it manually in the graph editor after all of your animation is done; you will do this by inserting keys on every other frame and using stepped between the keys. Although that is fine, it can make it difficult to go back and adjust your animation.

Gregg Azzopardi, one of the technical editors of this book, suggested this method to me. There is a script that can be found on HighEnd3D called twos.mel. It was written by Jason Schleifer. Schleifer is such a great brain in the rigging for animation field. Enclosed with the companion data for this book, you will find a modified version of the script.

> **Dig Deeper**
>
> As a plug for Jason Schleifer, if you want to learn rigging, I highly recommend his *Fast Animation Rigs* DVD (http://stores.lulu.com/ jschleifer). Check out his web page at http://jasonschleifer.com.

Install the Script

To use this script, you will want to copy the twos.mel script into your scripts folder. Generally this is in your home directory, **maya/ XXXX/scripts**. Substitute the version of Maya you are using for XXXX.

Restart Maya, or if Maya is already open you can type **rehash** in the command line. (Remember to hit Enter on the keyboard.)

Use the Script on Character Sets

If you are using character sets to animate, like we used in the example files, follow these steps:

1. Select the character set in the outliner.
2. In the command line, type **twos** and hit enter on the keyboard.

It will take a moment as the script goes through all of the animated attributes in your character, checks them, and then adds a node that controls the animation curves and sets them to run only on twos.

The script will then prompt you to add the following line on your shelf: **select -r timeOnTwos**. If you middle-click on those words and drag them to a shelf, Maya will create a button. When you click on that button, it selects the node that Schleifer's script has created for you. This node controls the timing.

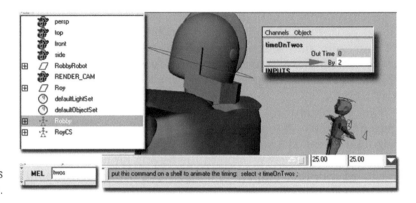

FIGURE 3.7b Jason Schleifer's twos.mel script in action.

By default, the "by" attribute is set to 2. You can simply keyframe that to different step rates to enjoy your animation on twos and on ones (or other increments) as needed.

When you play back your animation in Maya and look at the timeline or graph editor, you will notice that everything still looks the same. This script does not interrupt your animation process or the sweetening process at all. (Those wearing geek hats can check out the Hypergraph Connections editor to see the node and math expression that Schleifer has created to make this as seamless as possible.)

If you wanted to go back and animate Roy to use as reference, maybe just a few key poses of how he would react to being hoisted up into space, you will want to also put his animation on twos. Currently, he is following along with the robot, so you do not need to do anything special to his timing. If you did animate him, you would want to go through the same steps as outlined earlier: selecting his character set and typing **twos** into the channel box. He will be hooked to the *same* **timeOnTwos** node and **By** attribute. This is great. That means that your reference object will stay with the same timing as the robot. That is one of the hardest things to have to worry about—making sure that the 2D animation has the same keyframes and timing as the 3D. Why? If the 2D animates on frames when the 3D is holding still (or vice versa), things start to wiggle and you give away the illusion of registration.

Also, if you are not using character sets, you can select all of the animated controls and use the script. The result will be the same.

3D ANIMATION IS DONE, NOW WHAT?

When do we put toon lines on our animated characters? When do we do the final 3D render? When do we start animating our 2D character?

Good questions. In a production setting, you want to have your animation completed (and approved) first before you begin working on the final look. Iterations to a quick approval, adjustment, or a quick removal are key to not wasting time on production.

Because our 3D animation is complete and is to be handed off to the 2D department, let's also hand it off to the rendering department. If you are a one man or woman show, then I would suggest skipping the Toon Line Shading section until you have finished roughing in your 2D animation.

3D LEADS 2D: TOON FILL SHADING

Here we will apply toon shading to our 3D character, Robby. We are trying to get flat color with a little shading for the paint fill and a thick and thin line to match a 2D character's cleaned-up line.

FIGURE 3.8 2D character.

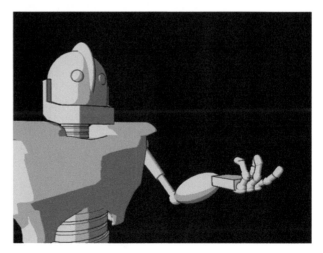

FIGURE 3.9 3D character with toon line.

Open the File

Open the animation file that you saved or our file **Robby_3DLeads2D_3.mb**.

Fill Shader

First, to work with our geometry and put shading on it, we will have to be able to select it. Most modern rigs have the geometry locked down so that the animators cannot touch it and harm it in any way. (If they didn't and are in my class, that is 10 points off.)

1. In the Layer panel, locate the GEO layer and make it editable by clicking on the R (R stands for *reference*; the object cannot be selected). Once you click the R, it will become a T (T stands for *template*; the object cannot be selected and it is displayed as a pink wire frame). Click again on the T and the box will become empty. Now the contents of that layer are editable.

FIGURE 3.10 Make the GEO selectable.

2. In the perspective window, select the robot's geometry and press the up arrow on your keyboard to select all of the geometry. (You can also locate the **GEO** group node in the outliner for the robot.)
3. In the Rendering area, select **Toon > Assign Fill Shader > Shaded Brightness Three Tone**.
4. Click on the Render icon to see what the fill shader looks like.

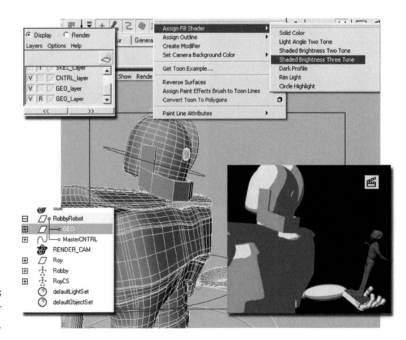

FIGURE 3.11 Render icon is clicked to see Toon Fill Shader on Robby.

> **Take Note**
> If you apply toon fill to an object and it turns out very chunky, there is an easy way to fix it. Toon Fill shaders will show faceting of low poly objects unless they have soft normals.

5. With the mesh selected, go to the Polygons area and select **Normals > Soften Edge**.
6. Re-render the frame to see the better results.

Tweak Fill Shader

The nice thing about fill shaders is that you can adjust them using IPR:

> **Random Note**
> I usually mutter odd things when teaching, ramble actually about the old days before the Internet. Do you know when I first saw IPR? It was the coolest thing back in 1992. It saves you time. Make sure you utilize it. It traveled a long way to get here.

1. Click on the **IPR** button, either in the render window that you have open or at the top status line.
2. When the render has completed, follow the directions found in yellow at the bottom: "**Select a region to begin tuning**."

FIGURE 3.12 Use the IPR render view to quickly tweak your fill shader.

3. Select the geometry in the Attribute Editor (**CNTRL + A**), and scroll through the tabs until you find the **threeToneBrightnessShader** tab.

FIGURE 3.13 The threeToneBrightnessShader tab.

4. The three-tone brightness shader is a ramp shader. You can click and drag on the small circles to adjust the threshold that the colors show up in. The rightmost color is the color that shows up where the light is the strongest. The leftmost color shows up where the light is the weakest.

FIGURE 3.14 Ramp shader with three colors.

5. Create a **dark gray** for the left color and a **light gray** for the right color. Let's find a midrange color. **Delete** the **middle color** by clicking on the X.

FIGURE 3.15 Delete the middle color.

6. Click on the **Selected Color** chip and a **Color Chooser** window will open. In that window, open the **Blend** tab.
7. In the blend tab, if you click on any of the four rectangles it will load the current color. Load in the light and dark colors from the ramp. (Remember, selecting the circle on the ramp selects the color.)

FIGURE 3.16 Add colors into the Blend tab.

8. Click on the ramp between the two colors and that will add a third color circle.

9. In the **Color Chooser** window, select the **eyedropper** tool and choose a color from the blend area. For me, this saves a lot of time by allowing me to use the blend feature to get something closer that I can work with.

FIGURE 3.17 Third color chosen with the eyedropper tool.

10. Click **Accept** to close the **Color Chooser** window.

This looks like a good place to save. Our completed file is saved at **Robby_3DLeads2D_4.mb**.

TOON LINE

The next step is to put on a toon line that matches the 2D character's cleaned-up line.

Open the File

Open the animation file that you saved or our file **Robby_3DLeads2D_4.mb**.

Toon Line Shader

The geometry should still be selectable from earlier in the lesson when we applied the toon fill:

1. Select the robot's GEO node in the outliner, or click on the geometry and click the up arrow key on the keyboard. (The robot should be highlighted green.)
2. In the Rendering area, select **Toon > Assign Outline> Add New Toon Outline Line Width = 0.058** or something smaller. (Don't go too small; we're about to adjust this line some more.)
3. Scroll down and open the section for **Curvature Based Width Scaling**; this will allow us to adjust the thickness of curved lines versus straight lines.
4. Turn on the check box for **Curvature Modulation**. (Where's the little green Marvin Martian? Give me the Q-36 Explosive Space Modulator.) You might have to adjust your global line width to make your lines visible again.

5. I find it hard to see the toon lines in the perspective window when they are highlighted in green. So in the camera view you can select **Show > Selection Highlighting** to hide the highlighting.

Let's look at that curvature width ramp. What happens when you move the curve? It might take a little bit to figure it out. It looks like the documentation has the explanation backward (I might be reading it wrong). Here is how I see it working:

FIGURE 3.18 Curvature width.

1. **[Left]** Moving the curve to the left side of the ramp affects the toon lines that are curved.
2. **[Right]** Moving the curve to the right side of the ramp affects the toon lines that are straight.
3. **[Top]** Moving the curve to the top of the ramp makes the toon lines thicker.
4. **[Bottom]** Moving the curve to the bottom of the ramp makes the toon lines thinner.

FIGURE 3.19 Curvature width ramp.

It takes some tweaking. If you get your curve to look like the one shown in Figure 3.20, you can get a little thick and thin depending on how curved the object is, and the straight lines are not as thick as the thin ones:

1. In the profile tab, bring the **Profile Width Modulation** to .3 to overall adjust the taper.
2. Adjust the **Profile Width** as necessary to get a line thickness that you like.
3. Test **Render**.

Creases

The crease in the front of the robot's chest may not have a toon line. Or perhaps there are other areas where you want to add a toon line. Let's see how to fix that problem:

FIGURE 3.20 Snapshot of the robot's neck and the curvature width ramp.

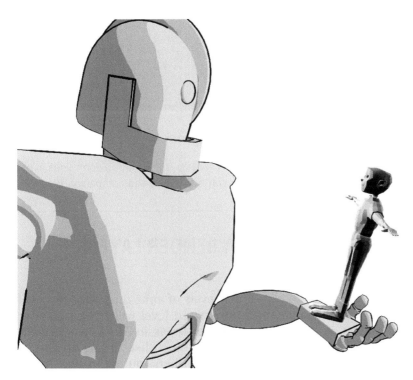

FIGURE 3.21 Robby with the Toon Line and Fill Shader.

1. Your first instinct might be to go to the crease menu, **turn off Hard creases**, and adjust the **Crease Angle Min** to see if you can dial in that specific crease in the robot. However, you end up getting a lot more creases that way, more than you want. (Keep bringing that slider down and you can do a nice wire frame render.)
2. Instead, keep the option for **Hard Creases on**. Go to edge selection mode and **select** a **line of edges** across the crease in the bottom of the rib cage (Figure 3.22).
3. In the Polygon area, select **Normals > Set Normal Angle**.
4. In the popup window, bring the value to **0** and click **OK**.
5. Adjust the **Crease Width** as necessary.

Figure 3.22 shows the visible crease at the bottom of the chest. Using hard edges only allows you a little more control of exactly what creases are shown.

FIGURE 3.22 The Hard Crease Lines option is turned on and edges in the chest are given hard normals, resulting in a crease line.

> ![Random Note icon] **Random Note**
> Gosh, there is so much more to show you in toon lines. I'm biting my lip wanting to show you more. See the companion website for an overview of toon lines.

3D LEADS 2D: MAYA RENDER LAYERS AND PHOTOSHOP

We are ready to export our levels of animation. One level will be the Robot Robby and the second level will be our stand-in character. To render out separate levels in Maya, you can use Render Layers. Setting them up is much like setting up Display Layers. In fact, be careful to note when you are in the Display

Layer mode versus the Render Layer mode. The following is how to use Render Layers in Maya 2008 or older versions. We'll look at Maya 2009 as well.

1. Render layers:
 a. At the bottom of the Channels box in the layers area, click **Render Layer**.
 b. In the outliner, select RobbyRobot, then click Layers > Create Layer from Selected.
 c. Double-click on the new layer (layer1) and name it Robby_ Anim. Click on Save. Note: Only the Robby is visible.

FIGURE 3.23 The Robby_Anim render layer only has the robot in it. Everything else hides (will not render).

 d. Click back on the Master layer, and you will see everything again.
 e. The toon lines more than likely were not added to your Robby Layer. **Select** Rob Robot's toon lines, then **right-click** on the **Robby_Anim** and choose **Add Selected Objects**. Repeat b through c for Roy, the stand-in.
 f. You should have the following render layers:
 i. Master layer—shows everything when clicked.
 ii. Robby_Anim—shows only the robot when clicked.
 iii. Roy_Ref—shows only the stand-in character when clicked.
2. Rendering the images. The next thing to do is to render out these images. You can set the background color to be something other than black. The renders shown in Figure 3.26 have

FIGURE 3.24 Roy_Ref layer with stand-in character.

a white background color. Background colors can be set in the camera attributes. This does not affect the alpha channel.

a. In the Render Layer window, choose **Options > option box for Render All Layers**.

FIGURE 3.25 Render all layers.

b. In the options box choose **Keep Layers**. Click **Apply and Close**.

c. Double-check that the Render All Layers is actually checked **on**.

d. Open your Render Settings window.

 i. We will use the following settings:

 (1) Set the **name**.

 (2) Naming convention is **name.#.ext**.

 (3) Number padding.

 (4) We'll use **.tifs**.

 (5) Choose the appropriate frame length; ours is **1-18**.

 (6) Choose the **RENDER_CAM** as the Renderable Camera.

 (7) Watch out! Make sure **Alpha** channels is turned on!

 (8) Resolution should be your final resolution.

 e. Now you can click **Render > Batch Render**. The renders for each layer will be placed in named folders. Look at the Script Editor to see the progress.

FIGURE 3.26 Completed render of layers.

Why did we go through the trouble of setting up render layers? Now we have a sequence of images for both characters. Each has its own alpha channel so that it can be composited overtop of a background or other levels as needed. Now we can take our robot's 3D render and use Roy's 3D reference render to draw the 2D animation and make sure that the registration is correct.

3D LEADS 2D: ANIMATING 2D ON TOP OF 3D

What software do you use to draw your 2D animation on top of the 3D animation? In class we have been using many different software packages and find that each one lends itself toward different final looks. You'll want to experiment with any software programs you think might work to see how well you can animate in them. We will cover the technical aspects of a few of them here in this chapter.

Maya and Photoshop

A new feature that was put into Photoshop CS3 is the ability to edit and work on sequences of images.

Random Note

 Why, I remember working on Photoshop version 1 and *trying* to make it animate. Here you have the ability built in. Ah, the good old days. Mac Ci, 100-MB hard drive. The patience we had to have to do anything. You young folk nowadays.

Open Our Renders

To open the rendered file sequence into Photoshop, click **File > Open**, select the first image of the Robot level. Ours is in the folder **Robby_Anim** and is named **rb.00001.tif**, click on the **Image Sequence** option.

Oh, look—an option to set the proper frame rate (remember what we said in Chapter 1—there are many, many places to mess up frame rate); select **24 fps**.

FIGURE 3.27 Remember to set the correct frame rate!

Notice the video layer in the layer palette. This is no longer a normal image layer.

FIGURE 3.28 Video layer.

If you repeated the steps presented earlier for the Roy images, you would have a separate Photoshop file. To import more video layers, we will have to do the following: select **Layer > Video Layers > New Video Layer from File**, select the first image of Roy, and make sure to choose Image Sequence.

You can't see both layers now can you? There is a difficulty here. Photoshop doesn't know what alpha channel to use, so it does not use any. We can get around this. Double-click on Roy's layer. In the option box window, change the blend mode to be **multiply**, and click **OK**. Now you can see both layers.

Later on in another chapter, we will learn how to work around Photoshop's video layers not seeing individual image alphas. For now, we are only using the layers as reference, so their alpha channel is not absolutely needed right now.

FIGURE 3.29 New Video Layer from File.

FIGURE 3.30 Multiply blend node allows you to see both layers.

To Animate

To draw frame by frame in Photoshop, you will need a blank video layer on which to draw:

1. Click **Layer > Video Layers > New Blank Video Layer**. Note the new blank video layer in the layer palette.
2. To be able to see the frames, you need to click **Window > Animation**. This will open the timeline animation window.
3. To see different frames, scrub through the timeline frames by clicking and dragging on the blue arrow.
4. You can do straight ahead animation easily, or to do pose-to-pose animation, you will want to turn onion skinning on so

FIGURE 3.31 Blank video layer to draw on.

FIGURE 3.32 Animation window.

that you can see keyframes before and after the breakdown. Turn on onion skinning by clicking on the **onion icon** at the bottom of the animation window. To change the settings of how many drawings you see before and after, click on the arrow at the top right of the animation window and choose **Onion Skin settings**.

5. Set brush size and style.

Dig Deeper

If you want to know a lot more about how to control the line look in Photoshop, check out *Creative Photoshop: Digital Illustration and Art Techniques Covering Photoshop CS3* by Derek Lea.

FIGURE 3.33 Onion skinning.

6. Animate by drawing on each frame. If you have keyframes with the 3D reference character posed, it helps the 2D animator tie down the contact points more clearly.

A note on animating in Photoshop: this chapter is using **timeline keyframes**. The other method of using Photoshop to animate is **frame animation**. In our classroom experience we have found that half of the room prefers using the timeline and the other half prefers frame animation. Frame animation is the original implementation of animation; timeline was developed later. If you wish to use the older version of animation, take a look at the Photoshop documentation. You can guess what side of the room I am on.

If you are using CS4 or later, you can use hotkeys to advance to the next frame or go back to the previous frame (super handy when animating). The hotkeys are the arrow keys, and you will need to turn on timeline hotkeys by clicking on the option arrow in the upper right corner of the animation window and turning on **Enable Timeline Short-Cut Keys**.

Rendering

When you are done animating, you will want to save out your file as individual images. These images can then be composited together with the other levels in the compositing package of your choice.

1. First, **HIDE** the reference layers. (Otherwise they will render with your drawn images. **OOPS!**)

2. Save the PSD file to retain the video layers for future changes.
3. Select **File > Export > Render Video**.

Use the following settings:

1. Set name and folder.
2. You can render out to quick time or individual frames. The only way to get alpha channels is to use QuickTime Movie.
3. To keep from losing render quality, click QuickTime **Settings….** Make sure the compression setting is set to **Animation** and **Millions of Colors**. This will not compress your images. (I would prefer to use .tifs, but at the moment Adobe packages do not seem to support .tif rgba.)
4. Set the **Alpha Channel** to be **Premultiplied with White**.
5. Warning! Watch out for the frame rate option at the bottom of the menu!
6. Click **Render**.

This will save a movie file of your animation with alpha channels. Note that you do not have an image for each frame. Instead, you have a movie file and that file can get quite large. It is the same difference—100 individual frames or one big file.

FIGURE 3.34 Rendering options.

Maya and Corel Painter

If you want to use Corel Painter to animate in, it takes a few more button clicks, but you get the added bonus of animating in Painter. The paintbrushes and paper textures can add a great look to your animated film.

There are some issues with Corel Painter. Unlike Photoshop, you cannot bring in separate image layers as video reference. (If

you find a way to do so, post it on the forum!) Second, I find that reading in .tifs causes Painter to crash. So instead, you will want a render from Maya that is a jpg and is not using render layers.

Re-Render

You can use Photoshop to composite the Robby and Roy reference images together or re-render in Maya. It is up to you. In this chapter, we'll use Maya very quickly to re-render.

1. Open the Maya file of your completed animation or our file **Robby_3DLeads2D_5.mb**.
2. Freak out because you only see Roy and not the Robot. (I did. I thought I had lost something. One shouldn't work so late at night. It makes you jumpy.)
3. Go to the Render Layer area and click **masterLayer** so that everything shows.
4. Turn off **Options > Render All Layers**.
5. In the render layers, make sure that an **R** is only on the **master-Layer** or you will wonder why you don't have the master layer rendered.
6. Change the render settings so that you output a jpg image.
7. Batch Render.

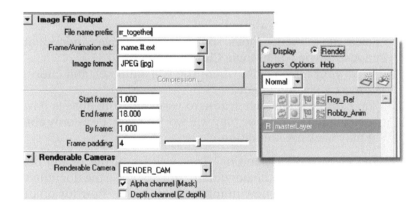

FIGURE 3.35 Render Settings to output for Corel Painter.

Animating in Corel Painter

Now it is time to set up a clone source from the reference image and a new movie file to animate in:

1. Open the reference image by clicking **File > Open**.
2. Because this is a sequence of images, turn on **Open Numbered Files** and follow the directions:
 a. Select the first numbered file, click **open**.
 b. Select the last numbered file, click **open**.

 c. Give a name to the movie file that Painter will save: **Robby_Roy_Together.FMP**.

 d. Select the proper level of onion skinning and bit depth (we'll use the defaults), and click **OK**.

3. Now, create a new file. My file size is very small: **320 × 240**. Yours will be the final size that you are working at. Watch out. You could run out of memory here. Set the number of images to be **18**.

FIGURE 3.36 Settings to create new movie document in Corel Painter.

4. Make sure that you are on frame 1 for both the reference movie and your new movie.

5. Select the reference movie so that it is the active window, and choose **Movie > Set Movie Clone Source**.

6. Select your new movie (where you will animate), and choose **Canvas > Tracing Paper**.

7. You can press **advance frame** to verify that the images have been loaded in. (Maybe play will work for you. I was only able to play back my animation.)

What about onion skinning? That was set in the dialog box when you first started the document. You can close the document and reopen it to set a new number of images to show for onion skinning.

Rendering in Corel Painter

When you have completed your animation, it is time to render out the images:

1. Select File > Save As….

2. Choose Save Movie as Movie File.

3. Use the same settings that we used in Photoshop: Animation Compression and Millions of Colors.

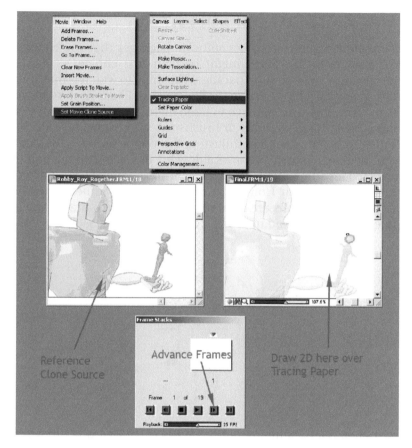

FIGURE 3.37 Animating using Movie Clone Source as tracing paper.

FIGURE 3.38 Rendering animation from Corel Painter.

Beware: Step 3 crashes my version of Corel Painter. When you are saving your images as a QuickTime file and you experience crashes, it might be the version of QuickTime you are using that is causing issues and not necessarily the piece of software. Try a different QuickTime version, possibly even an older one. If you are on a school's computer, where you are unable to install files, you may have to find an alternative method for saving your images.

MAYA AND OTHER SOFTWARE

Of course, there are other software packages that you can use to animate in 2D. **Flash** might be your first choice, as it was designed as an animation package. The thing to watch is that your line *looks* like a hand-drawn 2D line and not like a Flash redrawn line. To do this you will have to hand massage every line that you draw by turning the lines to brushstrokes (or drawing with the brush to begin with) and adjusting the vector points to smooth out the line. Figure 3.39 shows a drawing in Flash with the points selected for adjustment. To see an online example of Flash animation, take a look at Home Star Runner at www.homestarrunner .com. All animations are created in Flash, and each drawn line is massaged (or cleaned up) to be exactly what the artists intended.

FIGURE 3.39 Drawing in Flash.

A great package that might be on the expensive side but is the industry standard in 2D digital animation is **Toon Boom**. We'll take a look at drawing in Toon Boom later on in this book.

FIGURE 3.40 Drawing in Toon Boom.

Test each software package and decide which one best gives you the style you are looking for. Remember what we covered in Chapter 1? Give yourself time to test other software programs to come up with other looks. Otherwise you risk only knowing one pipeline/technique and coming up with a limited number of visual looks.

PUTTING IT TOGETHER

You should have two levels ready to be composited together. If you already know how to do that, you can skip ahead to the project section of this chapter. For the rest of you, we're going to look at timeline-based compositing very quickly, just enough to get you started.

There are two types of compositing software: timeline based and node based. After Effects, Premiere, Combustion, and other products of that price point are generally timeline based. They are good for quick workings and let those with smaller budgets achieve some great results. I'm not an expert in compositing systems and why they all are different from each other; I know which ones I like to use, however. Node-based compositing systems such as Shake, Flame, and Nuke have a different way of approaching compositing. For some, they are more robust at putting together complicated shots. They are considered the high-end compositing packages, can handle larger images, and handle bit depth—oh my, I'm starting to sound like a software demo jock; no, not that. Use what you have or what gets the job done. For animation, you do not need a super-duper compositing system; this isn't a visual effects movie we're putting together. However, there are a few things you will want out of your compositing system for putting together animations:

1. The ability to composite one image with alpha channels over another image: A over B. (If your compositing software doesn't have this, I hope it was free.)
2. The ability to create traveling masks to help register two images together.
3. The ability to use masks to color correct.
4. The ability to reuse artwork easily.
5. The ability to quickly render out the final product at different resolutions, for quick testing of the final results.

For this chapter, we will use After Effects. You will want to bring in your two levels, Robby and Roy, and composite them together to create the final output movie.

> **Take Note**
> Watch out for frame rate (again). We're working at 24 frames per second. After Effects (and most compositing software programs) default to 30 frames per second.

Set the Frame Rate

Go to the menu **Edit > Preferences > Import...**, and set the following:

1. Select **Sequence Footage > 24 Frames per Second**.
2. Interpret Unlabeled Alpha As **Premultipled (Matted with White)**.

FIGURE 3.41 Settings to ensure a proper import of animation into After Effects.

Import Images

1. Select **File > Import File**, and choose the robot's images. Make sure to select **.tif Sequence** and **Force Alphabetical Order**.

> **Take Note**
>
> What can go wrong here? If you do not have zero padding in your numbers—image-.tif, image-2.tif, image-10.tif—your images will come in out of sequence. Eeek! Don't do that, Batman! Instead, use zero padding in your image names: image-00001.tif, image-00002.tif, and so on.

2. Repeat step 1 for your 2D Roy images. If the files are a Quick-Time movie, which they probably are, you only have to select the file. After Effects will bring it in as you expect it to.
3. Drag the two image sequences into the composition area of After Effects. Drag and drop them with the Robot images on the bottom level.

FIGURE 3.42 Drag levels of animation into the composition area of After Effects. (Apparently my Roy is only red feet and no body.)

Because of the way this project is set up, you should not have any overlap between the two characters. This means the fingers should not come in front of Roy. Well, they could. You might have animated Roy hanging on for dear life. I would. If that is the case, you need to do some matting out of Roy. There are a couple of ways to do that. We will cover the matting process in the next chapter.

Render Your Final Movie!

You probably guessed where to go to export out your final 2D/3D movie. Go to **File > Export** and choose the final file format. We'll use QuickTime Movie. There actually is a reason for it: I can drag and scrub through the animation to better pinpoint frames to see what needs to be fixed.

Students in my class are required to use a good compression for playback and quality when submitting homework. **Sorenson 3** will give us that.

FIGURE 3.43 Compression settings for final composite.

 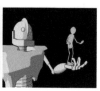

FIGURE 3.44 Keyframes from final composite.

PROJECT: 3D LEADS 2D

Due: _____

For the project portion of this chapter, you will use *The Iron Giant* as your inspiration. Create a short animation, no more than 48 frames, of the 2D character climbing into the robot's hand and being lifted. You can assign the emotion. Is he happy? Angry? Curious?

Use the rigs from this chapter: Roy and Robby.

Turn in a completed mov file of your animation. Make sure to use proper compression to keep file size at a minimum.

Things to watch for: Keep Roy leveled on top of the robot without the robot overlapping Roy. This will help you have a simple composite of A over B. We'll get into more complicated rigging further on in other projects.

You are assessed on the following skills:

1. *Technical problem solving.* Were you able to get an animation pipeline working to produce a finished product?
2. *Aesthetic ability.* Were you able to create an appealing 2D/3D character combination?
3. *Line look.* Were you able to make the 3D toon line and 2D line match?
4. *Registration.* Were you able to eliminate wiggling at contact points of characters?
5. *Animation principles.* Is it worth watching? Do a test first, a very rough test, to get the technical aspects down, and then do it again. Remember, you are an animator. Have fun with it.

Images of student examples can be found on the companion website at www.hybridanimation.com.

FURTHER READINGS

Lea, Derek. *Creative Photoshop: Digital Illustration and Art Techniques Covering Photoshop CS3*, Amsterdam; Boston: Focal Press, 2007.
LeDoux, Joseph. *Synaptic Self: How Our Brains Become Who We Are*, New York: Viking, 2002.
Rieman, Tonya. *The Power of Body Language: How to Succeed in Every Business and Social Encounter*, New York: Pocket Books, 2008.

STUDENT CONTRIBUTORS

Candice Ciesla
Claire Almon
Daniel Tiesling
Chelsey L. Cline
Jessica Huang
John-Michael Kirkconnell

TODD REDNER

Supervising Animation Director
Radical Axis, Inc.

Lets face it, we have limits in the real world and they are called "budgets." The only way we were able to make a 3D pilot and keep it under the budget was to use 2D animation on 3D models. The characters were sculpted as generic people. We simply unwrapped the models and drew all the facial features, colors, clothing, etc. in Flash. The 3D animators only had to worry about body movements, while the 2D animators did all of the eye movements and lip-synch in Flash. It worked really well and had a very unique look. It saved us time and money in multiple areas: we didn't have to purchase multiple workstations, render times did not kill us, and by separating the facial movements from the body animation, we were able to animate faster.

The biggest help in using 3D and 2D together for us has been with backgrounds and objects. You can spend some crazy hours on building realistic backgrounds for your 3D show. One of our projects was taking way too long to draw and paint the backgrounds. So our solution was to take rough sketches and build a simple 3D background. That way we could have the model done for all angles in one shot, get the shading done faster, and the perspective was already done before the next shot was laid out! After we pick the shot, we just render and add any texture or effects. Another show we did called for the reverse. The characters were entirely created in 3D, but we

painted the backgrounds in 2D. There were just so many shots that required crazy amounts of objects and sets that would just not work for our budget to do in 3D. So we creatively blended 2D and 3D into the backgrounds. No matter what the medium is, 2D, 3D, or 4D (fingers crossed!), whatever it takes to get the right look and also keep your project under budget is what we have to do. Otherwise, we are either losing money, losing work, or both.

4

2D CHARACTERS WITH 3D PARTS (2D LEADS)

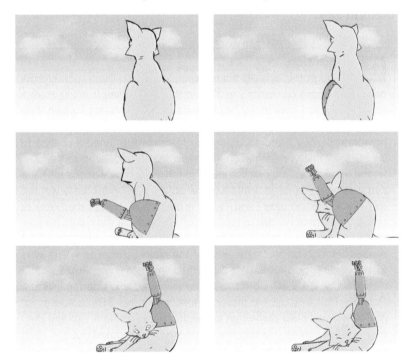

John-Michael Kirkconnell, 2009, SCAD, 2D/3D course.

LECTURE NOTES

This chapter explores a true hybrid character that is 2D and 3D. In Chapter 3, we looked at two characters of different media interacting. The contact point could have been skillfully hidden to avoid the issue of touch. We chose to show the touch/contact point because we were discussing how important touch between characters can be. However, in this chapter, we will look at one character in which we want the media to be seamless. We do not want the differences in the character's media to divert the viewer's attention from the character's acting.

As with everything we have encountered, there are questions that must be answered. How do we make the two media look like

DOI: 10.1016/B978-0-240-81205-2.00004-2

each other? What should we look out for? What pipeline is best to ensure registration? What method will allow for the best animation? What method will get in the way of the animator the least?

HOW DO WE MAKE THE TWO MEDIA LOOK LIKE EACH OTHER?

A good answer might be that we draw everything in 2D: animate the leading portion in 2D and then animate the 3D section. Then we would take the 3D render and draw over top of it in 3D. This doesn't help our line mileage any but can certainly make for a uniform look.

Trench Note

Although this is a 3D leads example, it is an illustration of how one can animate completely in 3D and then draw over it in 2D. Here's an old example I have in my head. Beware. If you thought I was pulling from old films before, I'm now pulling from the first thing I saw in person at Disney. Before I graduated from college, I had a chance to visit Disney Feature Animation in Florida. I was introduced to the one, let me repeat that, *the one* computer graphic animator. I shook his hand and was so starry-eyed. I told him the obligatory "how I really wanted to work in the industry" and "what a great thing it was that he was taking time out of his day to talk to me." He was just the nicest person, really. He worked in the "fishbowl" where the tour groups from MGM passed through on the other side of the glass ogling the artists who were working on the current production. At that point, Rob Bekuhrs was working on a 3D log crane for an animated short cartoon, *Roger Rabbit's Trail Mix Up*. He played the scene on his SGI computer for me. It showed a 3D crane that came down, picked up a log, and then moved it off screen. He told me that it would be printed out and used as reference. The cleanup artists would draw overtop of it. That was my first experience with seeing production work and seeing 2D/3D in action. Here is another side note for my students. You'll hear it said over and over again that the animation world is incredibly small. That nice guy who took time out of his crazy production schedule to entertain a starry-eyed college girl is one of the technical editors of this book. I've been his biggest fan ever since that day. Thanks, Rob.

Figure 4.1 shows an example of an animation that was done in Maya then redrawn frame by frame in Photoshop. In this case, the animation was of a camera moving around the three characters. Doing the animation in 3D helped the animator to work out the perspective changes and drawing overtop in 2D gave it a nice organic feel.

FIGURE 4.1 3D animation redrawn in 2D to create an organic feel. Image from *Three Magicians* by Claire Almon.

There are many examples of this type of line look. *The Pearce Sisters* by Luis Cook is an example of a hybrid animation created in 3D but drawn over in 2D (www.pearcesisters.co.uk/production .html). The resulting look is very stylized and was definitely influential to the *Three Magicians* shown in Figure 4.1.

Now that toon line rendering has come so far (though it cannot completely emulate the beauty of a nice cleanup line), we can put 3D and 2D together to create hybrid characters. Later on in this chapter, we will look at some industry examples of 2D/3D characters. Figure 4.2 shows a 2D/3D character from my group project class from the winter quarter of 2009. The cast itself was modeled and toon line rendered in Maya. The organic parts of the character are drawn in 2D using Photoshop.

To form a cohesive hybrid character, you will need to keep in mind the camera, lighting, shading, and movement.

Camera

The artist will want to flatten out the 3D as much as possible by using a telephoto lens (if feasible) to minimize the perspective shift of objects. This step is often overlooked as many new animators are not comfortable enough working with the camera in the 3D software. They tend to leave it at the default lens and focal distance.

Dig Deeper

If you want to learn more about cameras, read *The Bare Bones Camera Course for Film and Video* by Tom Schroeppel. Craig Slagel introduced me to this book when we worked at Electronic Arts together.

FIGURE 4.2 3D body cast with 2D character from *Jaguar McGuire* by Clint Donaldson, SCAD group project, 2009.

Lighting and Shading

When putting the 2D and 3D portions of the character together, we will want to minimize how rounded the 3D character looks by using flat toon shading, or, if we choose a rounded look, the 2D character portion will have to have tones on it to make it seem rounded as well.

Movement

We've gotten away with timing things out in 3D and basically rotoscoping the 2D on top of reference contact points. With a character led by 2D, the 3D animator will need to have access to the timing chart and x-sheet for the animation in order to see where the 3D keys should be placed and what type of spacing should be used. It is possible to proceed without x-sheets and timing charts, but doing so can cause a disjointed feel in the animation. Also keep in mind that the 2D will more than likely be on twos.

WHAT SHOULD WE LOOK OUT FOR?

When animating a 2D character that will have a 3D limb or some type of 3D appendage, make sure to draw in the placement

for the limb. It will be erased at compositing time. A beginner's mistake is to forget to sketch in where the missing limb is and thus forget to put weight on it and the like. The more information you put into your 2D animation, the more you have to follow when placing the 3D portion.

WHAT PIPELINE IS BEST TO ENSURE REGISTRATION?

When 2D leads, it doesn't affect registration if you use 2D paper or digital 2D. There will be some time spent on scanning in the 2D paper animation, but this should not add any registration issues. Remember, we have registration issues the second we print, not when we scan. In short, 2D leading is easier on the pipeline than anything else. If there have to be any 2D animation fixes after 3D appendage animation is done, I would suggest doing it digitally. If you don't, then you will have to go through a printing and pegging process for your 3D appendage and then you will have to rescan. Art production managers will be looking at their schedules and grimacing.

WHAT METHOD WILL GET IN THE WAY OF THE ANIMATOR THE LEAST?

When it comes to digital 2D animation, I have kept my eye out for different techniques. Recently, on a group project, we had a handful of animators working in Photoshop, Flash, and Toon Boom. We compared notes and debated on which method we liked best. I found that animators were very opinionated about the software process that they use when animating. One student and I have opposing ways of animating in Photoshop. We each tried to convince the other of the "better" way. Neither one of us has budged to the other's method. We'll cover different software and animation techniques. You can choose which one fits your pre-ferred method of animation and then debate everyone else. In fact, remember to go to the website (www.hybridanimation.com) to post your findings. I have a feeling we're just beginning these conversations.

WHAT METHOD WILL ALLOW FOR THE BEST ANIMATION?

Button pushing aside, there are other factors that are impor-tant to consider when choosing your pipeline for digital 2D animation:

1. *Timing.* You want the easiest method that allows you to work out your animation's timing.
2. *Playback.* You need to be able to play back your animation easily, often, and at the proper frame rate.
3. *Use of reference.* Though when 2D leads it isn't as important as when 3D leads, you want to be able to easily use reference images to see contact points. These can be from your 3D assets, sketches, and so on.
4. *Onion skinning.* It is important that the methods you use allow for pose-to-pose animation so that you can see your previous and next key while working on the pose inbetween. The method must not be cumbersome (uh oh, I'm slipping into white paper, software architecture language—"must not" "shall have").
5. *Line quality.* Can you draw in it? Does it slow your drawing process down? The hope is that it does not. This is the one main deciding factor in many of our group project/student project discussions. If the package you animate in doesn't give you the final line quality you want, that is okay. You may have to add another software package to do the cleaned-up line overtop the animation.

In fact, given the specifications listed earlier of what an animator wants out of the production pipeline, it is not uncommon to have multiple software packages. For example, you might use Flash for the timing portion because of the ease of the timeline, Photoshop for the second pass at the animation and inbetweens, Toon Boom for the final cleaned-up line, and After Effects for the final composite. Now, the software I just mentioned is just an example; it is more from a student's vantage point of the software he or she might have available. Toon Boom, however, would not normally be on a student's computer. Students might have to stay in Photoshop for the cleaned-up line if they do not have access to non-Adobe products. Other software programs that could be used include US Animation's Opus, Plastic Animation Paper, and CTP Pro, to name a few.

IS IT HARD TO ANIMATE A HYBRID CHARACTER?

Creating a hybrid character does add some technical challenge. You will want to have a good reason to do it. What reasons? Those that we spoke about in Chapter 1: visual target, line mileage, and complexity. If it supports the story by supporting your visual target and minimizes either your line mileage (how much the animator has to draw) or the complexity (perspective, lots of parts, etc.), then you have a candidate for a 2D/3D character.

The second you decide to do one character as multiple media you might find that your crew of animators cannot handle or prefer not to do both 2D and 3D. Some do, and those that do will be able to handle their shots alone. Some prefer only one medium, therefore you will have to assign two animators for one character. Did you hear an accountant just open a bottle? That does make for an expensive character. While one animator is working on the 2D portion, the other animator might have no work at his or her desk. Not an optimum situation for tight budgets.

Industry Examples

Using 2D for the character (be it traditional paper or digital) allows an artist to draw keyframes using those traditional skills that give so much personality to the character. On top of that personality, the artist is able to use 3D tools to push the character further by allowing more complex parts to be animated.

The most amazing mainstream industry examples can be found in Glen Kean's animation of John Silver in the animated film *Treasure Planet* and is shown more subtly in *The Triplets of Belleville*, where the 2D/3D integration is invisible.

I encourage you to take a look at the bonus features on the Treasure Planet DVD. There is so much information on there that you will have to watch it many times. In fact, it is one of the best examples of a visual commentary of a DVD. You can set it up so that you watch the film and, like a built-in lecture, the film will pause at the appropriate places, play a bonus video clip on how things were made, and so on, and then resume playback of the movie. It is a classroom on a DVD.

FIGURE 4.3 Pipeline test of 3D arm with Captain Hook animation. © Disney Enterprises, Inc.

If you look at the bonus features on the DVD, you will find a pencil test of Captain Hook that has his arm replaced with a 3D arm. According to Glenn Keane in his interview, they chose that

scene because it had such strong acting and vibrancy. If you watch, it should become evident that the 2D character leads. The idea of 2D leading is the same with the John Silver character. This makes sense because he is the character moving around and the arm, eyepiece, and peg leg (which are 3D) follow the 2D's movement. The character design allows for an easy fit of the pieces together. I don't mean to say it is easy, just that the character design does not get in the way. The arm seam, where it fits the body, is a logical seam in the drawing. If and when the 2D sleeve comes over the 3D arm, special care must be taken when compositing these together, because the 3D would be both in front of the 2D chest and behind the 2D sleeve. This would require a matte to hold out (or not show) some of the 3D arm.

FIGURE 4.4 Close up of John Silver's arm shows a clean joining line between the two elements. © Disney Enterprises, Inc.

However, you might have not noticed the most *invisible* examples of hybrid animation. In *The Triplets of Belleville,* you might have missed the 2D/3D portions. You probably noticed some distinct 3D elements like the bicycle wheel, but did you see the 2D/3D character? Any time a character is riding a bicycle, the character's contact limbs are actually 3D. The rest of the body is sometimes animated in 3D as well to use as reference. You can take a look at the bonus features on the DVD to see examples. The 3D line was dirtied up to make it less perfect in order to match the 2D line.

In Dreamworks' *Spirit Stallion of the Cimarron,* you may not have noticed that the main horse is sometimes 2D, sometimes 3D. The same goes for many foreground and background characters in the film. It could be categorized as a 2D with a 3D part or a 3D with a 2D part because it is so interchanged. Buy that film and look at the extras on the DVD. From the beginning, Dreamworks had computers at the desks of the 2D artists. It was always treated just like any other tool. This showed in their films where they combined 2D and 3D seemingly effortlessly. Dreamworks eventually did transition completely to 3D for most of its films.

FIGURE 4.5 *Triplets of Belleville* shows a 2D/3D character with a 3D bicycle.

Students in my class, your homework is to go watch these three movies once for the story and once more frame-by-frame to see the 2D and 3D animation.

One last example that you probably are not aware of (there was no mention of it on the DVD) is the moose from *Brother Bear.* It might have been mentioned in the commentary. The moose were animated in 2D, and then the animators brought their 2D drawings into Maya and animated the antlers in 3D to match the 2D drawings. The drawings were printed out, pegged up, and the cleanup drawings were done traditionally on paper. I wish I had a picture of the antler rig that was made for the animators, Tony Stanley and Broose Johnson. They came to my training room one day and showed me the "make funny" button, which put Groucho Marx's glasses and mustache on the 3D version of the moose's head. You have to keep a sense of humor.

Hands-On Examples

Now let's go through the process of making an animation of a 2D character who has a 3D arm. Our main concerns will be registration and line look. As discussed previously, the line look of the two elements will need to match. To do this, you must master the rendering process and render the 3D line look or use the 3D part as a template and draw over it in the software package of your choosing. Unfortunately, the latter choice does not decrease one's line mileage.

We will take sequence 1, scene 10, from the storyboard at the beginning of this section. This is a sequence from SCAD student Dianna Bedell's senior project. The character was not designed to be 2D/3D. We will retrofit the Hoodoo priestess with a 3D arm.

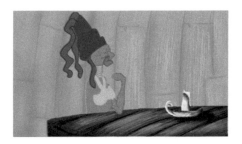

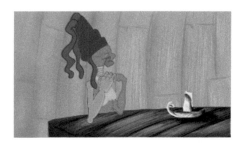

FIGURE 4.6 Finished 2D character design by Diana Bedell, cleanup by Amanda Powell, 2009, SCAD.

FIGURE 4.7 3D arm by Danny Tiesling, 2009, SCAD.

FIGURE 4.8 3D arm added to a 2D character.

All images for this hands-on section can be found in the companion data for this book at www.hybridanimation.com.

TIMING

When working out your animation timing, there are many software and analog options for you. I encourage my students to work in whatever method is fast and cheap. I don't mean cheap as in how much it costs. Instead, I mean cheap as in how dear it is to you? If you have to work very hard to create just one image, you will be less inclined to part with it if it needs to be changed or discarded. However, if you utilize a method that easily allows you to change an image that is not as dear to you, you are more likely to tweak. You will also want something that allows you to adjust your timing easily and go back to previous versions just as easily. This will allow you to be bold and experiment with new timing. Who knows what happy accidents might turn up?

Hopefully, you have already begun working in 2D and in this you have already begun working on the 2D animation pipeline that best suits you. In this chapter we're going to push for digital animation methods. Feel free to modify to fit the pipeline that best supports your creative process. By now you should know where to go to share your favorite method with the rest of us: www. hybridanimation.com.

This chapter will not help you on your animation and acting. You'll have to bring that to the table yourself. To further push your animations, you can always refer to *Action! Acting Lessons for CG Animators* by John Kundet-Gibbs.

To begin work on your sketches, stay loose and work in your sketchbook and then scan those in. Or you can use your favorite software to draw in. Film Roman, the studio that brings us *The Simpsons*, has recently gone through a transition from paper to digital drawing. Film Roman's animators use both methods

depending on the scene and need. They use Toon Boom's Sketchbook Pro to create their key sketches.

Once your main ideas are worked out, you will want to work on your timing, there are two pieces of software that I use: Flash or FlipBook. I have a few students who use Photoshop to do their timing. I find it gets in my way because I think in x-sheets and timelines.

Timing in Flash

For this example, we have scanned in our images using a flatbed scanner. Figure 4.9 shows an animation that has been scanned in with keyframes placed into Flash's timeline. Additional poses can be drawn easily in Flash. Keyframes can be moved. Held frames can be added or removed to adjust the timing. Playback is done easily as well.

FIGURE 4.9 Keyframes placed in Flash and timing adjusted.

> **Take Note**
> Remember to check your **frame rate** settings! We are working at 24 fps for this example.

Timing in DigiCel FlipBook

Another software program that you can use is DigiCel FlipBook. Here I'll show an example of using DigiCel FlipBook and a multi-feed scanner. (You will be spoiled rotten if you use one of these scanners.)

Flash

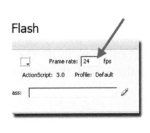

FlipBook

FIGURE 4.10 Frame rate settings in Flash and FlipBook.

In DigiCel FlipBook, click File > Scan to scan in the pegged up images. An example of a typical setting for a multifeed scanner is shown in Figure 4.11.

FIGURE 4.11 Scanning in images using a multifeed scanner (show peg holes).

DigiCel shows the images on an x-sheet. Click and drag the images to the appropriate frame. You can also draw, using the pencil tool, additional poses.

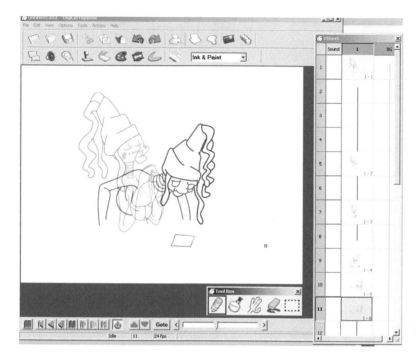

FIGURE 4.12 Keyframes scanned into DigiCel FlipBook to adjust timing.

Now, maybe I was having a bad day, but the first time I tried to do a timing test and draw in FlipBook, I had issues. The only thing that keeps me from thinking that possibly I had forgotten to install my brain that morning is the fact that I gave the same exercise to my class. Out of 10 people in the class, half had the same issues that I had. For those of us who had issues, let me hold your hand and walk you through it. The obstacles to get through are what the colors in the x-sheet mean and the use of the ALT key instead of the CTRL key (on a PC).

1. *Moving keyframes.* Once you have scanned your drawings into the x-sheet, you will want to drag them to the timing you think is correct. This really is simple. Select drawings in the x-sheet and they turn blue. You can use SHIFT to select multiple drawings. See Figure 4.13 to see two keyframes moved from frame 6 to frame 10.
2. *Onion skinning.* This one took me the longest. I swear it is silly. You thought I was smart. I get weird with some software; it must be an interface thing. How do we see our keyframes in

FIGURE 4.13 Moving multiple keyframes in FlipBook.

onion skinning? Here's the secret: When you double-click on drawings they highlight in yellow and that drawing will show up on the canvas. If you have **stack** enabled, you will see your drawings onion skinned. Don't want to see a drawing? Then **ALT + Click** on the drawing in the x-sheet *once*. The drawing you are working on shows up in green.

3. *Adding drawings.* To add a breakdown in FlipBook, simply double-click on the frame in the x-sheet on which you want to draw. It turns green. Draw your breakdown. Beware: you can have a frame in the x-sheet selected for moving (it is blue),

FIGURE 4.14 Seeing keyframes in onion skin.

but it is not the frame you are drawing on (that is green). That was my major confusion with the software. Glad I have that cleared up.

4. *Drawing.* The pencil is the default tool. The hotkey to switch between pencil and the eraser is **e**. To resize the pencil, right mouse click on the pencil icon to view the pencil attributes. You can see the attributes in Figure 4.15.

5. *Playback and adjusting.* Press the play arrow at the bottom of the canvas, and you will see your animation. To add more time to your animation, select a drawing in the x-sheet (remember, it is blue) and select **Edit > Insert**. It will insert a hold on the previous drawing.

Director Approved

Once your timing is done and director approved, you'll want to save your images for the next step. If you are the director and if

FIGURE 4.15 Yellow = drawing seen in onion skin, green = current drawing, and blue = selected to move in x-sheet.

Figure 4.16 Select a keyframe and insert time before it.

you are satisfied with your animation, then you are director approved. Move on to the next step.

In **Flash**, you will want to go to **File > Export > Export Movie** Because this is a low-resolution reference, we should not be concerned with compression. You can choose **jpg sequence**. This will save your animation as a series of jpg images with the base name plus the frame number in the old format of **name#.ext**. If you want a "." between the name and the frame number, add that in the base name you set. For example, you would use the base name "**tt.**" to get the final name of "**tt.001.jpg**."

In **FlipBook** you would also go to **File > Export > Export Stills**. You might prefer movie or avi files. For production, I'd rather have

individual images. It is easier and faster to touch up/replace one image instead of reexporting a whole avi file again. In testing I was only able to use **bmp**. I would rather have used **tga**, but the files exported oddly.

FIGURE 4.17 Settings for exporting a sequence of images from FlipBook.

3D ARM IN MAYA

Before cleaning up the 2D animation, you'll want to get the character completely animated and have that approved. We'll add the arm appendage. Depending on which 3D software program you are using, the buttons used will be different, but the process will be mostly the same. Your goal is to bring the 2D images in, set up a render camera to match the 2D image, work with the lens of the camera so that it flattens out perspective as much as you need to match your 2D, animate your 3D arm to that camera so that the image you create looks like it registers to the 2D image, and then render. Simple, right? Really, it is. Let's go through it, shall we?

IMPORT 2D

Inside of Maya, there are many ways to bring in an image plane. To make sure we are animating to the same camera as the 2D image we absolutely need to attach the image plane to the camera. Other techniques of bringing in the image and texture mapping it onto a polygon will not ensure that our 3D camera is accurate.

FIGURE 4.18 Pose test from FlipBook. Images by Dianna Bedell, SCAD, Senior Project II, 2009.

1. Create a new camera: **Create > Cameras > Camera**. Because this is a locked-off shot (the camera is not moving), we'll use a plain camera with no aim or up. Rename the camera **Render_Cam**, and give it a **Focal Length** of **150**.
2. Make sure this camera is the current camera. In the top of the camera window, click **View > Image Plane > Import Image** Select the first image of your 2D sequence.
3. But you have more than one image, don't you? You'll have to tell Maya that. Perhaps in a future version they will have a "Use Image Sequence" button right there in the open dialog box. Instead, at the top of the camera window click **View > Image Plane > Image Plane Attributes > imagePlane1**. In the attribute editor, click on the **Use Image Sequence** option.

Now in your camera view, you should see your animation. If you use movie files or avi files, those will read in as well (if you have

the QuickTime driver installed). If you scrub through the Maya timeline, you should see your animation in the Render_Cam window.

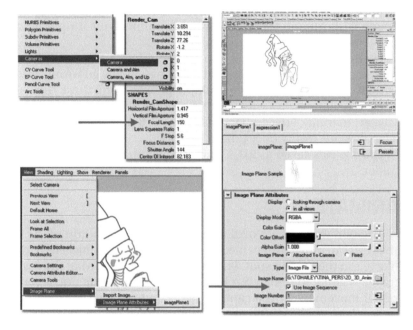

FIGURE 4.19 2D images imported into Maya.

What could go wrong here? If your naming convention is not **Name.number.extension**, Maya will not be able to figure out that you have an image sequence. If you have a number in the name, Maya gets confused. For example, *kitty10001.tif, kitty10002.tif* might have issues. It should work if you instead name it *kitty1 .0001.tif, kitty1.0002.tif.*

Take Note
Make sure that your Maya Render settings are the output resolution that you want! This is a locked-off shot, so the camera (canvas size) should match the 2D images that we created. A way to see immediately if your resolution is set correctly is to go to the Render_ Cam view and click **View > Camera Settings > Resolution Gate.** The resolution gate (or rectangle) is hard to see because it exactly matches the 2D image that was brought in as an image plane. In the upper right corner of Figure 4.19, the resolution gate is being shown. As you can see, the resolution size is barely visible over the image plane. You do not see the rectangle resolution gate, because it is white and the image plane is white. If the render settings were incorrect, you would see the resolution gate as a different size from the image plane.

Here's a good question: Do they need to match? No. Actually, your 2D images can be a separate size and you can adjust during compositing time. You would only need to globally resize your 3D image to match. But why go through that? Remember that bad habit we talked about falling into—the "we'll fix it in post" terror, which is shorthand for "I don't want to think about it right now. Let someone else fix the problem."

Hold on a moment. I need to stop and look at this. All these button clicks; all these things that could potentially go wrong. And in a group project we'll have multiple people doing these things? Golly. Animation that goes beyond a single actor doing a vaudeville act in front of the audience is not easy. But we love it, so, okay. That was our reality check. Back to work.

Our file was saved as **2D_Leads_3D_v1.mb** inside the 3D_Arm folder.

ANIMATE

The odd thing to get over when animating 3D on top of 2D is that you can move your camera all around to get the object looking like it is in the correct spot. The thing that matters is what the final image is going to render out like. So you can do some unconventional movement in the camera placement to cheat perspective or use it to your advantage. Beware: overuse of this power can make for some odd-looking animation.

Because we have the knowledge of what frames are keyframes via the x-sheet and we have an understanding of what timing was used via the timing charts, we have an easier time of matching the 3D animation to the 2D animation:

1. Import in the 3D arm rig. Click **File > Import** and locate the **ArmRig_v1.mb** file. This will bring in the arm at the origin.
2. Use the Perspective and orthogonal views to position the arm so that it looks like it is in the correct spot in the Render_Cam view.
3. Find the keyframes on the x-sheet and pose your arm for those main keyframes. Our x-sheet for this example is on a simple Excel spreadsheet: **x-sheet.xls**. You can see the spreadsheet on the left side of Figure 4.20.

 To help pose the 3D arm better, the Render_Cam has been torn off (much like we did in Chapter 3). Also, **Shading > Xray** has been chosen so that the animator can see through the 3D object to the 2D arm. If you have the 2D roughed-in arm, that will help you pose your limb. Of course, the perspective hand-drawn will not match. Look to match the contact points, the shoulder and wrist, more than the elbow.

 To set keyframes easily, this 3D arm has a character set: **Arm1**. Select the character set for the arm and hit "**s**" for each

keyframe. As Figure 4.20 shows, keyframes set in the timeline correspond to the x-sheet. You'll note that the perspective camera is used to pose the arm in 3D space so that it looks correct in the Render_Cam view.

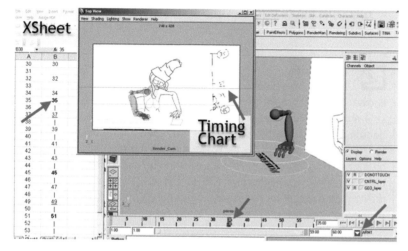

FIGURE 4.20 Keyframes set in Maya.

4. Next, look for breakdowns and the spacing they should have, and create keyframes for your arm. Again, if you have a timing chart from the 2D animation, you should be able to match the same spacing and achieve better registration with the 2D character. If you do not have a timing chart, you'll have to guess where the breakdown is and know that the next step is going to take much longer. In Figure 4.21, the breakdown 28 is halfway between the keyframe for 16 and 35. (For those truly following along with the enclosed data, frame 16 is held from frame 14, and in the enclosed example, frame 28 was moved to 29.)

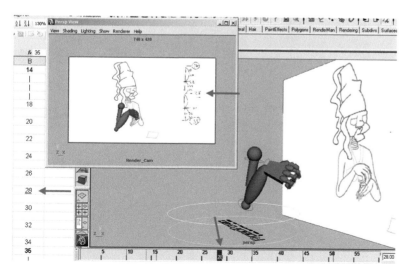

FIGURE 4.21 Breakdowns set in Maya.

5. Remember to roll through your drawings often to make sure that the arm registers in its socket. Look for jiggling at the contact point and adjust your keyframes to eliminate the jiggling.

6. Now, add your inbetweens. Use the graph editor to adjust the final spacing of the drawings to match the 2D.

> **Take Note**
>
> A note on following the timing chart. With the timing chart showing where breakdowns are on halves, or halfway between the keyframes, you can speed up your workflow and use Maya to your benefit. For instance, the timing chart between frames 16 and 28 calls for frame 22 to be halfway between the keyframes. Set the tangents on frame 16 to be linear. Frame 22 will then be mathematically halfway between the two keyframes. Go to frame 22, take a look at the drawing, and adjust as necessary to put things on arcs or add overlapping action and so forth, then hit "**s**" to set a keyframe.

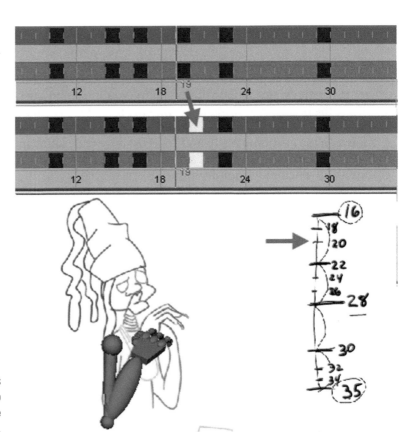

FIGURE 4.22 Using Maya's inbetweens but moving them to the correct time to match the timing chart.

The next half on the timing chart is for frame 22. That drawing is supposed to be halfway between frames 16 and 22. Let Maya do the work for you. Locate the inbetween that Maya has made that is visually halfway between frame 16 and frame 22. In our example, it is on frame 19. Go to frame 19 and hit "**s**" on the keyboard to make that a keyframe in Maya. Then simply use the dope sheet to move the keyframe to frame 20 as the timing chart indicates. Now you can more easily go in to the graph editor and adjust your spacing by moving the tangents. Your timing, where the keyframes and breakdowns are, is already in place. This method speeds up your workflow tremendously. Use Maya to do the work for you, but control it so that you don't end up with Maya inbetweens. The horror.

FIGURE 4.23a Completed animation in Maya.

7. We'll use your twos.mel script to put this animation on twos:
 a. In the outliner, select the character set.
 b. Type **twos** in the command line.
 c. You will receive the feedback: put this command on a shelf to animate the timing: "select –r timeOnTwos."
 d. Highlight the command "select –r timeOnTwos" and middle-mouse drag it to a custom shelf so that you can use it later on.
 e. Scrub through your animation to see that your work is now on twos.

 What? Oh. Your animation isn't always on twos? That is the case sometimes, isn't it? Let's look again at our animation. If you have timing that is on ones at some points and on twos (or fours, etc.) at others, you can animate

what the script has set your timing to be. It isn't too hard either. I like this method much better than setting every key on stepped and manually, making every keyframe on twos.

f. If you haven't clicked anything since running the script, the **timeOnTwos** node is still selected and you can see it in the channel box. If not, you'll need to click on the button you made or type into the script editor: **select –r timeOnTwos**.

g. You can animate this attribute as needed to adjust your timing. With the time set to frame 1, right-click on the attribute and **keyframe selected**. This will set a keyframe for timing on twos.

h. Advance to a frame where you need the timing to change to ones and change the **By** attribute to **1**. Set the keyframe on that attribute.

i. This way you can adjust your ones and twos but still use the graph editor without creating a large mess.

FIGURE 4.23b Using twos script to put 3D animation on twos.

8. Render the animation. There is already a toon shader and ink line on the arm for you. You need only to render the arm level. This means that you do not want the image plane to render. How do you get rid of that? You can either delete the image plane at this point or adjust the alpha gain for the image plane to be 0. Then render as follows:

a. Set the render settings. See Figure 4.23c.
 i. Name the level
 ii. Name.# extension
 iii. .tif (or something that keeps alpha channels)
 iv. Start and end frames
 v. Frame padding
 vi. Select the correct camera
 vii. Make sure to include alpha channels
 viii. Make sure your size is correct

b. Click Render > Batch Render.

FIGURE 4.23c Render settings and example of final renders.

Our arm level file names are arm.#.tif.

How did you do? Things should start to seem a lot easier now. If you did not have a good grasp on the graph editor to begin with, this might be a little tricky for you. Please, avoid keyitis. This is a horrible disease where the animator that does not feel comfortable in the graph editor begins to compensate by setting keyframes on every frame. Yes, you can do this, *but* you start to get into stop-motion animation at that point, where everything is being moved manually and no matter how hard you try, there will be pops and jumps between images. Of course, if you are going for a stop-motion feel—don't do it that way either. There are procedural ways to adjust your timing to get the same type of feel. I can't stop you. If you have to go through your keyitis phase, go ahead, get it out of your system. If you start to miss your quotas, come back and conquer your fear of the graph editor. Kudos to my students who I have seen work hard on getting over their graph editor fear.

> **Take Note**
>
> Remember, if you render out .tif images, they do not read into Photoshop with their alpha channel. .tifs are fine for every compositor that exists, just not Photoshop.

RIM LIGHT

Something to consider when you have a 2D object and a 3D object together in the same scene is do you want them to look very flat or do you want them to have some dimension? Usually this

boils down to the question, do you have time, money, and human resources to make rim lights, tones, and shadows for all of your characters? These types of elements are usually produced by the Special Effects EFX department. I'll talk more about this odd brand of artists later on in the EFX chapter. (I mean odd in a great way.) For our solo project, we will include rim lights (or highlights) on our 3D arm, as it is made of metal.

We will make the rim light as a separate pass from the rendered arm. This way we can adjust it at composite time to match everything else. Our goal is to create a rim matte: a black-and-white image representing the area that will be a highlight.

This is a different way to think. As you create this image, you are not thinking of anything but a black-and-white image that represents where the highlight will be. So do not worry about the main color of the arm. I'm starting with my last saved Maya file: **2D_Leads_3D_v5.mb**.

1. To start, I have to hide my image plane. The bright white gets in my way. I'll toggle off cameras by clicking in the Render_ Cam window: **Show > Cameras**. In my sample file, I have deleted the image plane.
2. Now, let's assign a special toon shader to the arm:
 a. Unlock the **GEO_Layer** by clicking the **R**.
 b. Select any part of the arm and hit the up arrow key or select the **GEO** group node in the outliner.
 c. Assign a Dark Profile Toon shader to the arm under **Animation: Toon > Assign Fill Shader > Dark Profile**.
 d. Create the color ramp so that its first chip is white and the second is black as shown in Figure 4.24. This will create a white area where we want to have a highlight and all else is black. Perfect.
 e. In the outliner, delete the Toon Line Shader. We do not need it for this pass.
3. Render the rim light pass.
 a. Go to your Render Settings and prepare your render. See Settings in Figure 4.25 and then Batch Render.

> 🖊 **Take Note**
> Even though we have set up the rim light as an RGB image that will be used as a mask, we still need the alpha channel for the arm. Make sure to use .tif or some format that keeps alpha channels.

Our Rim Light file names are **arm_RL.#.tif.tif**.

FIGURE 4.24 Dark profile added to the robot arm. This will be used as a rim/highlight matte.

FIGURE 4.25 Render Settings and an example of final renders.

CLEANUP IN PHOTOSHOP

To do proper cleanup in Photoshop, you will want to use a brush that gives the best line quality. Well, how do you accomplish that? For those of us who grew up with Photoshop, we have seen it change from a tool that you would never dream of drawing with

to a tool that has lots of potential. In fact, it has too much potential—it can be a thick forest to traverse through to get a brush that you like and fits what you need. (Those are two separate requirements. You can like a brush but it isn't what you need.)

The choices seem to boil down to these:

1. Use a built-in brush in Photoshop.
2. Create a custom brush.
3. Download one.

You might jump to the third option automatically. It sounds like the easy choice. Not any of the choices are easy, actually. You are forced to pick out one piece of candy in a nearly infinitely sized candy store. How can you do that? There could be a better-looking piece of candy in the next parameter that you tweak or in the next brush that you download!

I have watched various students go through this process as they work on the senior projects or on a group project. I have also gone through this same process myself. Just when I think I get a brush that I like, I try to draw very tightly and find that the brush doesn't work well enough for my purposes or does not draw smooth enough for me. Once I get a brush that I like, however, I can draw my heart out. It is the process of getting that brush that I imagine is enough; when an artist finds a brush, she or he might not try any others.

BUILT-IN PHOTOSHOP BRUSH

Let's start with built-in Photoshop brushes. Can you do cleanup with those basic brushes? Yes. For those who love a thick-thin cleanup line, you might not be satisfied with the results if you do not dig deeper.

I interviewed a student who had spent weeks doing cleanup on a senior project piece. A note to the concept of cleanup: we don't have an actual class on cleanup in the curriculum. We tend to focus on animation, acting, storyboarding, and the like. So students who take on the task of cleaning up, inking and painting, or otherwise completing a 2D film are learning as they go.

You might have taken a look at the basic brushes in Photoshop and scrolled through the presets. But did you ever load the other presets? I'll admit I hadn't for quite a while, until one day I went poking around to see what else was there. If you open the options for the brushes palette, you will see at the bottom various brush sets that you can load in. Figure 4.27a shows a few brushes that come with Photoshop.

When your cleanup and painting are done, you will export a raw movie file, like we did in the previous chapter. Remember to

FIGURE 4.26 Cleanup using Photoshop's standard brush.

Dry Media Brushes

Calligraphic Brushes

FIGURE 4.27a Preset brushes in Photoshop.

include alpha channels! That catches some students—and professors.

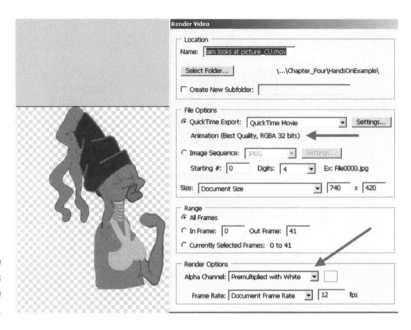

FIGURE 4.27b Exporting the final level of Jam, saving as raw QuickTime in order to have alpha channels.

The cleanup file name in the companion data is Jam_Lvl_12fps. mov. This is a raw QuickTime movie. There is no compression.

CUSTOM BRUSHES

You can push further than the stock brushes and create your own. There is a lot you can do when you modify the attributes of the stock brushes, and you can come up with an amazing assortment of looks that are much more painterly or at least nonround. It takes a lot of time to experiment, so make sure to set someone on this task early on in your group project. If you are doing a solo project, that someone is you.

When you create custom brushes, the brush shape is based on a grayscale image. Complete black areas will fully deliver paint to the canvas, gray areas will deliver a varying degree of paint, and white areas will not paint. The brush attributes can be applied to your custom brush tip.

How do you make that black-and-white image? You can paint it in Photoshop, scan in an image, or create it in Illustrator or a similar program.

Here's an example of creating a custom brush:

1. Create the desired brush tip shape in Illustrator and save.
2. Open that file in Photoshop.

3. Click **Edit > Define Brush Preset…**. This creates a brush from that image.

4. Tweak the parameters until you get the desired results.

FIGURE 4.28 Using an Illustrator file to create a custom Photoshop brush.

> **Dig Deeper**
>
> Learn how to harness Photoshop's brushes with *Creative Photoshop Digital Illustration and Art Techniques* by Derek Lea. Just reading the first chapter sent me off painting with Photoshop like never before.

DOWNLOADING BRUSHES

Of course, why reinvent the wheel? There are an amazing number of brushes waiting for you to download. In just doing a quick search for the group project, I found more brushes than I could ever test in one session. For example, I ran across a brush website: **myphotoshopbrushes.com**. Though there were many sets of brushes that I could have looked at, I focused more on traditional media brushes and ran across this set called **Dukal's Artistic Brushes** by Alex Dukal. You can find these brushes at http://myphotoshopbrushes.com/brushes/id/248.

I downloaded these brushes and found that they were at a very high resolution, meaning the brushes were huge and contained a lot of detail. You can scale the brushes down to do detailed work and, of course, use them as large sweeping brushes as well. I then

took a look at Alex Dukal's website to see what type of work he does with these brushes (www.circografico.com.ar). Lovely work. Figure 4.29 shows the Dukal brushes loaded into Photoshop and one quick use of brush "Splat 2."

FIGURE 4.29 Dukal's artistic brushes.

Alex Dukal.
Areas of interest: Childrens Illustrations, Picture Books, ADs.
Website: www.circografico.com.ar
Email: alexdukal@gmail.com

What can you do with brushes like these? Figure 4.30 is an illustration by Dukal using his Photoshop brushes. This originated as a doodle on a Post-it note. The background is scanned-in mag paper. The brushes he used were his collection of Artistic Brushes #2.

FIGURE 4.30 Alex Dukal's Chick of the Year.

I didn't search for it, but I would bet there is a downloadable brush set of coffee stains or stains in general. I'll have to put that onto my to-do list for looking up or creating. Can you imagine it? I could put coffee stains on all of my lecture notes or PowerPoint slides.

OR CLEAN UP IN TOON BOOM

Another package that you might use to do cleanup is Toon Boom. This package might be a little pricey for a student, but it is worth it.

In Figure 4.32 you see the x-sheet at the bottom of the screen. The keyframes that were drawn in Photoshop have been brought into one level and a drawing level has been placed above the keys.

To get a tapered line in Toon Boom, you will need to adjust the settings for the pen tool. See Figure 4.31a for an example. A range between a minimum of 0 and maximum of something of your choice will vary the thickness of the line. The attribute smoothing will try to auto adjust your line. The higher the number, the more

FIGURE 4.31a Animation brought into Toon Boom for inbetweens and cleanup.

it believes you cannot draw and will try to draw for you. For some this is a bonus, for others it is a major annoyance. Bring that setting down as low as you need to for sanity. Another thing you might notice directly off the bat is that the line seems jagged when you draw. This is a vector line and you are only seeing a quick screen representation. You will have to render or hit CTRL plus the ENTER key to see the real line as shown in Figure 4.31b.

FIGURE 4.31b Cleanup line in the jagged preview.

FIGURE 4.31c Cleanup line in the final render view.

FINAL RENDER

We'll use After Effects to composite the different levels together. Later on in this book, we'll use a node-based compositor to see the difference in how you approach a scene.

Let's review the levels that we have starting from the back to the front. Refer to Figure 4.32. The bottom level is a **background**, which was painted in Photoshop. The next level up is the **character** level, which is composed of both the ink and the paint level. These levels could be separated into two levels. With them separate, there are more compositing tricks that you can do with the ink lines. Next, there is the 3D **arm** level, which also has both the ink and paint together. Above those is the RGB version of the **Rim Light** level. It is important to remember that we are seeing an RGB image of a matte and not looking at an alpha channel. (One is inverted from the other.) Lastly, we have a table level, which is titled **underlay/overlay**. It has this title because it lays over most everything but also "lays" under Jam's elbows.

bg jam_ink arm

armRL (rim light) olul (underlay/overlay)

FIGURE 4.32 Levels that need to be composited together and a final composited image.

SETTING UP THE COMPOSITION

Bring the art assets into After Effects. Remember to check your import preferences so that they match the frame rate that your project is in. See Figure 4.33 for an example.

To keep things neat and orderly, create a folder for the levels that are individual .tif images. For example, the arm and the arm rim light levels would have their own folder. We will make a "precomp" of each of those levels. First, make a composition of the arm level by selecting **arm.0001.tif** through **arm.0050.tif** and dragging them onto the **Create a New Composition** button. This will open a dialog box. To get the images to show up one after the other, you need to select **Sequence Layers** and make sure that the **Still Duration** is one frame: **0:00:00:01**. See Figure 4.34 and Figure 4.35 for examples.

FIGURE 4.33 Import preferences should match the frame rate of the project.

FIGURE 4.34 Creating a precomp of the arm level.

FIGURE 4.35 Arm composition.

Create a new composition and drag in the levels in the following order starting from the bottom level to the top: background, olul, Jam. Do not drag in the arm and arm rim light just yet. See Figure 4.36 for an example of how the composition should look at this point. You'll note that Jam is overtop of the table. That is great for her hands, but her body needs to be behind the table. We'll have to matte that out. We'll tackle mattes later on in this chapter.

FIGURE 4.36 Levels in After Effects.

3D ARM WITH RIM LIGHT

The 3D arm is going to take just a little bit of working with to get the rim light on it. The great thing about using mattes to adjust lighting is that in this comping stage, you can see the arm level in relationship with all of the other levels.

1. Create a new composition by clicking the **Create New Composition** icon.
2. Give the composition the name **3DArm**. Make sure that the composition is the correct size, and watch out for frame rate!
3. **Drag** the **Arm** composition that we made earlier into this new composition.
4. **Right-click** in the timeline and add a **New > Adjustment Layer** above the 3D arm.
5. **Drag** in the **Arm Rim Light** composition and place it above the Adjustment Layer.
6. Select the Adjustment Layer and from the top menu click **Layer >Track Matte > Luma Matte**. You will be able to see the arm level again. You'll notice a matte icon next to the Adjustment Layer and the Arm Rim Light level.

FIGURE 4.37 Arm and Arm Rim Light put into their own composition.

7. **Right-click** on the Adjustment Layer and add **EFFECT > Color Correction > Color Balance (HLS)**.
8. Bring Lightness up to the desired level.

FIGURE 4.38 Rim Light matte level used to adjust the color of the arm.

Another great thing about having this rim light matte is that you can adjust the color of the painted object. Some tutorials might have you make a black-and-white matte, adjust the opacity, and just lay it overtop of the arm level. That is a valid method but does not give the most color correction capability.

Let's work with that matte just a little bit more.

9. Select the Arm Rim Light Layer and click Effect > Blur & Sharpen > Gaussian Blur.
10. Blur the matte by changing blurriness to a desired number. Ours is set to 3. (Make sure the visibility of the layer is off.)

Back in the main composition, drag in the 3D Arm composition that we just completed. You should now have a 3D arm with rim light on top of your 2D character.

FIGURE 4.39 3D arm with rim lighting added to main composition.

MASKING OUT BODY

One last thing to do with the body is to add a matte to mask out where the table is so that the arms stay on top of the table but the body is not visible. The easiest steps to create a mask are to select the layer you want to mask out and then click on the pen tool and draw the mask. There are other ways to do it, but this way requires the fewest number of clicks.

1. Select the **Jam** level.
2. Near the top of the application, choose the pen tool (or hit **G**).
3. Draw a mask along the edge of the table. Take care to draw around the 2D elbow on the table. Click on the beginning point when you are done, and the mask will complete.
4. And it will mask out everything else but the bottom of the body. In the timeline, open up the Mask attribute that has been added onto the **Jam** level. Click **Inverted**. Your mask should now be masking out the bottom of the body as you want.

📝 Random Note

The words are bugging me here, in case you couldn't tell. In my vocabulary, a matte is a noun; it is what you draw. The verb is mask. Using these terms, a matte masks out things. However, After Effects calls the mattes *masks*. Oh, bother.

FIGURE 4.40 Body masked out so that it is not visible overtop of the table.

You might have noticed that the 3D arm is overtop of the hair at the beginning of the animation. Repeat the same steps above for the 3D arm level to make it look like the hair is on top of the arm. Something different you will have to do is make it a traveling matte; in other words, animate it moving along with the hair. Simply use the **Selection Tool** (or press **v**) to move the points around. After Effects will auto keyframe for you.

FIGURE 4.41 Traveling matte created to hold out the arm where the hair should appear on top.

At every stage that we have gone through, there is room for being meticulous. To not be so is to create errors that will show up in the final stage. You can imagine in a large production, or even in your small group project, many of these steps are carried out by different people with no idea what the other people are going to do with their images when they are done with them and

no idea of how the whole pipeline fits together. At every stage, you want to look for areas where you can plus the image and understand how those before and after you are going to work with the asset you create so that you can help and not hinder them with your work. You'll have to make mistakes to figure that out. My suggestion is to do group projects, often. This will help you see those costly mistakes before your paycheck is riding on it.

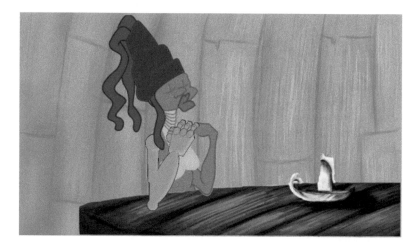

FIGURE 4.42 Final comp.

PROJECT: 2D LEADS 3D

Due: _____

For this chapter's project, you are to take a 2D animation and replace an appendage or accessory with a 3D counterpart.

Here are your choices:

2D animation. You can use your own 2D animation or use the 2D animation that is in the companion data for this chapter. If you choose to create your own 2D animation, keep it short. You will want time to experiment and find your way around in the 3D and compositing stages. The 2D animation can be found in **jam looks at picture_CU.psd**.

3D appendage. Feel free to use your own creation for an appendage. You will also find an arm rig that you can use in the companion data for this chapter. The 3D arm to import into your scene is **ArmRig_v1.mb**.

Follow these steps. Take your 2D animation, scan it in if needed, add a 3D element of your choice, render the 3D element, composite in the package of your choice, and turn in a completed avi or movie file.

You will want to have the following levels:

1. 2D character
2. 3D element
3. Rim light (can be hand drawn or a diffuse pass)
4. 2D background (a sky card is fine)
5. Shadow pass

For my students, you must try to match a style. This will help you achieve a higher aesthetic goal (styles to match: *Treasure Planet* or *Triplets of Belleville*).

You are assessed on the following skills:

1. Ability to match 3D animation to 2D character and achieve a cohesive character animation
2. Technical use of 3D application
3. Technical use of compositing tool
4. Overall appeal of the shot
5. Matching of style

FURTHER READINGS

Kundert-Gibbs, J. *Action! Acting Lessons for CG Animators* (Pap/Dvdr.), Indianapolis: Sybex, 2002.

Lea, Derek. *Creative Photoshop Digital Illustration and Art Techniques*, Amsterdam; Boston: Elsevier/Focal Press, 2007.

Schroeppel, Tom. *The Bare Bones Camera Course for Film and Video*, Coral Gables: Schroeppel, 1980.

STUDENT CONTRIBUTORS

John-Michael Kirkconnell
Claire Almon
Clint Donaldson
Dianna Bedell
Amanda Powell
Daniel Tiesling

5

3D CHARACTERS WITH 2D PARTS (3D LEADS)

Bouncing 2D/3D balls, by Jessica Toedt, 2009, SCAD, 2D/3D Compositing course.

LECTURE NOTES

How are you doing so far? I hope that you are getting used to the process and thinking up ways to combine the media and reasons why you should. Once you have everything broken down into the basic patterns of problems—2D leads, 3D leads, using

DOI: 10.1016/B978-0-240-81205-2.00005-4

cameras and textures to flatten 3D or using tones and shadows to round 2D (we'll cover that soon), rendering in layers, compositing, and using masks—then it's just a matter of finding the best ways to achieve your look with whatever techniques you need.

By now you have probably lost a little fear and do not believe that you need to stay in one package for your scenes; heavens, no. By now, you should be thinking in layers of images. You should be thinking that the output of any given software package is just an image and that your character is made up of multiple passes of images. Good, you have come far.

Often in class (or even the industry) I see those who become mesmerized with the 3D package. They get stuck in that 3D Cartesian world and think that everything has to be done there. Students get stuck into thinking that they need to render the whole frame in one go and overlook the concept of breaking things into levels. Breaking things into levels allows animators to use mattes in a compositing package to adjust colors and to isolate elements into levels so that if something needs to be tweaked or adjusted, they do not have to re-render the *whole* frame, just the one level. Ah, the time savings that process gives; it makes me happy.

The same thing goes for our characters, as we have found. They do not have to be stuck in one medium or software package. For many reasons, we have discovered you might want to use 3D to help along your 2D animation, whether it be to reduce line mileage or help with perspective and complexity of the character. We have focused on why one would use 3D. But why would one use 2D? Can't everything be done in 3D nowadays? If I were in a classroom, in front of you, I would have a perplexed look on my face and would be trying hard not to let my sarcasm show. Yes, many things can be done in 3D. But should they be?

In my classrooms, the students have to produce a senior film (with a passing grade) or they do not graduate. I'm sure this is the case in many campuses: the films tend to be mono media. It is a monochromatic sea of 3D-ishness, and it all looks the same. Of course, if it were all 2D films it might look the same too because of similar animation style emulation in the curriculum. However, more than likely, it will not all be similar simply because of the different artists' hands. I am generalizing, of course. The 3D work doesn't all look exactly the same, but there is a trap that young artists can fall into. When they create something using the 3D tools, the same 3D tools that the next 500 artists are using, they become satisfied with what they see on screen and think that it is the vision they were after, when in actuality, it is the easiest thing that the tool has offered them and the other 500 to 1000 artists. Only the few, who know what their artistic vision is and push to make the software do their biddings, produce images that are not in that monochromic 3D sea. Because the tools produce some-

thing that can be labeled as the 3D package programmers' artistic vision, those without their own clear artistic vision settle for the programmers' vision. Even if you do not use 2D/3D in your independent films, at least, push beyond the programmers' artistic vision. I will put away my soapbox.

On our campus, only in the past few years after introducing this 2D/3D class, I have seen the nonmono films created. It is nice to see this transition. I hope that we will see more. I'm counting on you to try things and post it on the website at www.hybridanimation.com (I have a quota for how many times I have to remind you about the URL.) We must break free from the monochromatic sea. How did I get back up on this soapbox?

We have done a 2D character with 3D parts, where the 2D character leads. Now we will turn our attention to a 3D character with 2D parts, where the 3D character leads. The question to ask then is, why use 2D parts?

Why indeed should we use 2D? With enough time for research and development, nearly anything can be done in 3D that can be done in 2D. Back in Chapter 1, we discussed that no longer is it the subject matter that decides. Human characters do not *have* to be done in 2D, because they can be accomplished in 3D. Fuzzy characters do not have to be done in 2D. 3D has come a long way. So it isn't exactly the subject matter that decides the medium. What was that? The student in the back row, you had an answer? Yes. You are correct. The look, supporting the artistic vision, is a great reason to choose 2D over 3D. You have been listening. Very good. This is my point: once the student or young filmmaker gets beyond the thought process that the programmer's artistic vision is a good one, simply because it is easier to push a button, then that filmmaker can grow into seeing which method will best support his or her own personal artistic vision.

Then you can start to see that sometimes 2D can be the answer. We'll look at some industry and student examples further on in this chapter. First, let's categorize some reasons you might decide to use 2D over 3D.

Line Look

What if you truly needed to have a certain style of line that currently can't be replicated with 3D toon lines? Perhaps you need a lovely cleanup thick and thin line. Perhaps you want a scratchy hand-painted line? Possibly you could create it with 3D, but that brings us to the next reason. Read on.

Time

Sometimes it takes less time to draw it than it does to do all of the research and development to figure out how to do a given

thing in 3D. We'll examine the element of time in the industry examples section.

Animation Style

Another reason that might tip the scales toward 2D instead of 3D is to match a given animation style. It might be easier to animate in 2D.

Whatever the reason, it sometimes is the hardest decision to make, to add in 2D. We love our 3D shiny buttons and widgets. It is hard to stop and wonder if it would be easier, look better, or possibly take less time than it would take for the research and development department to draw the assets. Did I just say 2D could cost less than 3D? If you consider how much time it can take to test, develop, and render 3D assets to look like what you want, then yes, 2D can cost less. I'm referring to more risky 3D assets, which possibly you have not done before or that are highly technical like water, goo, dynamics, and so on.

Industry Examples

The hydra from Disney's *Hercules* is a good example of when 2D was used to get it right. When the hydra's heads grow from the stump where the previous head was severed, there is an eruption of goo. The hydra was a 3D element in a 2D film. The animators used flat shading on it, with tones and highlights. There were rendered toon lines done with Renderman. (In that day, you had to work hard to have toon lines.) For the goo that was to erupt from the stump, they investigated 3D particle systems. They spent a long time trying to get the particles to look right. It wasn't working. Finally the look development supervisor had a wonderful idea. She asked, "Can we do it in 2D instead?" It looked great. The animators did a simple 2D EFX element of goo and composited it into the shot.

Now that you are getting used to the idea of 2D/3D animation, it may not seem that odd to you to consider drawing a 2D element on top of a 3D element. Four chapters ago you might not have so easily come to the idea of putting 2D goo on top of 3D. There's no turning back now. It is just an image. Anything goes to get that animation on the screen.

Recently I wandered through a room where Dreamwork's *Spirit* was being played. It had been a while since I had looked at that film. It is a great example of 2D/3D mixtures. The sequence playing was one in which the lead horse falls into a river. (Why animal movies, both animated and live action, have to always douse animals in raging rivers, I do not know.) As the horse struggled in the 3D water, his splashes were 2D. It worked pretty well to have

the 2D splashes at the contact point of the 2D horse and the 3D water. To have 3D perfect water around a flat 2D horse would have drawn attention to the contact point and drawn attention away from the action of the scene.

I have another Disney example that I lived through. For *Fantasia* 2000's Pines of Rome sequence, the animators worked hard to develop 3D whales. They were lovely whales; you can check out the DVD to see them. The story is a cute tale about a baby whale and his adventures while trying to fly with his parents. There were a few elements in that sequence that could not be executed very well in 3D at the time. In 1995, 3D was not the best at a few things. The first element that was not convincing in 3D was the eyes for the whales, and the second element was the water splashes. Both elements were done in 2D. The 3D whales were printed, pegged up on paper, and used by the 2D artist as reference. I'll assume that there was some hand adjusting of the 2D eyes in the compositing software at the end of the process if there were any registration issues. The eyes were drawn in 2D, and the water splashes were not only drawn in 2D, they were drawn in an older style of EFX animation with the side of the pencil instead of drawing outlines. A similar style was used in the Sorcerer's Apprentice sequence in the original *Fantasia*.

For months I watched these sequences as they went through animation. I didn't even work at Disney at the time. I worked at Dreamworks. After getting off work I would drive to Flower Street to take dinner to my spouse, who worked as a cleanup artists in the character department by day and did overtime in EFX at night. He was in crunch time then and was working overtime drawing those whale eyes and water splashes. It was a huge undertaking and turned out very well. I marveled at the roto prints of the 3D whales. For some shots they were printed out on 24 field paper, and the artists had to draw eyes on that large 24 field paper. I wish I knew for sure, but I'm confident that animating on 24 field paper (which is incredibly huge) had to have caused some slight registration issues. Imagine these huge pieces of paper that were twice the size of normal animation paper and the only thing on them were a couple of small whale eyes. I'm not sure why they were using 24 field paper. Usually when you are drawing a small image on a large background, you can draw on smaller paper and composite the drawing into the correct place. I'm sure there was a reason.

Hands-on Examples

I run a group project class at least once a year. In 2008, the group project was very successful for such a small team. I'm proud to say we placed in the Daytona Film Festival, the Savannah Film

Festival, and the Atlanta Film Festival. The group project for 2009 was of a slightly larger scope, and our team size doubled. At the start of the project I knew that I wanted it to line up to produce artwork for this book. So I put onto the group one restriction: the character had to be a 2D/3D character. At first I worried that forcing a restriction like that would hamper the creative process or it would be forced onto the story with no reason. The rules the team came up for the use of 2D and 3D was this: organic = 2D, nonorganic = 3D. I thought this was an interesting concept. We'll take a look at a sequence that exemplifies those rules and the 2D/3D process.

JAGUAR MCGUIRE: CAPE ON FIRE SEQUENCE

The short group project film that we came up with for 2009 is titled *Jaguar McGuire.* It is a story about a conflict between a cat and his owner. The cat owner is none other than Jaguar McGuire, who, the audience finds out in the opening shot, is a daredevil. They also realize quickly that he must have had bad fortune in his career as he is in a body cast. The second shot shows Jaguar looking longingly at his cape and seemingly reminiscing over his career, which, as a newspaper headline reminds him, is definitely over. Just as we are feeling sorry for poor Jaguar McGuire, we realize that his troubles are far from over as we hear the first of many hundreds of meows that come from his cat. This troubled cat owner's cat still requires the things that cats need. How will Jaguar quell the meowing? What ensues is a physical comedy that is sure to have you laughing.

During the struggles, there is a sequence where the cat climbs on top of Jaguar's body cast. Jaguar has one free leg and tries to kick the cat off. Unfortunately, the cat jumps off just before the leg connects and instead of kicking the cat, Jaguar kicks his own injured leg out of the sling. The momentum propels his leg off the side of the bed and knocks over his table, which launches a vase of water (in slow motion) through the air. The vase crashes and short-circuits an electrical outlet. The sparks, sadly, catch the hem of the cape on fire. Jaguar watches in helpless horror as the flames burst up the length of the cape. Being a daredevil, Jaguar believes he can stop the fire and uses his only free foot to try to stomp the flames.

We'll take a look at how the characters came to being in the 2D/3D process for this sequence. Many individuals were involved in the creation of this short animated film. We started with a team of 14 that met weekly in the classroom for 10 weeks and then worked with many more artists outside of the classroom as we continued through production and postproduction.

JAGUAR

Many designs by students were turned in for the main character Jaguar McGuire. Our art director, Jason Walling, compiled different ideas and ultimately came up with the page of design ideas you see in Figure 5.1. The character design allowed for a 2D leg, 2D head, and 2D wiggling toes and thumbs, all else on Jaguar being in a cast is 3D. You'll note that the face and leg are completely encased in bandages. It took some convincing, but we finally came to the agreement that at least the leg would not be covered in bandages. The reason for minimizing the bandages is that 2D bandages are incredibly hard to keep up with when animating, and the cleanup on them would make it difficult to manage quality control. Anyone who has gone through 2D animation classes has probably heard the evils of stripes, long flowing hair, prints on clothing, complicated ribbon work, and the like. All of these items can contribute to a more complex cleanup line, which if not managed well can cause strobing, jiggle, or otherwise distract from the animation. The bandages on the face stayed, because those were important to keep up the high level of frustration needed throughout the film.

Our director, Clint Donaldson, took the concept and began working on ideas of how the 2D and 3D would work together. In

FIGURE 5.1 *Jaguar McGuire* character design by Jason Walling.

Figure 5.2, you see a visual target created by Clint that is our first depiction of a 2D Jaguar body inside of a 3D cast. From the very beginning, the idea of a 3D cast that was simply immovable backed our story of this trapped stuntman. It fit the story and I was pleased that the restriction I originally gave did not end up feeling like it was retrofitted into the story.

For the first 10 weeks of production we had a class of 14 individuals. Many were tasked with modeling and texturing. The 3D

FIGURE 5.2 Jaguar McGuire's 2D/3D visual target by Clint Donaldson.

cast rig was created along with a 3D version of the head and leg to be used as reference for the 2D animation. Figure 5.3a is a shot of the room with Jaguar's prone body on the bed. Because this was a production pipeline with many individuals involved, we utilized the reference concept for everything. The model and the rig file were all referenced into the main blocked Maya scenes. This way the scenes could be pushed through the pipeline before the models or rigs were completed. As the modelers finished the higher-resolution versions of the models, they updated the reference files. Then as the riggers finished rigging the files, those were updated. From the animator's point of view, they animated a block version of the character in a block room one day and as the

production went along the room they referenced in became more high resolution and filled out until it was a completed room ready to render.

FIGURE 5.3a Jaguar McGuire 3D model. Head and leg are 2D reference stand-ins.

The animation was completed in Maya. The animators chose to animate the 3D stands-ins completely to better visualize the animation. Figure 5.3a shows keyframes of the 3D animation including the stand-in leg. The stand-in for the head is a low-res version. This was the rig that was pushed through earlier on in production. Later on in the production, a higher-res 3D head was developed to allow more perspective help for the 2D animators (Figure 5.3c). This higher-res head was necessary for other shots where we did a crazy zolly shot (a right of passage, according to the artists). A zolly shot on a 2D/3D character, though, is very challenging. Another thing that the higher-res head gave us was the ability to cast shadows on the head and pull those shadows to composite overtop of our 2D character. We'll look at that technique in the chapter on EFX.

The animation was done normally in Maya, creating a character set and setting keyframes as you are used to. Also, the twos.mel script was used to make sure that the animation was on twos. You can see a playblast of the animation of the 3D character in the file **3DLeads2D_3Danim.avi**. This playblast from Maya shows the controls from the rig as well. It was a simple rig, as no deformations were on the cast itself. It was debated whether or not to add them. In the end we decided that for comic effect we would try it without any deformations.

Upon completion of the 3D animation, Clint brought the animation into Flash to rough out the 2D animation. Clint and Jason, the two directors of the group project, preferred creating their rough 2D animation in Flash because it is easier to set up keyframes in the timeline and adjust timing. They were not familiar

FIGURE 5.3b Jaguar McGuire's 3D low-res head referenced into the animator's scene.

FIGURE 5.3c Jaguar McGuire's 3D high-res head referenced into the animator's scene.

with animating in Photoshop. They also liked working with the timelines and being able to adjust the timing of their 2D easily by moving keyframes in Flash. You can open the Flash file to see the layering used and the rough 2D animation drawn overtop of the 3D in the file **Shot41-43_2DRough.fla**, found in the companion data. This is the sequence animated by Clint Donaldson.

FIGURE 5.4 2D rough animation drawn in Flash.

Not all animators in the group project were able to do both the 2D and the 3D animation. Clint and Jason both were able to, and they handled the total animation of each of their shots. The cleanup, originally, was to be handed off to our team of volunteer cleanup artists. Using the standard round brush inside of Photoshop, they were to complete the cleanup pass of the character. However, it was found that the animators had fairly clean lines in their animation. Most of the cleanup was completed in Flash with a very small brush.

JAGUAR'S NECK BRACE

There was much discussion early on about whether or not we would break our rule of "organic is 2D" with the neck brace. Clint and I pushed for a 2D neck brace, thinking it would be easier to animate that way. I also believed that it might make for an easier contact point between the 2D and the 3D. To our art director's credit, Jason did not think we were correct and did a test to show us that a 3D neck brace would work just fine. He animated shot 9 with a 3D neck brace. The neck brace had a simple lattice deformer on it, and it worked just fine. In fact, since we rarely see the neck of the character, the 2D head can mostly be composited on top of the character with few registration issues. We all had to agree that Jason was correct. The test proved it.

Figure 5.5 shows how the 3D neck brace moves along with the high red 3D head. A playblast of scene 9's 3D is in the companion data: **3DLeads2D_3Danim_shot9.avi**.

FIGURE 5.5 Shot 9 of Jaguar McGuire and his 3D neck brace animated by Jason Walling, our art director.

The 3D animation was then brought into Flash where the rough 2D animation head was placed. The high-res version of the head in Maya helped the animator with perspective on the face and ears. When combining 2D with a 3D shot, it is extremely important that the 2D follow perspective as much as possible. Otherwise there would be a visual mismatch that would detract from the animation.

The Flash file for this rough animation scene is in the companion data for you to view: 3DLeads2D_2DAnim_shot9.fla.

The scene was cleaned up in Flash using a very small brush. Then the scene was ready for final composite.

FIGURE 5.6 Shot 9 of Jaguar McGuire's 2D head, animated in Flash by Jason Walling, our art director.

FIGURE 5.7 Cleanup draw in Flash, by Jason Walling, 2009, SCAD group project.

YOUR SHOT 4

Now it is your turn to take a shot from the project. You have been issued shot 4. This is a reaction shot of Jaguar. He has been looking at his cape and cards and the newspaper headline that pronounces his career over. Just as he sighs, a deep sad groan, his nostalgic lamenting is interrupted by his cat's meow.

3D ANIMATION LEADS

Start by opening the Maya file **Shot4_Blocked.mb**. If your project is not set, Maya will automatically call in the referenced

rig file **jaguar_bodyCast_v2.mb**. If Maya cannot find it, you will be prompted to browse for the file. Once the file is loaded into Maya, you can switch views to display the animated camera for this scene, **camera1**. To do this, in the panel window click **Panels > Perspective > Camera 1**.

FIGURE 5.8 Blocked in Maya, this file was opened and viewed through an animated camera.

The animation for the head has been blocked in already for you. The scene is **100 frames** long. The frame rate is **24 frames per second (fps)**. Our camera rendering settings are **HD720**. You will note that the blocked-in animation was not placed on the rig controls but on the head itself. Select the head so that it turns green, and you will be able to see the keyframes in the timeline. This is normally naughty rigging. In rigging classes, I teach the students to lock down all geometry so that the controls are the only thing that can be animated. Rigging this way keeps novice animators from breaking the rig easily. However, in a small group project like this one, where most of us were familiar in the outliner, we broke convention and animated the geometry. In larger group projects or when the team issues scenes to animators who are not familiar with the rig (like you), this convention could cause confusion. In many scenes throughout the film, we had to break the rig to get the posing we needed. This is entirely to be expected in settings outside of a sterile classroom. Do what you need to do to ensure that the shot is completed on time, but do not cause more issues for others down pipeline from you. Because you are being issued this scene, please note that there is no character set on Jaguar, and the head geometry has been animated.

FIGURE 5.9 Animation is on the geometry—naughty rigging.

The camera has been animated, which will likely be the case in a production environment. You are to animate the 3D character. Those who have worked in production know this to be the case; for students, this might be a new concept.

The neck brace is not rigged. You can select on it directly and rotate it as you see fit for your animation. Those who take my rigging courses know that this bothers me to the core of my being. Make a note: these students did not take my rigging class and we'll live with the unclean implications. In a perfect world, we would have a completely locked down rig with controls in place. Breaking the rig on a shot-by-shot basis is one thing, but having a part of the rig that should have controls to be animated in every shot is another. It is simple animation for the brace, so we can animate the geometry.

FIGURE 5.10 The neck brace can be animated directly by moving geometry.

When you have completed your animation, do not forget to run the **twos.mel** script by typing **twos** in the command line. This will put your animation on twos for you, and in this scene there shouldn't be a need to change it to ones unless you feel you need to when the character quickly turns to find the source of the meow.

RENDER 3D REFERENCE IMAGES

Save your project and render out a sequence of images to bring into the 2D package of your choice. There is no need to render out render passes in this scene because the head only needs to be composited right on top of the body. This is an easy registration scene. However, if it will make your registration a little bit easier, we can render out the head on a separate level so that when you are drawing in your 2D package you can hide the head and only see the body level. This will allow you to see if you truly have proper registration.

Create render layers as we did in Chapter 3 for the head and the body:

1. Click on the body; it should turn green.
2. In the Render Layer window, select **Layers > Create Layers from Selected**.
3. Label the layer **RLBody**.
4. Repeat for the head.

FIGURE 5.11 Render layers for the body and head.

Remember the settings that you need to have in order to render layers:

1. You have to tell Maya to render all of the layers in the Render Layer area by clicking **Options > Render All Layers**.
2. Make sure that your render settings have the following:
 a. Correct naming and file extension
 b. Correct frame range and padding
 c. Camera1 selected and alpha channel
 d. HD720 resolution

> **Take Note**
>
> Watch out. I would prefer to use .tifs or tgas for the whole process, because that has been the image of choice in production. However, with our Adobe software there will be issues. For the final render, you can use tga or .tifs when we composite into After Effects. To use them in Flash or Photoshop, we have to convert the .tifs or tgas into a raw QuickTime movie file to retain the alpha channels.

What would happen if we used .tif images and skipped making them into a QuickTime movie file? Glad you asked, because I did use .tif images and when I brought them into Flash they read in as an astronomically huge file that I could not see. If you try to use a tga, it will open correctly but without the alpha channel. Both image types opened well enough in Photoshop as a single image (which we have seen before), but they will not open with their alpha channels when brought in as a video layer. Abandon your ideas of .tif images here, sadly. We must add the extra step of converting to a QuickTime file.

1. Then click Render > Batch Render.
2. Your images will be placed inside of folders with names matching your render layer names.
3. In the package of your choice, convert those .tif or tga images to a QuickTime movie file. I will use After Effects. As we have done before, drag your images into After Effects and create a composition with the proper frame rate. To check if your alpha channel is there (please check, this will save you the headache of having to come back and redo this), click on the **Show Channel** icon and select **Alpha**. You should see a black-and-white image that matches the shape of the object in your image. If you only see white, you have no alpha channel. Go back to step 2 and make sure you are not using jpgs or some other image format that does not support alpha channels. I'll wait for you right here until you get back.
4. Once you are sure that you have alpha channels, export the images as a QuickTime movie with the compression set at Animation. This will basically be a movie of full-res images that contain alpha.
5. Repeat for the head layer.

2D ANIMATION FOLLOWS

In today's project, we will do our 2D rough animation in Flash. Create a new document with the following dimensions: **1280 × 720, 24 fps**.

We will bring the reference images into the timeline.

1. Go to **File > Import > Import Video**, and select the body level movie file.
2. In the options, make sure to choose the following:
 a. Deployment > Embed video in SWF and play in timeline
 b. Encode > Video > Encode alpha channel
3. Repeat for the head reference layer.

DRAWING IN FLASH

Insert a new layer above your video layers and choose the pencil or brush tool to draw in. The shots with rough animation shown in Figure 5.12 were drawn using the brush tool in Flash. You can see in Figure 5.12 that using the brush tool still creates a vector line; the outline of the brush is vector. The brush tool works with tablet pressure sensitivity as well.

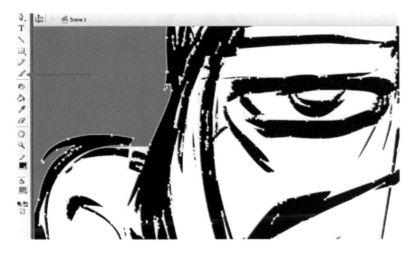

FIGURE 5.12 Rough animation using brush tool in Flash.

For those new to drawing in Flash and the concepts of keyframes, here are a few tips: lock all layers that you are not currently drawing on. If you don't, you might accidentally draw on layers that you do not wish to. Also, you can drag and drop keyframes on the timeline; but beware, you can accidentally duplicate keyframes and cause a messy timeline. Refer to Figure 5.13 for the following explanations:

1. The current time is indicated by a red bar.
2. A blank keyframe, where nothing is drawn, is indicated by a white block with an empty circle. You can right-click on the timeline to insert a blank keyframe or use the hotkey **F7**. Once

you have a blank keyframe, or a blank piece of paper, you can begin to draw your key; the circle will fill in and the keyframe will turn gray.

3. To create a keyframe that also has a copy of the previous drawing on it, use the hotkey **F6**.

4. To extend a keyframe by holding it longer, use the hotkey **F5**. The end of a hold is indicated by a gray rectangle on the timeline.

FIGURE 5.13 Using the timeline in Flash.

When you have completed your rough animation, you will want to export those images so that they can be brought into the cleanup package of your choice. For our production Jaguar McGuire, we debated on using Toon Boom or Photoshop. In the end, because of its familiarity and to enable students to work on projects at home, we chose Flash for most scenes. By now you should already be thinking of the next step. If we need the alpha channel, can we output a series of .tifs or tgas? We'll export a QuickTime file:

1. Delete all but the rough head animation levels. Even if you hide layers, they will export.

2. Choose **File > Export > Export Movie**.

3. Give it a name, choose **Quicktime Movie**, and click **Save**.

4. In the export settings, make sure that the image size is correct.

5. If you want an **alpha channel**, make sure that **Ignore stage color (generate alpha channel)** is clicked on.

6. Click **Quicktime Settings ...**.

7. Make sure that the compression settings are for **Animation**, and that the frame rate is correct.

8. Then click **Export**.

It is always good to be paranoid when exporting images and always double-check that they exported what you wanted them to. All too often you get five steps down the pipeline only to realize

FIGURE 5.14a Exporting rough animation from Flash.

you have exported completely blank images or images from the wrong camera. It is also good to check if alpha channels are present and if the images are the correct size. While testing this chapter, I was happily following along until I realized that my images were not exporting out at the correct size from Flash. This is very sad. Then I remembered that the same thing happened during a 24-hour art challenge where I did a 2D/3D shot, and at 5 in the morning my brain could not process why my 2D image (which was drawn in Flash) was not lining up with the 3D image. Now I see why. When you export a simple line drawing from Flash, even though your export settings are the correct size, it will crop to the smallest rectangle that will encompass your image. That can be quite a shock. A way around this is to place a bounding rectangle around your canvas that is just at the cutoff size. If you make it a guide layer, it will not render. This will ensure a proper export. Warning: If the box is bigger than the output file size should be, you may have registration issues in your compositing software.

CLEANUP IN PHOTOSHOP

The easiest way to open a QuickTime movie into a video layer and make sure that the file size is the correct dimension is to simply go to **File > Open** and open the movie file you exported out of Flash. This will open the QuickTime file into a video layer and give you a document that is the correct size and bit depth. Watch out for your document's playback settings, however. During

FIGURE 5.14b Placing an outline in Flash to ensure an export of the proper canvas size.

testing, our frame rate had to be changed manually. You can see in Figure 5.15 where the frame rate is incorrect.

Add an extra video layer and use the brush that you wish to draw in your cleanup line, as we have in previous chapters. When you are done, export your video layer for final compositing.

MORE ON TOON LINES

We haven't looked at toon lines in a while, and you were promised more. Let's take a look at some more features of toon line. What if you wanted a scratchy, non-pencil-like line? Let's use our shot 4 scene and test out some paint effects toon lines.

Open the **Shot4_Blocked.mb** file or the file you have just animated. Select the body cast and neck brace and apply a new toon shader by clicking on **Toon > Assign Outline > Add New Toon Outline**. Now a toon line is applied to your character and you can see it in the main viewport. Next we want to work with the paint effects brushes and apply them to the toon outline. Some of these become heavy to render in the viewport; you might have to turn off **Display in Viewport** in the attribute editor. Other paint effects brushes do not display well and are only appreciated when ren-

FIGURE 5.15 Using rough animation in Photoshop for cleanup.

FIGURE 5.16 Cleaned-up animation in Photoshop.

dered. To begin with, open the visor window by clicking **Paint Effects > Get Brush**:

1. Select the **pfxToon1** toon line node in the outliner.
2. Select a brush in the visor window > Paint effects tab. In Figure 5.17, the **Toon > ThickOilLine** brush has been selected.

3. To apply the brush to the toon line, click **Toon > Assign Paint Effects Brush to Toon Lines**.

You can see in the viewport shown in Figure 5.17 that the paint effects toon line is visible. Figure 5.18 is a render of the toon line composited with the rough animation.

FIGURE 5.17 Applying the paint effects brush to toon line.

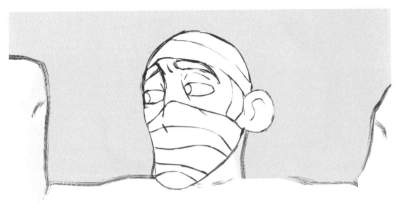

FIGURE 5.18 Composite of 3D with a 2D head.

You can use the brushes with the default settings such as you see in Figure 5.19. Here the **Oils > dryOilRed** has been applied to the toon line.

FIGURE 5.19 DryOilRed Paint Effects brush.

Or you can select the brush in the Attribute Editor and adjust the settings for more control. In Figure 5.20, the paint effects brush **Oils > thickOilRed** was applied to the toon line. As you can see in the image, the brush type was set to Thin Line, MutliStreaks was set to 2, and Streak Spreads was adjusted. Give yourself time to work with these attributes, as it takes time to become familiar with them. When you first begin to work with pain effects and toon lines, take screen grabs of the settings you have adjusted and the renders you come up with. These can help you navigate through good and bad adjustments.

FIGURE 5.20 ThickOilRed Paint Effects brush.

Don't overlook nontraditional sounding paint effects brushes. You will be surprised by what you can use. In Figure 5.21 I took a chance and used an intestinal flow paint effects brush.

FIGURE 5.21 Intestinal flow paint effects brush.

PROJECT: 3D LEADS 2D

Due: _____

For this chapter's project, you have two tasks:

Analytical

Take a critical look at a film of your choice on which the animators could have done a better job at combining their 2D and 3D elements. What is wrong with the combination? What could have been better? Include screen shots in your report to visually highlight the issues.

You are assessed on the following skills:

1. Depth of analysis
2. Use of visual aids
3. Use of 2D/3D glossary terms
4. Understanding of 2D/3D techniques and their application

Practical

Create a scene of a 3D character with 2D parts. Complete either the Jaguar McGuire scene or one of your own. The scene should be short enough to finish in two weeks time. The scene should be turned in at the final composite stage.

You are assessed on the following skills:

1. Ability to match 2D animation to a 3D character and achieve a cohesive character animation
2. Technical use of 3D application
3. Technical use of 2D application
4. Technical use of the compositing tool
5. Overall appeal of shot
6. Matching of style

STUDENT CONTRIBUTORS

Clint Donaldson
John-Michael Kirkconnell
Jessica Huang
Jessica Toedt
Shani Vargo
Jason Walling

MARTY ALTMAN

Former CGI Technical Director, Walt Disney
 Feature Animation
Currently Chief Creative Officer, Louisiana
 Immersive Technologies Enterprise

The convergence of all things "digital media," the ever-growing demand for content, and in particular shrinking budgets and time frames means the mixing of approaches and techniques is becoming more prevalent. Progressively more examples appear almost every day now, but this trend started years ago. Some specific examples of hybrid approaches from the not-too-distant past help tell this story.

The palace crowd element in Disney's animated feature film *Mulan* was an interesting mix of 2D and 3D approaches. We utilized a slightly modified version of the proprietary crowd simulation, which was used for the wildebeest stampede on *Lion King*, the crowds on *Hunchback of Notre Dame*, the whales on *Pines of Rome* in *Fantasia 2000*, as well as the hun charge on *Mulan*. We also used a modified version of the editor written for the hun charge. The simulation placed the characters in 3D, and behaviors were simulated as before. The editor was a 3D application with certain 2D capabilities.

The 2D approach really came in with the palace crowd characters themselves. All the crowd behaviors, both cycles and transitions, were traditionally animated characters converted over to an interesting system of animated textures and mapped onto individual polygons. Colors for some portions of the textures, in this case skin tone and hair color, were locked. Other portions of the textures, such as clothing, used a false-color technique and art-directed color palettes to increase perceived variety.

This hybrid approach not only matched the traditional style of the film but provided a wide range of usefulness for the characters—they could appear full screen as could any other animated character in the film, and the same system could place 30,000 characters in a single scene. While still a good bit of work to traditionally animate the crowd characters, a pure 3D approach would have taken significantly more calendar time to meet those same requirements. If pure 3D had been the only option, we likely would have lost the palace crowd element due to budget and time constraints.

The Pooh's Hunny Hut attraction at Tokyo Disneyland provides examples of integration issues going beyond just 2D and

3D, because of the practical aspects needed for a theme park attraction. One involves traditional painted backgrounds, a 2D character (Tigger) bouncing across three large screens, and a swarm of 3D characters (bees). It also has a big multiplane camera move incorporating both the projected artwork and several levels of practical elements placed between the viewers and the screens. For the multiplane shot to succeed, all these levels have to work together.

Another Hunny Hut example makes use of projection onto a half-silvered mirror, so viewers see themselves with a 3D character. Several issues made this challenging. A special projector was shipped straight from the factory to Tokyo, so we never had the chance to test our imagery directly and instead had to make adjustments based on phone conversations with the Imagineers in Tokyo looking at the screen. The heffalump is a semitransparent 3D character that fills up with semitransparent honey, and since the projector was fed with an NTSC source, we had to anticipate color issues. Of course, the heffalump's primary color was red (arguably NTSC's least favorite color).

The short time frame and increased logistical issues required a different thought process. The heffalump element was broken down into several more rendered levels than would ordinarily be used, to provide maximum flexibility for controlling the final look in the composite. We also borrowed a bracketing technique from traditional photography to further cut down the need to go back and forth between Orlando and Tokyo to resolve the final version. A comment like "a third of the way between number 2 and number 3" meant one tweak of the parameters in the composite and we were done.

The convergence of animation, film, visual effects, broadcast, games, web and interactive, and other related industries is leading us to a place where the true power user not only prefers to have many tools in his toolbox but also has an insatiable need to learn more. The rationale is straightforward. The more tools and techniques you have at your disposal, the better your chances of seeing connections that lead to higher aesthetic quality, or to greater efficiencies, or both. Better quality gets you noticed and is always good. Efficiency, as in getting the job done on time and within budget, helps ensure you get the next call.

EFX

Melting Man, by Troy Gustafson.

LECTURE NOTES

In the previous chapter, we discussed 3D characters with 2D parts. One of the examples we talked about was goo on a three-headed hydra. For this chapter, let's take a look at the art of special effects (EFX). It is a worthy topic that is more than often left out of animation discussions.

When training the different departments in feature animation studios, I found that the EFX team was composed of odd, quirky individuals, more so than the other departments. In a building of more than 150 artists, who are normally slightly odd and fun loving, these individuals looked at things completely differently than the character animators. Where character animators look at the body mechanics and acting as a whole large unit, the EFX animators look at the subcomponents of the character. EFX animators look at the self-cast shadows on the body, the highlights from a key light, water dripping down the hair, goo (if any), inci-

DOI: 10.1016/B978-0-240-81205-2.00006-6

dental props, and the like. In other words, they see the world completely differently than do character animators, and in my opinion they are underappreciated and lack appropriate representation in animation tombs. Of course, that is understandable, as few EFX animators have written anything, although a few books have been published on the subject. We will not be able to do the topic justice here. We will only be able to gain an overview and apply it toward our 2D/3D adventure.

> **Dig Deeper**
> If you want to dig deeper into the topic of traditional EFX, read Joe Gilland's book *Elemental Magic: The Art of Special Effects Animation.*

FIGURE 6.1 EFX example by Joe Gilland in his book *Elemental Magic, The Art of Special Effects Animation.*

Let's try to categorize the types of EFX elements to give you a better understanding of what to look for in your scenes. The constant rule throughout all EFX elements is that usually these are nonacting, or noncharacter, elements in the story. However, there are exceptions to that rule, which we will discuss later on in this chapter. When discussing this topic with many individuals, we have come up with the following categories for EFX animation and example elements:

1. Solid shapes
 a. Props with contact points: leading the character or led by the character
 b. Moving manmade objects without contact points to a character
 c. Moving organics: trees, flowers, rocks
2. Abstract shapes
 a. Liquid: flowing, contained, drops, or streams
 b. Fire: small, large, linear, billowing
 c. Smoke/vapors: linear, billowing, wispy
 d. Wind/weather: rain, snow (while in the air)
 e. Earth particulates: dust
 f. Magic/sparkles
3. Light
 a. Highlights
 b. Shadows
 c. Tones

No matter how you dissect the subparts of EFX elements, there are at least two separate groupings: a solid shape group and an abstract shape group. Solid shapes are, if you remember your science class, solids. They have definite form and shape and can usually be broken down into smaller shapes. The abstract category includes liquids, gases, and plasmas. We define them as abstract because the shapes they form, when drawn, include a certain level of design that is inspired by nature but does not mimic it exactly. There are those who prefer to animate the solid shapes and those who prefer to animate the abstract shapes. For either category, 3D tools, particle systems, fluid simulators, and procedural shaders have been designed to aid in the creation of these EFX. The third category, light, could arguably be placed under either the solid or abstract category based on the property of light being observed. The thing to note is that in EFX, we are thinking of the shape of visible light or the absence of it. We are not looking at light as in 3D lighting and rendering. We'll look at each of these categories more in depth.

SOLID SHAPES

In our listing of solid shapes, our first item is props with contact points. These are things that the character moves (coffee cups, cigars, pipes, forks, newspapers, etc.) or things that move the character (bicycles, cars, spaceships, etc.). The second listing is objects that move but have no contact point to the character. This can include just about anything you see in an environment that is man made: trash, road signs, garden gnomes, and wind wheels. The next category is moving organic objects such as trees, flowers,

FIGURE 6.2 3D BMX bicycle modeled by Jeff Dutton and Michael Spokas.

and grass. Depending on animation style, the amount of movement to these items may be kept at a minimum because it can be extremely time consuming to create this movement, even when done in 3D. Rocks and boulders are in this category because they are solid shapes that can fall and react to gravity. If we must continue to categorize, you would want to include ice and glaciers into this category as well, because they are solid in shape.

ABSTRACT SHAPES

In calling these elements abstract, we do not mean that their shape or movement is abstract, because there is reason for their form and path of movement. However, as stated earlier, these elements are more able to be designed and are actually a designed form *abstracted* from their observance in nature. Each element—liquid, fire, smoke, wind, earth, magic, and so on—has its own law of movement, reaction to gravity, loss of energy, entropy, and volume that the animator must adequately study in order to reproduce.

FIGURE 6.3 Fire and smoke example, by Troy Gustafson.

LIGHT

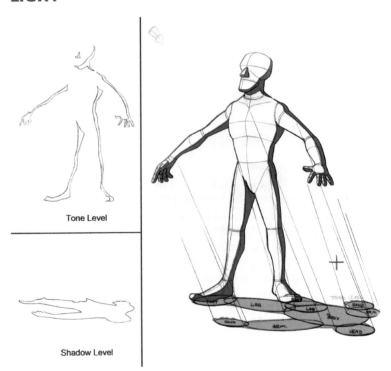

FIGURE 6.4 Tones and shadows on a character, by Troy Gustafson.

In 2D EFX, light must be drawn. It is usually drawn as animated mattes that are used at compositing time to affect the coloring of the character and environment. An artist can also pull animated mattes from a 3D render and use them when compositing to achieve different lighting and shading effects. There are three

visible elements to lights when drawn in this manner. *Highlights* are the bright areas on a character. They are usually caused by a kicker light, or rim light. *Tones* are the darker areas on a character where the light is not illuminating the character. Tones add great depth to a character, especially when combining a 2D character with a 3D character. However, beware: drawing tones on every character in every shot takes a lot of time. During a time crunch, this is usually the first element to be removed. *Shadows* are, obviously, the shadows that a character or object casts upon the environment. All three elements are usually blurred and minimized in movement so that they do not distract from the main action of the story.

EXCEPTIONS

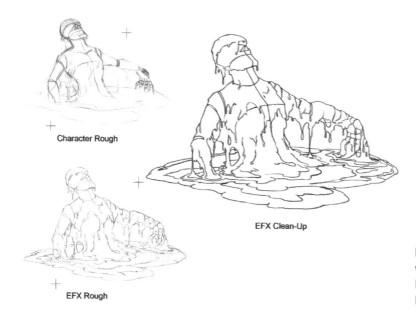

Character Rough

EFX Clean-Up

EFX Rough

FIGURE 6.5 Melting character with rough character level, rough EFX level, and final cleanup EFX level, by Troy Gustafson.

There can be a blurry line between character animation and EFX animation in certain cases. What if the shadow is telling the story? In that case, it is a character and may be taken over by the character animators. What if the character is made of wind or fire? (Think about the element characters in Disney's feature animation *Hercules*.) What do you do with a character who is basically composed of an EFX element? Something like that might be roughly animated by the character animator, and then the EFX animator adds his or her expertise of fire/wind/ice to the animator's expertise of character movement. What if the prop that the character is holding is intricate to the acting? Depending on the

character animator, he or she may rough in the placement of the prop or even animate the complete prop. The EFX animators would do what was needed to finish the prop's animation.

> **Trench Note**
> All of these examples are based on studio culture and the artists found therein. This information is based on the general pattern that I witnessed in the two studios where I have worked. Both studios were large. In smaller studios where individuals have to wear many hats, of course, these ideas can be found to be very different based on the talent found there.

CONTACT POINTS AND PIPELINE

The questions as always are these: Which element leads? Where are the contact points? What media will be used?

Usually the prop animation is the first one to be considered. Props either lead the character or are led by the character. As in our earlier discussions, props themselves can become complicated in line mileage and perspective. So using 3D props has become popular.

After considering props, the next factors to consider are the environment and the elements. Most elemental items react to the character; therefore, they follow after the character animation. Even when the environment and elements to do not react to the character, they are still usually done after the character animation so that they do not accidentally obscure the important story points trying to be conveyed in the scene.

The last element that is usually drawn is light. This is the light that is cast upon the characters, props, water, goo, and so on.

> **Trench Note**
> You can imagine that after the character animators are done and having their celebratory "animation is done" parties, EFX artists are still bent over their desks working on the light, props, and abstract shapes that are in the very scenes whose "doneness" is being celebrated. The same can be said for the other departments that follow EFX. These departments are referred to as the "back end" of production. At the Disney studio, these departments were called scene planning, scanning, color models, ink and paint, compositing, and final check. The departments and the breakdown of tasks vary from studio to studio. The takeaway here is that the waterfall of "doneness" is never complete until the wrap party.

Industry Examples

You do not have to look very hard to find plenty of examples of props leading 2D animation: *Futurama, Family Guy, The Simpsons, Lilo and Stitch, Triplets of Belleville, Mulan, Atlantis, Treasure Planet, Sinbad, The Road to El Dorado, Pokemon* movies, *Macross Zero,* and the list goes on and on.

You might have noticed the heavy use of 3D spaceships and environments in *Futurama.* I've had students comment that they did not notice it until taking my class, where they were told to go look. The flat shading and toon shading did not cause the 3D to stand out too much, which we know from Chapter 1 is a sign of success. Other examples that students have commented on include the obvious use in the *Family Guy* movie, *Clone Wars.*

Other films have used 3D and you might not have even noticed. *Mulan,* for instance, used a large amount of 3D for both character and EFX. One complicated shot comes to mind where Mushu is looking for Mulan while riding a shield down a 2D avalanche. The background was a traditional painting. The snow avalanche was done in 2D. In this case, the 2D EFX avalanche was leading, so an animated grid was created to help with the perspective of the sloshing snow. A 3D shield holding a 3D reference Mushu was also created. The 3D shield was the only 3D element that was to be used in the final composite; all else was reference. The Mushu character was so small for some of the shot that they kept the 3D stand-in for that section, much to the happiness of the 3D animator. The 2D avalanche was added along with snow chunks, snow particulates, tones, shadows, and a Hun head. This scene itself was extremely challenging because it contained a traveling pan across so much 2D snow, and this was done before we had Cintiq tablets. Lacking a way to do digital 2D animation meant that a printing/pegging process had to occur so that the 2D animators could use the 3D reference. Because this was a large camera pan, the paper that was used for printing was extremely large: 24 fields, the printing/pegging days. Come to think of it, wouldn't that be a great shot to re-create as a homework assignment? Note to self: maybe for the advanced version of this class.

Using 3D for props and environments, if not having contact with the 2D character, is relatively easy, and therefore the use of 3D props is widespread. As we have found, once the different elements begin interacting, things take on a bit more complexity. The trick when combining the 3D prop with the 2D character is making sure that their dimensionality matches. Either the 3D prop needs to be flattened visually to match the 2D, or the 2D needs to be made more rounded by using tones and highlights to match the 3D. If the 2D appears to be very flat and the 3D appears very highly rendered and round, the styles may clash

considerably. In the last chapter's assignment you may have already found some of your own examples of good and bad 2D/3D that might show this style mishmash.

Using 2D animated EFX on top of 3D usually would not seem cohesive if the style were a highly rendered 3D look. However, if the visual style is flat or toonish, then 2D EFX elements can be used. We examined the goo used on the hydra's head in the previous chapter. We also took a look at shots from the group project *Jaguar McGuire*. Next we will examine a few shots that had 3D props, 2D EFX elements, and some interaction between both.

Hands-on Examples

We will now examine five EFX issues that might need to be resolved in a 2D/3D film:

1. 3D props leading 2D
2. 2D leading 3D
3. Tones
4. Shadows
5. Compositing tricks with ink lines

3D Prop Leading 2D

In previous shots, Jaguar McGuire has tried to kick the cat as it sat on his broken leg. Instead of connecting with the cat, Jaguar instead kicks his own broken leg, which propels it out of its sling and it hits a nearby table, sending a vase filled with flowers through the air (in slow motion). Please visit Chapter 6 in the Gallery section at www.hybridanimation.com for the storyboard displaying the following sequence. Our shot, 39, shows the vase of flowers hitting the floor. Upon hitting the floor, the flowers and water splash out. The water, unfortunately, splashes into an electrical outlet. The outlet short-circuits and shoots a fiery spark to land on Jaguar McGuire's cape. The cape must be old and dry, or soaked in kerosene, for it instantly bursts into flames. Jaguar, being a super daredevil and still believing himself inhuman, tries to stamp out the fire with his free foot.

The elements in shots 38 and 39 are listed here, along with the software that was used to create them:

3D Background	Maya
3D Vase	Maya
2D Water	Photoshop
2D Flowers	Photoshop
2D Spark	Photoshop
2D Fire	Flash and Photoshop
Ink and paint	Toon Boom
Final compositing	Toon Boom

vase

water

flowers

Temp background

FIGURE 6.6 Elements from shot 38: temporary 3D background, 3D vase reference, 2D water, and 2D flowers.

The pipeline for 3D prop leading 2D is the same as a 3D character with 2D parts. This should begin to be familiar now.

Begin by setting up your camera in the 3D package of your choice and animating the 3D prop. In the example shown in Figure 6.7, you see the camera placed in the 3D room and the keyframes of a 3D vase. This is the shot we were discussing earlier in the industry section of the lecture notes. Clint Donaldson, the director of *Jaguar McGuire*, did the animation of the 3D vase.

In this example, the render size is HD720, which has a pixel size of 1280 × 720 in Maya's render settings. Because we are only rendering out a reference image for the 2D animator, we can simplify things by rendering out the vase layer only. Also, the alpha channel is not necessarily needed here. We can add a gray background to the camera's environment setting so that we do not get a black background.

To set the background to be gray for this reference render, follow these steps:

FIGURE 6.7 Perspective camera viewing animated vase keyframes and render camera viewing animation.

1. In the rendering camera's viewport, click **View > Camera Attributed Editor ...**. This opens the Attribute Editor for the camera.
2. Open the **environment** tab and change the **Background Color** to the desired color.
3. Render a series of images as usual. Remember to select the rendering camera. If you need the alpha channel, then remember to select it, and as we have learned, to keep that alpha channel you will need to create a QuickTime animation compression file. For this example, we do not need the alpha channel, so we will stay with a series of .tif files.

A quick check in Adobe Bridge shows us that the images are rendered correctly: from the right camera, named with frame padding (leading zeros), correct background color, and correct version of animation. We've already talked about it before, but I cannot stress enough that it is a great timesaver to check your renders before proceeding. It is an even better work habit to do a spot check on one frame before kicking off a render that might take a long time. Once you lose a couple of hours worth of time to a silly oversight, you'll start developing "rules you should live by" too. You can share those with us on the website at www. hybridanimation.com. (We haven't spoken about it in a whole chapter!)

The render mentioned previously has been included in the chapter companion for this book. Look inside the folder: **Chapter Six > 3D leads 2D > vase**.

2D Animation in Photoshop

Open your .tifseries of images in Photoshop by clicking **File > Open** Select the first image of the sequence and click on image sequence. Don't forget to set the correct frame rate.

This will automatically create a canvas with the correct image size and load the image sequence into a video layer.

FIGURE 6.8 A reference loaded in as a video layer in Photoshop.

As we have done before, you will want to create a video layer to draw your EFX layers in. We have many EFX elements to draw in this shot: water, flowers, sparks, and flying copper bits. We'll start with the flowers. If you remember back to our lecture at the beginning of the chapter, flowers would come under our solid shapes category.

In Figure 6.9, the vase reference layer is in the bottom layer position. A flower animation layer is also visible. As a note to my students, notice that the flowers are extremely roughed in. This is a great way to animate through your shot quickly so that you can test out various versions or, as was the case with this example, get the animation supervisor's feedback and approval. A great guideline is to work rough and fast; show early; show often.

All of the flowers were created on one video layer. Was this a great idea? Remember that the video layers will be exported out for ink and paint and compositing. If all of the flowers are on one layer, that makes for one sequence of images that will be inked and painted. It might make inking and painting easier to have the

FIGURE 6.9 Rough pass of a flower animation.

flowers all on one layer, but that makes it more difficult for the animator to keep track of the stems. Animating using video layers sometimes causes bad habits of putting elements all in one layer. It is quite common for elements to appear on one layer and then move to another layer so that they have proper leveling. Ultimately, do what is right to get the proper animation, but keep in mind how the leveling is going to happen during compositing. Keep those x-sheets handy. As you gain more experience with creating shots, you'll start to see how to break apart the levels.

Once the flower's rough animation was approved, a more polished version of the animation was completed.

FIGURE 6.10 Final animation of flowers.

A special note on animating in Photoshop: in shot 39, the timing of the vase movement was worked out in Maya, and that dictated the main movement of the 2D flower and water elements. The water element was easy enough to animate in Photoshop because it was mostly animated straight ahead. Animating pose to pose in Photoshop is difficult when using video layers. It can be done, or the animator can choose to use the older method of animating in Photoshop: using the frame method versus using video layers. Why is it difficult to animate using video layers? When there is a keyframe on frames 1 and 7 and you want to create a breakdown on frame 5, all of the other blank frames on the video layer get in the way of rolling through your animation (see Figure 6.7). For animators that like to flip back and forth between the drawings instead of using the onion skinning, the blank frames can cause the eye to lose where the previous drawing was. It is still possible, with some duplicating of layers, to use a familiar flipping or rolling method.

The following method can be employed when doing cleanup in Photoshop or animating pose to pose:

1. Draw the first and second keyframes in a video layer, as we learned in previous chapters.
2. Duplicate the layer.
3. In the timeline, open the layer and notice the blue boxes on the altered video line. You cannot move these keyframes (drawings), but you can move the duplicate layer itself so that the keyframes line up where you want them visible.
4. Repeat as needed so that you can see your keys in the correct order to roll or flip the images as desired while you draw the needed breakdown drawing.
5. When you are done, delete the duplicate layer(s).

In Figure 6.11, three flower keyframes have been drawn. The layer has been duplicated and moved so that the two keyframes show up at the same time. In order to roll the drawings, the duplicate would be moved back one frame in time.

To flip or roll images has a different definition based on what studio/country one is in. In some U.S. studios, to flip images means the animators stack their papers in such a way as to look at the first key, look at the breakdown that they are currently drawing on, and then flip back a page to the second key. It is called flip because you end up flipping forward and backward to see the motion. To roll, in the United States, is to stack the papers in order and to roll through the frames with the first key on the bottom, the breakdown on top of that, and the second key on top. Depending on one's dexterity, one can roll up to five drawings at once. These terms have to do with paper and what one has to do in order to keep the drawing one is currently adjusting on top for

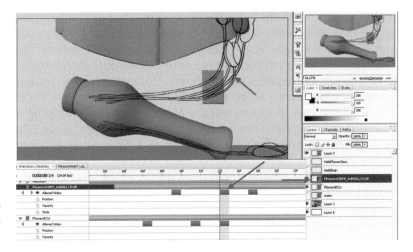

FIGURE 6.11 Using duplicate layers to roll through keyframes without blank inbetweens.

drawing. In our digital animation pipeline, you will mostly be rolling or you might hear the term *scrub* (which comes from the digital editing field). However you manage it or whatever you call it, it is imperative for the pose-to-pose animator and the cleanup artist to have the ability to roll through their drawings without seeing the blank inbetweens.

Another type of EFX element that we discussed was abstract elements. Water can fall into this category because it is purely drawn in as an abstraction of its natural form. Liquid, water, and smoke are all abstract elements. Our shot 39 depicts a vase, filled with water, flying through the air. The vase hits the ground and the water splashes out onto an electrical outlet in the wall. The same method of roughing in the animation with video layers was used. You can see an example of the rough and final animation in Figures 6.12 and 6.13. You'll note that the rough animation is extremely rough, with nothing more than bouncing balls to indicate direction and volume.

FIGURE 6.12 Rough animation of the water in the vase.

FIGURE 6.13 Final animation of the water EFX element.

Ink Lines

Once the animation and cleanup are completed, you will want to add color to your artwork. There are many ways to do it and many different software solutions. Let's look at the things you might want to do with your ink lines before we deal with the button clicking and different software programs.

The first thing we will do is make sure that the ink line stays separate from the paint. Why would we want to have the ink line separate from the paint? We can reuse the ink line in our compositing software to create various visual compositing techniques.

With the ink line separate, you can easily change the color of the ink line if your paint package lets you fill in color and keep alpha channels. In Photoshop this can be done by selecting **Edit > Fill** and making sure that the **Preserve Transparency** option is turned on.

FIGURE 6.14 Using Fill to color ink lines easily.

A simple example of what finesse can be done with ink lines is shown in Figure 6.15. The ink line has been duplicated and blurred. This blurred ink line was clipped (or masked out) by the paint layer. This way the blurring did not extend on the outside of the water, giving the water an unwanted halo. The harsh edges of the blurred ink line are never visible because the original ink line is layered on top of it, as you see in the top portion of Figure 6.15. The paint layer is also transparent, though that is not visible in this image.

Final Water

Ink

Blurred - Clipped Ink

Paint

FIGURE 6.15 Ink line sample.

Figure 6.16 is similar to the previous example, except that there is not the addition of the original ink line on top. The blurred ink line is also colored to be similar to that of the paint. This is a useful technique when combining 2D elements with 3D elements that do not have strong toon lines. Just because there is a drawn line for the 2D element does not mean that it has to stay visible in the final composite.

If you use Photoshop or any painting package in which you use something like a paint bucket tool, a good technique to use for painting is the following:

1. Place the ink line on one layer.
2. Create the paint fill on a second layer.
3. Paint using the paint bucket and brush tools. Don't worry about coloring outside of the lines too much.
4. Using a magic wand tool, select the paint that is outside the lines. In Photoshop, make sure to have **sample all layers** turned on.
5. Delete the extra paint. Touch up any missed areas.

Final

Blurred-Clipped Ink

Blurred Paint

FIGURE 6.16 Ink line sample.

FIGURE 6.17 Creating paint fills on a separate layer in Photoshop.

Node-Based Compositors
Shake

One of my favorite node compositing systems is Shake. I first learned node compositing on Eddie, an old system, and Flame/ Flint. (I barely used them more than a week, so don't be too impressed.) I have used Shake quite a bit and have looked at newer node compositing systems like Nuke and Toxic. Once you know a node-based system, it is fairly easy to pick up another node-based compositor. As we stated earlier, there are two main types of compositing systems: node and layer (timeline) based. I prefer node systems. They seem more organic and fluid for how I work/think. I would encourage you to become familiar with both types of systems. Where you to find yourself in a Visual Effects (VSFX) house as a compositor, you will have to learn proprietary compositing systems; knowing both types will give you a head start on learning how the pros do it.

If you have ever worked in Maya's Hypershade or Hypergraph Connections Editor, then you have worked with node networks.

We'll do this water composite in Shake. I won't go through the Shake interface too much; you can read the documentation for

that. Like most software, the install comes with a manual and plenty of tutorials. Students, please familiarize yourselves with finding answers in the documentation. This is a skill I see lacking in students. (I'm putting the soapbox away.)

If you want to follow along, images can be found in the companion data in **Chapter Six > Ink**.

1. Locate the **image** tab and click on the **File In** button. This will do two things. It will open a window for you to load your images and it will create a File-In node in the node view window.
2. To see the full image (it might come in cropped), you can **right-click** on the image in the **preview window** and select **View > Fit Image to Viewer** (hotkey = **f**).
3. The node shows the first frame of the sequence. In this case, that image is blank. If you double-click on the green bar at the bottom of the node, it previews into the image viewer.
4. Make sure that the image node is selected (it will be green), locate the **Filter** tab, and click on the **Blur** button. This will add a Blur node to the output of the File-in node.
5. In the **Parameters** tab, you can adjust the amount of blur to be used.
6. Locate the **Layer** tab, and click on the **Over (A over B)** button. If you had the blur node selected, it will connect the Blur node to the Over node.
7. We actually do not want the Over node to be connected, we want to do the connections manually. Click and hold on the **Over** node and shake it back and forth. Really, shake it. That breaks the connection and is the reason for the software's name. Programmers are funny individuals.
8. Make the connections.
9. If you click and drag from the bottom of the image's File-in node, you will see a string/connector following your cursor. By dragging that line/string to another node and releasing, you form connections:
 a. Attach the output of the image into the top of the Blur node.
 b. Attach another output of the image to the top left of the Over node (that is, A).
 c. Attach the output of the Blur node to the top right of the Over node (that is, B).
 d. Double-click on the Over node to see the image in the preview window.

The image now has a blurred ink line underneath a nonblurred ink line. There are two things left to do: (1) add the paint, and (2) cut off the blurred line so that it doesn't extend outside of the edges of the ink line:

1. From the **image** tab, click on the **File-In** button and load a series of the paint level. (For this example, the ink and paint lines were done as separate layers in Photoshop and exported out as separate file sequences.)
2. From the **Layer** tab, click on the **Over (A over B)** button to get another Over node.
3. Hook them up:
 a. Hook the output of the first Over node to the A side (top right side) of the second Over node.
 b. Hook the output of the paint layer to the B side (top left side) of the second Over node. This will give you an ink layer composited overtop of the paint layer.
 c. This is the extra fancy step. Hook up the output of the paint layer to the right side of the first Over node. This will read the paint layer as a **matte** and will only show the blurred ink line wherever there is paint. This way the ink line does not blur outside of the lines!

FIGURE 6.18 Adding the paint and containing the blurred line.

Now you have gone through a crash course in node compositing. The great thing about using node systems is that you can reuse series of images easily and hook everything together, if you are prone to thinking this way. Those who aren't should challenge themselves and step up to a higher-end compositing method, if you have access to such software.

TOON BOOM

Toon Boom is a wonderful piece of software, but traditionally it has been expensive. As this book goes to press, the Toon Boom software is going through major changes as the company changes its focus and positioning strategy. The newest version **Toon Boom Animate Pro** ($2000) has node-based compositing. The version used in this book is Toon Boom Studio ($400), the cheapest version of the software and more likely what a student might have.

I have not used Toon Boom much at all. We added it to our classrooms so that the students could gain exposure to it. It has been tested and prodded and put to good use by daring students in their advanced Digital Cel classes. We do not use the auto lip-sync functionality of the software. However, that feature is probably useful for those in a short turnaround, small-budget situation.

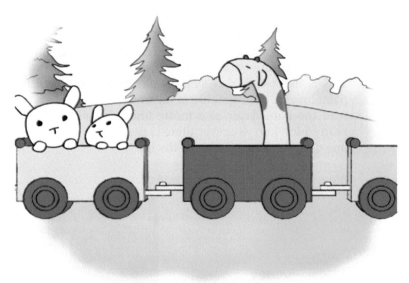

FIGURE 6.19 2D characters drawn in Toon Boom over a 3D train from Maya. By Jessica Huang, 2009, SCAD, 2D/3D Compositing course.

Here is a listing of some websites that can help you get started with the package:

www.toonboomtutorials.com
http://toonboomcartooning.wetpaint.com

Let's cover the basics of bringing some images in that have been animated in Photoshop and also in Flash. First, we'll export out of Photoshop; things should be becoming familiar now. However, each software package you use brings a different set of button clicks, and with each version those button clicks will change. All is based on how the software reads the alpha channels and what file formats the software works with. The more back and forth between multiple software packages that you gain exposure to, the easier time you will have at problem solving these pipeline issues.

Photoshop to Toon Boom

1. Hide all but the layer that you want exported out of Photoshop, and select **File > Render Video**.

2. The options are what we have used previously: QuickTime/ raw (to keep the alpha channel), premultiplied with white for the alpha channel; make sure your frame rate matches and that you have number padding on. Click **Render**.

FIGURE 6.20 Exporting animation from Photoshop.

Note: Before you run ahead and go through the steps of bringing the movie file into After Effects and exporting the image sequence, as usual, you'll need to know one more step for a Photoshop-to-Toon Boom pipeline.

When you open your movie file in After Effects, it normally has a black background when viewed in RGB mode. If you click on alpha channel mode, you can see the alpha channel.

FIGURE 6.21 Alpha channel on the movie clip in After Effects.

However, if you export this as an image sequence and bring it into Toon Boom, the current version will see that black background. This is probably not what you want.

FIGURE 6.22 RGB of the movie clip in After Effects.

You will be as shocked as I was to see a black background, so we must add another step to our exportation of image sequences:

FIGURE 6.23 Black background reads into Toon Boom. Oh my.

3. Bring the QuickTime video into After Effects.
4. Drag it to the Composition icon to create a composition containing the QuickTime video.
5. Click **Composition > Background** and select **WHITE**. This does not affect your alpha channel. When you bring it into Toon Boom (we'll learn how in a moment), it will look correct. We are expecting it to look like the image in Figure 6.24.

FIGURE 6.24 White background reads into Toon Boom just fine.

6. To export out of After Effects, select **File > Export Image Sequence**.

7. Choose the **tga** file format, and uncheck **Insert space before number**. Remember to save the file name with leading zeros.

FIGURE 6.25 Exporting the composition with a white background as an image sequence.

Now you are ready to import your image sequence into Toon Boom:

1. Open a new project in Toon Boom; make sure that the canvas size is correct.

2. Locate the exposure sheet tab at the bottom of the screen. Toon Boom defaults with one drawing level.

In Toon Boom, image and drawing levels are different. Images are imported, nonadjustable levels, like backgrounds; drawings are drawn in the application or scanned-in images that can be vectorized, inked, and painted. See the documentation for more guidance.

3. Right-click on the drawing layer, and select **Import Images > From File ...**.
4. In the file browser window that opens, select the first image and the last image, then click **Open**.
5. This opens a preview window. You have some control over vectorizing images. In the Ink and Paint appendix found on the companion website, we will cover the pros and cons of this vectorizing method.

The images are added to the exposure sheet and visible in the preview area. Do not be scared by the pixilated line. This is a preview. Creating a test of the scene will show the actual line quality. This is all dependent on the vectorization settings in step 5. You may have to go back and repeat until you have found the correct settings. See the Ink and Paint appendix for testing that happened on the group project *Jaguar McGuire*.

FIGURE 6.26 Water drawings in the exposure sheet.

To create the same type of compositing effect in Toon Boom as we did in Shake, we will explore the Toon Boom method of leveling compositing. The next version of Toon Boom has the addition of a node-based compositor.

TOON BOOM PRO

1. Locate the **Timeline** tab. **Right-click** on the ink level and duplicate it twice. Name them Ink2, Ink, and Paint. The Ink 2 level will be the normal ink level that is unblurred. The middle

ink level will be blurred, and what will become the paint level will be on the bottom of the image stack.

2. In Figure 6.48, you see the paint level. The paint bucket tool was used to fill the ink with paint. After painting, the ink line was removed.

3. The middle ink layer is the one that needs to be blurred. Use the selection tool to select all of the ink lines. (This needs to be done per frame.) Select **Tools > Feather Edge**.

4. The settings are familiar to a feather edge in Flash. This is a vector blur as well. For this example, we used a larger number: 5.

5. To see the top ink line on top of the blurred-in line and paint, locate the **auto light table** button (it looks like a light bulb) and click it on. This will show all of the levels together. To 2D animators, this is similar to backlighting your disk.

6. To get rid of the blur outside of the clean ink line, select the edges of the blur and delete as needed. (This needs to be done frame by frame.)

Figure 6.27 is an example of a blur of a smaller value. The inner portion of the water is not covered by the blurred ink line. The final render of the water shows the paint level, blurred ink level, and normal ink level composited together (Figure 6.28).

FIGURE 6.27 Smaller blur value.

FIGURE 6.28 Final composite of water element.

2D LEADING PROP

Another area for the effects artist is that of putting props into 2D character's hands. The prop itself can be in 2D or 3D. Many times it is in 3D. The hand placing of 3D props in a 2D character's hands can be tedious and is prone to having jiggle because the 2D animator does not animate her or his 2D character holding a spatially perfect prop. The easiest method is to bring the 2D animation into a 3D software package as an image plane and place the 3D prop visually so that it seems to match the character's contact point. Another method that is now becoming available is the limited ability to bring 3D objects into Photoshop, After Effects, Flash, and other 2D packages.

With this ability, the animator does not have to leave the 2D package to animate the 3D to follow the 2D. If the 3D is to have any larger animation ability beyond translate, rotate, and scale, then the artist will need to use a 3D package to do that advanced animation. Simple prop following animation could be limited to translate, rotate, and scale. However, this limited animation for the 3D may make it stand out as 3D if the 2D character is squashing and stretching in a cartoony way. If that is the case or if there are large perspective cheats that must happen to match the 3D to the 2D, then a 3D package will need to be used.

During production, prop requirements for a film can be large. Hundreds of props may be needed. If a team or student does more than one film, sometimes props can be reused or revamped to use in multiple shows. Having a good system to store and reuse props can help speed up your process.

We'll briefly cover using 3D objects in Photoshop CS4 or later. Photoshop can read in many types of 3D objects files. Some of these file types are simple to write out and have been around for ages; others are relatively new. File types that read in are as follows:

3D Studio	.3DS
Collada	.DAE
Google Earth 4	.KMZ
U3D	.U3D
WavefrontOBJ	.OBJ

EXPORT YOUR 3D OBJECT

For this exercise we will work with a simple, blocky hat that has been created out of polygons in Maya. It has been UVed and even has a checkerboard texture on it just to show the UVs. The file is found in the folder named 2D_Leads_3DProp and is called **Hat.mb**, if you want to open it and look for yourself. The checkerboard texture will actually not be saved out with the OBJ texture because

that is procedural. You can convert a procedural texture to a file, and then it would be exported.

To export an object out of Maya as an OBJ object, you will first have to turn on the plug-in **objExport.mll**:

1. Open the file Hat.mb in Maya.
2. Click **Window > Settings/Preferences > Plug-in Manager**.
3. In the window that opens, turn on the **Loaded** and **AutoLoad** checkbox for the **objExport.mll**.
4. Select the hat object (it will highlight in green).
5. Click on the Option Box next to File > Export Selection.
6. Under General Options, select File Type: OBJexport.
7. Click Export.

This has given us the exported files **hat.obj** and **hat.mtl**. You can find these files in the folder named **exportFromMaya**.

IMPORT OBJ FILE INTO PHOTOSHOP

Inside of Photoshop CS4 or later, open up the sample file that we will use by clicking **File > Open**, and locate the file **DanMurdock_BigGulp_Section.mov** inside of the **2D_Leads_3DProp** folder.

FIGURE 6.29 DanMurdock_ BigGulp_Section.mov in Photoshop, by Dan Murdock, 2009, SCAD, Digital Cel I course.

Wavefront is one of the original 3D packages that was ultimately bought and incorporated into Maya, thus you have the obj exporter built in. OBJ is a universal object description. If you wanted, you could open the obj file in a text editor and look it over. It is geek readable.

IMPORT 3D OBJ OBJECT

In Photoshop CS4, locate the 3D menu. This is what we will work with now. To bring in the obj object from Maya into Photoshop, click on:

1. 3D > New Layer from 3D file
2. Locate the hat.obj file. Select the file and click open.

The hat object will load into the 3D layer. In Figure 6.30, you see arrows indicating the 3D hat, the 3D layer, and in the timeline editor a keyframe that has been added to the 3D positioning of the object.

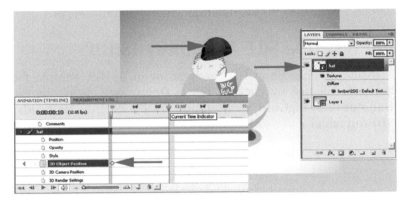

FIGURE 6.30 OBJ loaded into a 3D layer.

Two new buttons have been added in CS4, along with two hotkeys that allow you to move the object or the camera. The hotkey **K** (that is, **shift + k**) toggles through the options for 3D objects: rotate, roll, pan, slide, and scale. The hotkey **N** (**shift + n**) toggles through the options for the camera: orbit, roll, pan, walk, and zoom.

FIGURE 6.31 3D tools in Photoshop CS4+.

You can even paint the 3D object in Photoshop. Figure 6.32 shows the hat in various stages of being painted. The normal paintbrush was used. Remember that paint job; we'll see the texture that was created in just a moment.

FIGURE 6.32 Painting a texture for the 3D object.

To set keyframes, turn on the stopwatch for the **3D Object Position**, and use the 3D move tool to position and rotate the hat for the keyframes needed. You can see an example of a finished animated obj in the Photoshop file **DanMurdock_BigGulp_Section .psd**. Figure 6.33 shows a keyframes set for the hat obj.

FIGURE 6.33 Keyframes in Photoshop.

The last portion we will cover as we explore the 3D capabilities in Photoshop is exporting the object file and the texture that we painted. Feel free to explore the 3D paint capabilities in Photoshop.

To export 3D objects out of Photoshop, simply select **3D > Export 3D Layer ...**. This will save the obj file, a material file (mtl), and a texture (psd).

If you are using the obj file in Maya, you can load in the psd texture that was created in Photoshop. Figure 6.34 shows the texture loaded into Maya. This is great news for Photoshop texture painters, because this shows a different work flow for painting the textures and using the familiar tools of Photoshop painting.

FIGURE 6.34 A psd texture loaded into the Maya scene.

The exported files are in the companion data in a folder titled **exportFromPhotoshop**. This is just the beginning of working with 3D in Photoshop. I'm sure you'll have a lot more to put on our website: www.hybridanimation.com.

TONES AND SHADOWS

These two terms come from 2D animation. Because we are dealing with the compositing of elements to make a final image and not rendering everything in 3D for one final frame, we will continue to use these 2D terms for our 2D/3D pipeline.

The term *tones* refers to the area on a character that the light does not fully illuminate, the area in shadow. This dark area can be caused by self-shadowing or cast shadows from other characters, props, and the like. Although it is technically a shadow, when this shadow area is on top of a character, in animation it is referred to as a tone. The term *shadows* refers to the cast shadow from the character onto the background elements.

In 3D animation, the artist must only think about setting the light up for good illumination and the rendering engine takes care of the tone and shadow portion of the image based on the materials applied to the objects. The person in charge of lighting looks

to make sure that the tones are not covering the character in a distracting way.

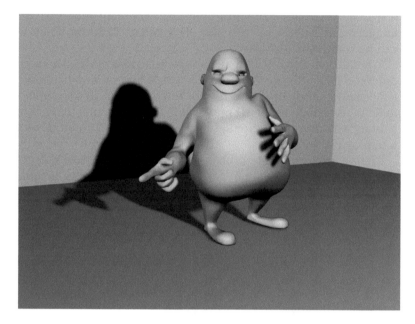

In 2D animation, the artist must draw the areas where the light is not visible. This 2D representation of dark areas—tones and shadows—is used in the compositing stage to darken the character's painted colors.

The difference in the representation of light can cause issues when putting 2D and 3D images together. If the 3D element is rendered with 3D lighting and shadowing, the 2D imagery cannot

match because it will be flat and at most have a slight shadowing from hand-drawn tones and shadows. We have examined many films, both in this book and as part of chapter projects. In your research, you have seen examples of extremely rendered 3D imagery combined with very flat 2D imagery. This combination can be somewhat jarring.

What do you do with light and shadow if the media look at them differently? How do we make them match? The answer is to choose a lighting/shading model to use for both media. You can choose to light and shade using 3D methods for any elements that are in contact with one another or light and shade using 2D methods for touching elements.

There's a key concept in this approach. It is only when characters of different media are in contact with one another or when a character itself is made up of different media that the lighting models must match. A character and the character's background can have different lighting models.

FIGURE 6.37 Example of a 2D character without tones and a highly rendered background. Model and pose by John Vu, 2009, SCAD, 3D Character Setup and Animation class.

3D TONES AND SHADOWS

In the previous chapter where we discussed creating a 3D character with 2D parts, we set ourselves up for the perfect example of a character that could use 3D tones and shadows, even on top of the 2D. Because the stand-in 3D character is so highly modeled and basically used as reference for the 2D, we can pull tones and shadow mattes from the render and use that in our composite.

FIGURE 6.38 3D character with 2D parts without tones or shadows.

FIGURE 6.39 3D character with 2D parts using a 3D lighting model to tie the elements together.

In Chapter 4, we used a toon shader to create a rim light matte for our 3D arm. We will use the same technique here, but we will apply the output to our 2D *and* 3D images during our composite.

TONE MATTE

First we'll create our 3D tone matte for both the 3D portion of our character and the 3D reference section: Jaguar McGuire's body and head. Please visit Chapter 6 in the Gallery section at www.hybridanimation.com for images displaying the following steps.

1. In your 3D package, create a light and shine it at your character. A spotlight has been created to shine on Jaguar McGuire by clicking **Create > Lights > Spot Light**. The display is in lighting mode (hotkey: **7**) so that a hardware view of the lighting and shading can be seen.
2. Remember, for our mattes we want a completely black-and-white image to use during compositing. Select the whole object and apply a toon fill shader in the Render section by clicking **Toon > Assign Fill Shader > Light Angle Two Tone**.
3. The default color of the shader is gray, so it is not very useful to us.
4. Change the first chip color to **black**. This produces a tone that is too hard to use.
5. Change the interpolation type to **spline**. This produces a tone that is too soft to use.
6. Click in the black area to create a third color chip of black and move it toward the white area of the ramp shader. This should produce a smaller threshold between the black-and-white color change.

7. To adjust the parameters and interactively see feedback, you can use the Interactive Photorealistic Rendering (IPR) window. Click on the IPR button in the render window and follow the directions to draw a box around the render region. As you adjust the sliders to the toon shader, it will interactively update in your window until you get the shader just right.

FIGURE 6.40 Using the IPR window to interactively see toon shader adjustments.

Once you have the settings you think are correct, take a moment and go through your animation to check for any unwanted tone effects. A quick way to do this is to use the **keep image** feature of the **render view** window.

Render the first image in your animation to look at the tones. In the **render view window** you can save images by clicking the **keep image** button at the top of the window. Then render another frame later in your animation at a key point of the movement. You can use the **slider** at the bottom of the **render view window** to scrub back and forth between the images and check for unwanted popping in the tones or shapes that obscure important features of the character. If such things were to show up, you would need to readjust the lighting in your scene.

FIGURE 6.41 Using the keep image feature of the render view window to check the tone matte.

Once you are satisfied that your tones will render correctly, you can render your tones. Steps like these can help you catch errors before you kick off a render, walk away to get coffee, and come back

to a surprise. Of course, this is not to say that after you return from getting your coffee you still won't be surprised. That is the nature of the medium. Those who have been around the digital block a time or two, feel free to ignore these musings. Students, take heed.

When rendering the tone matte, we can use .tifs because this is now going to final compositing. Remember to use **alpha channels** and **frame padding** (Figure 6.42).

FIGURE 6.42 Rendering tone matte.

For the *Jaguar McGuire* shot, we rendered out the background element as one image, because the elements are not being animated and the camera is locked (no camera movement). Maya will happily let you render 110 frames of something that isn't moving. Give an extra moment before you hit the render button to contemplate—do you need all 110 images? Normally you will not need an alpha channel on a background.

FIGURE 6.43 Rendering held background element.

Next we'll render the cast layer much as we have done previously. The reference head has been hidden. It is a good idea to do a quick test render of one frame and make sure that the alpha channel is there. You might find that you haven't hidden everything. This was the case during the making of the following image. The background wall was the same gray as the perspective window, so one thought it was hidden when it was not. Only after the render was completed was it noticed that the alpha channel was a pure blank rectangle of white. A quick render test would have shown that was the case and caused the animator to investigate more and discover that the wall had not been hidden. Didn't we just say that students were to heed the importance of test renderings? It is so easy to click that render button without thinking to check. Remember!

cast[1-110].tif

FIGURE 6.44 Rendering an animated cast element without a head.

As we saw in Chapter 5, the head has already been drawn in Flash. We have already inked and painted the character in Flash. See the appendix for more about inking and painting images.

To have a rendered frame for every frame (which can be easier when compositing if the render time is not an issue), we will select all of the keyframes and right-click to select **Convert to Keyframes**.

FIGURE 6.45 Prepping 2D animation to export for final composite.

Once this is done, there is a keyframe for every frame of animation.

There is not an option to export a series of .tif images in Flash. Depending on the software that you are using, you might be able to use the swf file itself. If that format does not work for your compositing software, then you will have to use a QuickTime format. Remember to use animation (no compression) export settings.

To export out a swf file, there are not many file settings that you need to change. We turned off any compression settings. In a production setting, I would test between QuickTime and swf files to see if there was any loss of image quality before proceeding. We tested only slightly during one quarter's class and found that exporting QuickTime out of Flash created a slip in frame rate! Instead of exporting out at 24 frames per second, it was exporting at 24.9, with no obvious way of correcting the error. The slippage showed up at the compositing stage when we were running a frame short in anything that came out of Flash. My students reported that they were using the animation compression, which should not have created any slippage, yet it was there. We chose to use swf instead. Test. Test. Test!

You can use any compositing software to put these images together. We'll use both After Effects and Shake so you can see the differences between the two types of compositing systems: time-line and node based.

First we will use After Effects. Bring your elements into After Effects by dragging and dropping them or importing them. See Figure 6.46 for an example of elements brought into After Effects. In this example we used a swf file for the head.

Create a composite for each element layer that is made up of individual images. In our example, that is the cast element and also the tone matte. To create a composite:

1. Select the cast images 1-110.
2. Drag them to the composition icon.
3. Make sure the settings are for a duration of **one** and that the **sequence layers** option is turned on.

You'll see in Figure 6.47 that the composition is indeed made at 24 frames per second.

Repeat the same steps for the **tone** element.

Now we will affect the body with the 3D tone that we created. We will use the same method from Chapter 4. We will use the tone matte to adjust the color of the head and the cast levels:

1. Create another composition, and drag in the **head**, **cast**, and **bg**. Label this **head_cast**.

FIGURE 6.46 Animation elements brought into After Effects.

FIGURE 6.47 Creating a precomp of the cast element.

2. **Right-click** in the timeline and add a **New > Adjustment Layer** above the head level.
3. **Drag** in the **tone** composition and place it above the adjustment layer.
4. Select the Adjustment Layer and from the top menu click **Layer > Track Matte > Luma Matte**.
5. **Right-click** the Adjustment Layer and **add EFFECT > Color Correction > Color Balance (HLS)**.
6. Bring Lightness down to the desired level.

FIGURE 6.48 Creating a precomp of the tone element.

You'll note the red arrows point out the errors that can result from this method. The 2D animation did not exactly follow the 3D head that was used to generate the shadows. The tones can still be used. A separate cleanup pass will need to happen to extend the mattes to better match the 2D animation. If your team has many junior effects artists, or in our case new sophomore students helping out on a group project, using 3D tones can help the artists have something to go by and help with quality control. If your 2D animation matches very well to your 3D animation, then your tones will match correctly. This process can even go the other way. You could animate in 2D, then roto match a 3D stand-in just to cast tones upon. Do whatever helps you to attain the shot.

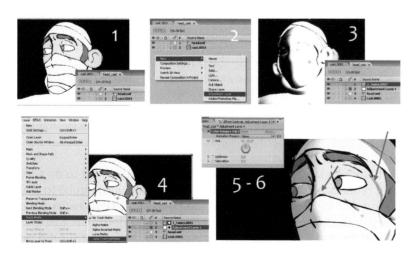

FIGURE 6.49a Adding the tone element in After Effects.

Just one way of fixing the tone mattes is to bring them into Photoshop or any paint package and to simplify them there. Remember, do not hand-blur the edges. If you hand-blur edges across multiple frames, they will not animate very well and cause boiling in the final composite. It is better to have a hard-edged matte and blur it in the compositing package than to try to hand-blur each image. In Figure 6.49b, the matte has been simplified. All of the areas around the eye facing the light have been removed, as well as some shadowing on the jawline. Note: You are seeing the RGB layer of the matte.

FIGURE 6.49b Simplifying the tone matte in a paint package.

SHADOWS

We'll use the same technique of creating a 3D shadow in Maya and compositing it in After Effects.

To create a shadow matte in your 3D package, you'll need to be able to render a shadow pass. In Maya 2008 or earlier versions, you can use render passes. In Maya 2009, the company changed how you create render passes. We'll show both methods. The concepts are the same, only the buttons are different.

We'll continue using our *Jaguar McGuire* shot. The first step is to set up a light that will be used to cast the shadow. This does not necessarily have to be exactly the same as the light used in the main render. Remember, your goal is to create a shadow that ties the 2D and 3D elements together. In this shot we have a 3D head that will cast the shadow for the 2D head layer.

Before kicking off a full render, it would be prudent to do a few test renders just to make sure the shadows are going to be to your liking. For instance, in our shot the character's right ear was not used in the 2D animation, so it needs to be hidden. Of course, you won't see that in the following image because the author did not

FIGURE 6.50 Spotlight added to the room to cast a shadow.

FIGURE 6.51 View of character though the camera.

follow her own advice and kicked off a render without checking, resulting in the need to re-render the images.

To create a shadow layer, you should isolate only the objects that are casting or receiving the shadow as well as the light that is casting the shadows. Figures 6.52 and 6.53 show the room before a render layer is created. Create a layer by selecting **Render (layer) > Layers > Create Layer from selected**. Remember that when a render layer is selected, as you see in Figure 6.53, only those objects are visible.

Before you go on, is your light set to cast shadows? Make sure the light that you have included in your render layer is indeed casting shadows. Not that the author has ever made that mistake before. What gave you that idea?

FIGURE 6.52 Creating a render layer.

FIGURE 6.53 Render layer shows only what is in the layer.

FIGURE 6.54 Spotlight is set to cast depth map shadows.

To create a shadow render pass, **right-click** on the render layer and select **Preset > Shadow.** You will see that the render layer's second button turns red (Figure 6.55). This render layer does not include parts of Jaguar McGuire, in order to simplify the cast shadow.

FIGURE 6.55 Render layer shadow pass created.

Render as normal. For a shadow pass the render is not creating an **RGB** image, it is only creating an **alpha** channel. This is different than what we have done before where we actually used the RGB created by the toon shader as a matte. This time we are using a true shadow matte. It can be slightly disconcerting the first time an artist opens the shadow matte and sees nothing in the RGB channels. Do not panic. Look in the alpha channel.

FIGURE 6.56 Alpha channel of a shadow pass.

CREATING A SHADOW PASS IN MAYA 2009+

A few features were added in Maya 2009 to add more functionality to render passes. At first testing, I couldn't figure it out without finally giving in and reading the documentation. I used what was there to figure out how it really worked. Here's a quickie overview of using render passes in Maya 2009+.

The previous steps will work if you have Mental Ray selected as your renderer. You *must select Mental Ray as your renderer* in order for the list of passes to show up. I was unable to include a screen grab of the passes: there are plenty of them to choose from.

1. Select your object and in the Render Pass window and select **Render (layer) > Layers > Create Layer from Selected**, as we did previously.
2. Choose Mental Ray as your renderer in the **Render Settings Window**.
3. Right-click on the render layer and click **Add New Render Pass**. Select the desired render pass from the large list presented.
4. If you look at the **Passes** tab in the **Render Settings Window**, you will see your render layer listed there.
5. Render as normal and wonder where your render layer is.
6. In the render window, select **File > Load Render Pass**. This will open your render layer.

Read the documentation for more information, including movies on how to use the new implementation of render passes.

Right Mouse Click for Passes List

FIGURE 6.57 Render layers in Maya 2009.

COMPOSITING

We'll bring the shadows into our After Effects composite. Here is a different way to bring in images. Previously we dropped them in as single images. This makes it easy to pull out an image should you need to reuse just one. For these shadows, we'll bring all of them in as one piece of footage. Please visit Chapter 6 in the Gallery section at www.hybridanimation.com for images displaying the following steps.

1. Click File > Import > File.
2. Select the first image in the sequence.
3. Make sure that Interpret as Footage is selected.
4. This will bring all of the images in as a footage clip. You can see them listed as one piece of footage in the project tab.

Once the footage has been brought into After Effects, you can drag the shadow layer between the head and the bg layers. See Figure 6.58 for an example. It doesn't matter if the shadow is bigger than what you need because the character will cover it. However, if there are any gaps where the shadow does not quite meet the character, you will need to extend the shadow in Photoshop or a painting package. In the image on the companion website, the shadow area (the white area) has been extended and simplified.

FIGURE 6.58 A shadow image placed between the character and the background.

Depending on your art direction, you could simply adjust the opacity of the shadow layer and call this shot finished. However, just adding a black shadow does not give you a rich color palate. Instead, we will use the same method that we used previously for the tone to use the shadow as a matte to adjust the color of the background image(s):

1. **Right-click** in the timeline and add a **New > Adjustment Layer** above the background level.
2. **Drag** the **shadow** layer above the adjustment layer.
3. Because this is truly an alpha channel that we are using, select the Adjustment Layer and from the top menu click **Layer > Track Matte > Alpha Matte**.
4. **Right-click** on the Adjustment Layer and **add EFFECT > Color Correction > Color Balance (HLS), Brightness and Contrast** or whatever color correction method you desire.

5. Adjust the color correction settings until you receive the correct shadow level.

FIGURE 6.59 Final composite in After Effects.

3D TONES IN SHAKE

To carry on our tradition of using multiple types of software to achieve the same look, let's take a look at how to achieve this composite in a node-based compositor. We'll use Shake. As we have pointed out, node-based compositors are somewhat similar. You'll be able to apply the same ideas to the software of your choice.

1. Locate the **File In** button in the **Image** tab and load in the assets. In this example, the following image sequences were loaded:

a.	bg.tif,	Maya Render
b.	shadow[1-81].tif,	Maya Shadow Pass
c.	J_tone[1-81].tif,	Maya Two Tone Shader (RGB)
d.	cast[1-81].tif,	Maya Render
e.	head.mov	Flash swf converted to mov (Animation settings)

 You'll note that the head.swf file we used in After Effects does not read into Shake. Therefore, the raw movie file or an image sequence needed to be used. In Figure 6.60, the images were loaded and show up in the node view tab.

2. First we'll composite the head overtop of the cast by locating the **Layer** tab and selecting an **Over** node (**A over B**).

3. Next, drag a connector line from the **bottom** of the **cast** image and hook into the **top right** of the **Over** node. Drag a

FIGURE 6.60 Shot assets loaded using multiple File In nodes.

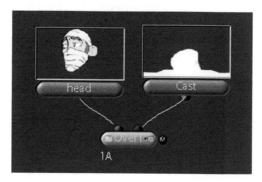

FIGURE 6.61 Compositing the head over the cast.

connector line from the **bottom** of the **head** image and hook it into the **top left** of the **Over** node.

4. Locate the **Color** tab and select a **Brightness** node. Hook up the output of the **Over1** node (we should have named those— it would have been easier) to the new Brightness node. This will give an overall brightness to the head/cast composite.

5. To limit the composite to only the tone area, hook the output of the **Tones** image node to the **right side** of the Brightness node. This is where mattes are hooked in.

6. You'll note in Figure 6.62 that the tone matte is working but it is giving the opposite effect. Anyone know why? Look back at the hint located in the listing of assets (step 1). Do you see it? The tone is in RGB, which means its alpha is actually the opposite of what we want to use. Mattes use the alpha channel.

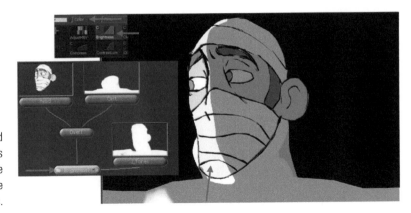

FIGURE 6.62 Tone matte used to brighten the head/cast. This tone was created in RGB. The alpha is what the matte input uses.

7. To correct the issue, double-click on the **Brightness** node in the node view tab. This will load the preview image into the preview tab (if it wasn't already there) and load the adjustable parameters into the parameter tab.

8. Click on the little plus sign next to the **Mask** option. This will open more parameters. Click on the **InvertMask** radio button to turn it on. It will turn **green**. As you can see in Figure 6.63, the area that is being darkened is the correct area.

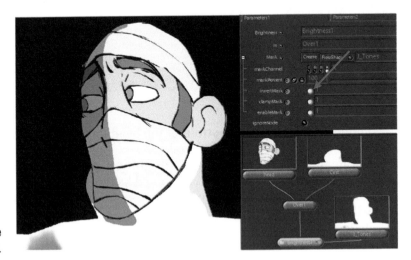

FIGURE 6.63 Inverting the tone mask.

9. If you want to add a blur (or anything else) to adjust the matte, you can add that to the node network ahead of the **Brightness** node. In Figure 6.64, you can see the addition of a **Blur** node.

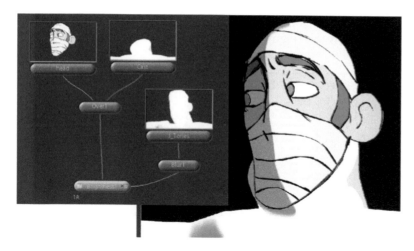

FIGURE 6.64 Blur node added to the matte before the Brightness node.

10. Continuing to the background area of this composite, select a **Brightness** node (found in the **Color** tab). Hook the **background** to the **top** of the Brightness node and the shadow to the **right** side of the Brightness node. This will use the shadow as a matte. Because the shadow pass was rendered out as an alpha channel, it will work as intended without any additional button clicks (Figure 6.65).

FIGURE 6.65 Shadow matte used to darken the background image.

11. The last step is to put the two parts together. Select an **Over** node from the **Layer** tab. Hook up the output of the **Brightness2** (the background and shadow precomp) to the **right** side of the **Over** node. Hook up the output of the **Brightness1** (the head/tone precomp) to the **left** side of the **Over** node.

Double-click on this last **Over** node to see the preview in the preview tab (Figure 6.66).

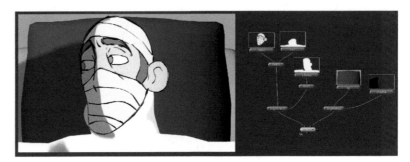

FIGURE 6.66 Final Composite Tree in Shake.

12. To export your final movie file, you add a **FileOut** node to the last node in the tree. Actually you can put a FileOut node anywhere if needed. In the **Image** tab, click on the **FileOut** node. Take the output of your last node in the composite tree, Ours is called **Over2**. Hook it to the top of the **FileOut** node.

FIGURE 6.67 A FileOut node.

13. In the **FileOut** node's parameters, add the path and file name of your final output (for example, **JM_shot6_Final.mov**).
14. To kick off the final render, make sure that the **FileOut** node is selected (it should be green) and click **Render > Render Node**.

2D TONES AND SHADOWS

When drawing tones in 2D, the artist has to calculate where the light is hitting the character or object and draw this 2D matte. It is essential that these mattes flow along the character's surface and react to the volumes of the character as it moves in the light. When drawing the shadows, the artist draws a stylized representation of where the shadow falls on the background. The mattes should not pop or wobble and cause attention to be drawn to themselves; however, the mattes are usually blurred so some wobbles will be minimized.

Shadows and tones do not have to be exact representations of what they should physically be. If they were, they would become too distracting, which can be the case with 3D tones and shadows. The mattes should be simplified ideas of the shadowed areas.

Figure 6.68 shows a coffee cup standing in the light. The light direction has been drawn in. You can see where the light rays have been extended through the coffee cup and onto the ground plane. This is the shadow area. Where the light hits the cup creating self-shadow areas, this is what is called tones. The tones follow the volume of the cup. Of course, this is a simple object. If your character has lots of dangling hair, eyeglasses, and so on, the tones and shadows could be extravagant. When creating 2D tones and shadows, you have the option of simplifying these elements so that they do not detract from the main animation.

FIGURE 6.68 3D coffee cup showing tones and shadows.

To draw 2D tones and shadows, you can use any method we have covered so far in this book: paper, Photoshop, Toon Boom, Corel, and the like. Paper would be the most difficult to keep registered because you would have to go through a printing process. Figure 6.69 shows four levels of images broken apart so you can see what each looks like. The cup and background level are 3D renders. The tone and shadow are drawn in Photoshop.

FIGURE 6.69 3D cup and background render and 2D tone and shadow drawing.

You can follow the same processes we used before to composite the 2D tone and shadows into your scene. A tip to keep in mind when creating tones and shadows, especially with 2D, is that generally tones and shadows are blurred. 2D tones and shadows tend to be blurred more to help make them feel softer much like you would get with a 3D tone or shadow. If you over blur the mattes they will pull away from the character (or coffee cup) as you see in Figure 6.70. When drawing 2D mattes, it is best to over draw them so that they overlap the edges. In other words, draw outside of the lines. Because we are using them as mattes on top of the character and tracking them as luma or alpha mattes, they will not be seen. So overdrawing the mattes will not cause any harm.

FIGURE 6.70 Overdraw mattes to keep them from pulling away from the edges when blurred during compositing.

PROJECT: 3D PROP LEADS

Due: _____

For this chapter's project, you are challenged to animate a 2D character riding a 3D bicycle. The scene must also contain shadows and tones. You will want to keep the animation short; a cycle is suggested.

Use the Maya file **CycleLegs.ma**, found in the companion data for this chapter.

You will have the following levels:

1. 3D bicycle
2. 2D character
3. Character tone
4. Bicycle tone
5. Character shadow
6. Bicycle shadow

For my students, you must try to match a style. This will help you achieve a higher aesthetic goal. Styles to match include *Triplets of Belleville, Iron Giant,* or *The Pearce Sisters.*

You are assessed on the following skills:

1. Ability to match a 2D character to a 3D prop
2. Ability to match tones and shadows to animation
3. Technical use of animation tools
4. Technical use of compositing tools
5. Overall appeal of the shot
6. Matching of style
7. Problem solving

FURTHER READING

Gilland, Joseph. *Elemental Magic: The Art of Special Effects Animation,* Boston: Focal Press, 2009.

STUDENT CONTRIBUTORS

Dianna Bedell
Clint Donaldson
Jessica Huang
Alston Jones
John-Michael Kirkconnell
Dan Murdock
Daniel Tiesling
John Vu
Jason Walling

7

CAMERA: FLAT, LIMITED, AND DEEP SPACE

Example of flat to deep space by John-Michael Kirkconnell, SCAD, 2009, 2D/3D Compositing class.

LECTURE NOTES

You, dear reader/student, now have examined working with 2D and 3D art. When combining animation media, the artist must create a world that houses these media. The next topic to explore is how to look at the world where these images come together.

DOI: 10.1016/B978-0-240-81205-2.00007-8

The most common method (not that we are saying it is the best) is to put everything into a 3D world. Surely this has been the case as 3D objects and environments have crept into the 2D animated films. In fact, the history of animation has seen a steady progression from the use of flat, to the use of limited, to the use of deep space environments. Mostly, in 2D animation we were accustomed to flat space camera work until the multiplane camera was invented and we began to see limited and even the beginnings of deep space usage. Then a mismatch of the space usages began. We would find ourselves watching a flat space film with some usage of limited space; a 2D character would be happily telling his story while moving left and right across the screen and sometimes coming toward the camera for added depth; and then wham, we would come across a scene where the camera was suddenly liberated and moving through a 3D environment that possibly had a few 2D characters in it. Those geared toward the novel thought, "Wow!" Those geared toward the story thought, "Oh, boy!" That was a failure. We made them say, "Wow, look at the shiny thing" instead of feeling the story point more.

An example of such an incident came about when I was still in college at Ringling School of Art and Design. (I think it has changed to Ringling College of Art and Design now.) At the time, the head of the training department at Walt Disney Feature Animation's Florida studio would visit the college every year looking for the next round of internship candidates for Disney Feature Animation. During the visits Frank, the Disney representative, would treat us by giving a sneak pre-screening of that year's animated film. At that time, it was a great treat in the lost end of Florida to see movies before they were released. Students nowadays barely can understand how special this was, given their current ready access to bootleg videos. (Oh, and if you think you can enjoy a movie on your iPhone, please skip this chapter. It is not for you.) Frank, who is a lovely energetic man, had screened a number of films during my stay at Ringling. One was *Beauty and the Beast*. I was studying computer animation at the time, so I was very tuned in to any use of 3D, as we all were. In the center of the film, of course, there is the great ballroom dance scene where the characters walk into a ballroom and the camera follows them. The camera then swoops up and around the ceiling of the ballroom, revealing all to be in glorious 3D and textured, and then it comes back down to swoop around the dancing 2D characters.

Many of us were stunned. What a lovely example of 3D usage. Wasn't that beautiful? Did you see that? They were really pushing the envelope. We all marveled together.

It wasn't until years later, when I worked at Disney and was more educated on the process and art of animation, that I realized that some considered the scene a miserable failure. In one swoop,

it took the audience out of the moment and showed off the technology.

The point to take away from this is that we shouldn't show off our technology, our pipelines. There should be reasons for everything we do, including the world we create and how we move our camera about.

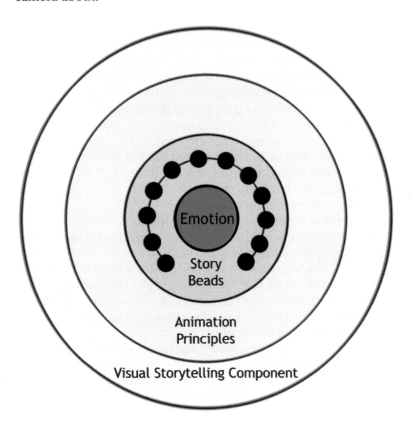

FIGURE 7.1 Bull's-eye to keep us focused on why we set up shots.

We have come full circle then. (I'm sure there is a pun there.) In the opening chapters of this book, we discussed Bruce Block and the outer ring of the bull's-eye: visual storytelling components. Block, in his teachings, reminds us to tie the intensity of our visuals tightly with our story. We know this; it is usually something we do instinctively. However, you might have noticed in your research that there is a fine line between adding visual intensity to a film when the story needs it and adding visual intensity to a film at every chance. The problem with the latter is that ungoverned intensity will become numbing and ultimately lower all intensity. If you have ever seen a visual effects film where one unit shot all of the exposition and talking heads and another unit executed all of the whiz-bang fight sequences, you might have felt this problem profusely. It might have felt like this: talking heads =

flat, flat, flat; fighting = wow, wow, wow. But possibly the fighting was over-wowed with each shot so that by the end you were thinking to yourself, "Is it over yet?" So to help us govern our usage of visual intensity, Block gave us the tool of charting the storybeats to the visual intensity.

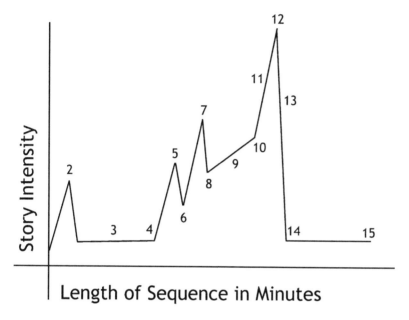

FIGURE 7.2 Block's intensity chart.

Block's book covers all of the actors that can be used to display visual intensity. You will want to read and understand his text. We cannot cover all the ways to apply the different actors in this book. We have room only to discuss the actor called *space*. We will only be looking at the placement and movement of the characters and cameras in this chapter. You will have to pursue the other sub-components of space in your supplemental readings of Block's book.

It has been rumored throughout the student body that any student who takes a class of mine should not move the camera. Students give each other the advice to always have the camera locked down. They explain, "Professor O' hates camera moves." On the contrary, I love them. Yet they must be well done and have a reason.

When trying to understand where cameras should go and why, I found myself on a journey of exploration into many ideas, methods, glossary terms, and ideologies. Many cinematography books explained how certain camera positions would make the audience feel. However, I found that some of the books were talking about single shots and not looking at the whole film and how the shots related to one another. If you want to gain a holistic

understanding of using the camera, I would suggest a reading list that includes the best cinematography book you can find, along with Bruce Block's book, plus a concise book about camera mechanics, and something on the placement and movement of camera blocking. I suggest the following:

1. *Cinematography: Image Making for Cinematographers, Directors, and Videographers* by Blain Brown, for better appreciating why shots are set up the way they are.
2. Bruce Block's book, *The Visual Story*, for learning more about how to focus on the whole structure of the film as it relates to the story.
3. *The Bare Bone Camera Course for Film and Video* by Tom Schroeppel, for understanding what a camera actually is.
4. Hollywood Camera Works, which is an amazing resource of tutorials and includes an exhaustive set of tutorials on where to put the camera and how to actually move it. See the companion data and the website (www.hollywoodcamerawork .us) for more information.

Of course, reading books such as these helps to float glossary terms, rules, things to avoid, things to remember, etcetera, in your head during the creation process. However, you then need to have hands-on time in order to put these ideas into practice and develop them into a reality and not just an abstract idea. So before we continue on to techniques and methods that are being taught away from the larger context of a full story, please remember to utilize the Intensity Chart from Figure 7.2 and heed Block's teachings when you apply these methods to your story. Do not simply apply tutorial knowledge to your films without understanding the whole of it. I mean it, or I'll have to start lecturing to you on the neuroscience of it all. Don't make me do it. Ding. Ding.

> **Dig Deeper**
> If you wish to understand how the audience's brain is working as viewers watch your film and how to use that information to your advantage when trying to elicit emotional responses out of the audience, read *Synaptic Self: How Our Brains Become Who We Are* by Joseph LeDoux and view the numerous videos out there that focus on this topic, even those shown on YouTube.

SPACE AND CAMERA MOVES

Four types of spaces can be created in your film's world. We spoke of these briefly in Chapters 1 and 2:

1. Flat space
2. Limited space
3. Deep space
4. Ambiguous space

We create these worlds and control them by our placement and movement of characters and cameras in relationship to one another. The following is a brief overview of a few of the subcomponents of space. Of course, refer to Bruce Block's book for a complete understanding.

Any of these spaces can be created in any medium. However, some media traditionally have lent themselves to certain special relationships.

Flat Space

Character placement. On the same vertical plane, similar size, move parallel to the camera.
Camera movement. Parallel to the characters, pan, tilt, zoom.
Parallax between levels. None.

The visible symptoms or subcomponents of a flat space shot can be seen in how the characters are placed and move, how the camera moves, and how little parallax is shown between the elements. Basically, all depth cues are removed from a flat space scene. Characters can be placed on the same vertical plane and be shown at similar sizes. If there are big and small characters, their size difference can be minimized by seating them or showing close-ups of the characters and not showing them standing next to one another. If the characters move at all, they should move in front of the camera and never toward it. If the camera moves, it should move parallel with the characters so that they stay a similar size throughout the shot.

Think about Charlie Brown for a moment, as he walks down the sidewalk into the front door of his house, out the back door of his house, and approaches the doghouse upon which Snoopy sleeps. If you have seen the comics or the television cartoon shows, you have seen an example of absolute flat space. The characters, in addition, are all just about the same size just to add to the flatness. It is the style of *Peanuts*. This style is allowed to be broken mostly when Snoopy fights the Red Baron. Okay, that's an old reference. Let's look at something that is in the same homage but more modern: Calvin and Hobbes. Yes, that series never will be animated, yet a similar idea can be found in those comic strips.

In fact, 2D animation is easiest when created in a flat space. It is the perspective and parallax of movements that make it more

difficult to draw. On the other hand, it is more challenging, yet rewarding, to make 3D worlds into flat space. This can be done by paying careful attention to the placement of characters and the movement of the camera as well as applying a mindful usage of tonal separation and textural diffusion. (You know where to go to read more about that.)

Camera movements for a flat space shot are pans, tilts, and zooms. Basically, the camera does not move. This keeps the parallax of elements down to a minimum. This is an easy space to achieve by locking the camera and characters in one position or, if they move, moving them together. If it is so easy, why is it not done in 3D very often? Because it is also just as easy to fly that camera around for no reason whatsoever. Remember, you must have a reason to move the camera and a visual rule to describe why you are choosing to pan instead of track, or zoom instead of dolly.

Pan

To pan a camera is to stand in one place and basically pivot the camera on its stand from one side to the other, usually to follow a character. As Figure 7.3 illustrates, when you pan the foreground elements and background elements, move across the screen at the same rate. How far apart are the foreground and background levels? You do not know, because the special clues have been removed. Note in Figure 7.3 that the distance between the branch and the boy's head never changes.

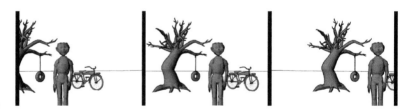

FIGURE 7.3 Camera pan.

Tilt

Tilt is similar to pan, in that the camera is held still and pivots on its stand. For a tilt, the camera tilts up or down to follow an object. Usually something motivates the camera to move. That topic is beyond the context of this book; pity. Tilting, like panning, moves foreground and background elements up and down the screen at the same rate. Note in Figure 7.4, as was the case in Figure 7.3, that the distance between the branch and the boy's head never changes.

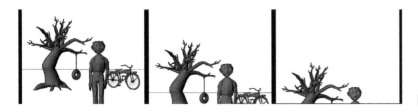

FIGURE 7.4 Camera tilt.

Zoom

The act of zooming is done by a push of a button or a twist of a lens to change the focal distance. (In Maya, this is the focal length.) This action scales all characters, foreground and background, at the same rate.

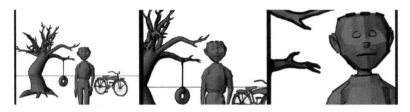

FIGURE 7.5 Camera zoom.

If you aren't quite sure about what a 3D world would be like in flat space, think about your grandfather holding the video camera. Not all grandfathers, but many, do not move much when they hold the video camera. They stand in one place watching the soccer game. They pan the camera from left to right across the field, tilt the camera up to watch the ball as it flies into the air, and use the zoom to gain a closer look at their prize grandson playing defense. As long as the soccer players run across the field and do not run toward the grandfather, you have an example of flat space.

Before continuing, please note that flat space does not mean that you must use the 2D medium. The same space can be created in 3D or live action. Students who are new to the concept of defining space sometimes confuse medium with spatial relationships.

In the hands-on section, we will take a 3D world and compress it to create a flat space scene that has been inspired by the Cohen Brothers being inspired by Busby Berkeley a la *The Big Lebowski.*

Limited Space

The following is a list of common attributes found in limited space:
Character placement. On distinctive foreground, midground, background planes.
Camera movement. Track, multiplane.
Parallax between levels. Parallel parallax.

The visible symptoms or subcomponents of limited space are seen in how the characters and elements are placed in relationship to one another in front of the camera. Their placement is typically in distinct levels that will show off the distance between them as seen by the camera. You can think of these levels as a foreground, midground, and background. There may be more levels than this in actuality, they are still usually grouped psychologically into a foreground, midground, and background area. Character movements usually stay within their given level with limited interaction back and forth around other elements in their level. In the purest version of limited space, there is no Z-depth movement of the characters or elements. The camera does not move toward the characters and elements, nor should the characters and elements come toward the camera. They are locked into their horizontal level. Perspective is generally still squashed as much as possible and vanishing points are hidden in this linear space world.

Camera movement in a limited space world is tracking the camera from side to side to give the depth cue of parallax between the levels. An example that you can look up on watchthetitles.com is *Teeth of the Night*. These titles use limited space and multiplanes throughout the sequence.

Track

To track is to pick the camera up and move it horizontally in front of the levels or, inversely, to pick up the levels of artwork and move them underneath the camera, depending on how you are compositing your shot. The object is to show off the parallax of movement between the characters. To do that you must understand the next concept: multiplane. In Figure 7.6, the camera is moved left in front of the characters. The characters that are farther from the camera move across the screen at a different rate than the character closer to the camera.

FIGURE 7.6 Track shot.

Multiplane

Multiplane is not really a camera move, it is the name of a camera designed in the early 1930s and perfected by the Walt Disney Studio. Now the term is used as a verb meaning to set

artwork up in such a way as to show the parallax between levels. This was originally accomplished by using the multiplane camera that allowed artists to stack glass plates up and move them at varying speeds to simulate parallax of movement from left to right under the camera. The main idea is that the artwork is set up at different depths away from the camera and all of the elements move at varying ratios in relation to one another to display parallax.

FIGURE 7.7 Multiplanes in a 3D space.

You are probably most schooled in limited space setups. This is the traditional setup for 2D animation. Foreground elements, background elements, and characters are set up into their individual planes. To break away from the flat space that comes with basic animation setups, things such as multiplane cameras were created to help move the planes in relation to one another, causing parallax between levels. This was the case with many of the 2D feature animation films. Remember that just because something is in 3D does not mean that it has to be in deep space. You can set up a limited space shot in 3D and live action as well. Think of a theater stage and the different fly areas in that stage. (If you've ever looked at the different levels of curtains on a larger stage and seen that they hide, you have seen the fly areas.) Early musicals and early films were vaudeville plays that had a camera set down in the audience's seat. Those films were most commonly in limited space. This can still be seen in the theater today. Why use it in 3D? As Block has suggested, it is a good way to emphasize the emotional center of your film. If you keep your characters jailed in

limited space and then finally release them into deep space at a strategic point, the emotional impact will be all the greater. To emphasize this point, I like to show my students Chapter 16 from *Little Miss Sunshine*, where the brother character, who has been held in limited space for a very long time, learns he is colorblind and finally escapes into deep space. Check it out—it is very powerful.

In the hands-on section, we will create a traditional multiplane scene using some wonderful imagery from a SCAD student's puppet theater. Because you are not in my classroom, I won't be able to play a song from my favorite musical to inspire you. It's a shame. "Little shop, little shop of horrors."

Deep Space

The following is a list of common attributes found in deep space:
Character placement. Exaggerate size difference, move toward the camera.
Camera movement. Truck, dolly, boom, and other free movements of the camera (steady cam, wire track, helicopter, etc.).
Parallax between levels. Showing perspective, has vanishing point.

Deep space is the most modern of world spaces. Most advances in camera usage have pushed this specific type of space. Even in animation, it wasn't long before the jump from multiplane limited space scene setups became deep space, just by moving the camera toward the artwork and adding Z-depth. Compositing software packages were created that allowed for these multiplane-type shots to have unlimited numbers of layers and to move beyond parallel parallax, and they added in the ability for the camera to move in Z-depth through the flat levels easily. Z-depth camera moves are the definition of deep space, obviously.

Characters in a deep space shot are placed to exaggerate the size difference, and dynamic compositions can be created. They are free to move toward the camera or the camera toward them. When using 3D, it is easier to create deep space than any other type of space.

An example that you can look up on watchthetitles.com is *Gruesome School Trip*. Though the titles are 2D flat planes, deep space is applied to them.

Track

For deep space, the camera can track, or move from left to right. The difference between a track in limited space and one in deep space is the exploitation of perspective. Limited space shots do not have vanishing points or use three-point perspective, whereas deep space shots do.

Dolly/Truck

A dolly is to pick the camera up and move it toward the characters. As a result, the characters visibly scale at different rates. The opposite of this is a zoom (see the section on flat space), where the characters scale at the same rate. In Figure 7.8, the boy character scales up at a slightly different rate than the background elements.

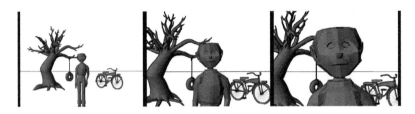

FIGURE 7.8 Dolly camera move.

Boom

A boom is an interesting camera move. The camera is physically moved up (or down). Sometimes it is combined with a pan or pivot, where the camera pivots on its moving stand to continually face the character. This changes the perspective planes of the character, and all characters in view move at different rates (parallax). In Figure 7.9, the boy moves out of the frame quicker than the background elements do.

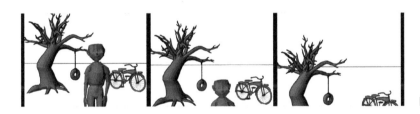

FIGURE 7.9 Boom camera move.

Multiplane with Perspective

If you take the concept of multiplane and add forced perspective onto the actual planes themselves, you create a world with deeper space. This is a method that has been explored in 2D/3D animation. It is achieved by taking what would normally be limited space, with different levels placed in Z-depth, then adding dimension to the planes to augment the parallax in the images themselves as the camera moves through the planes. Some might think this is a concept novel to animation; however, similar concepts have been used for years in theater stage design, live-action set design, and stop-motion stage design.

This type of deep space multiplane with perspective was used throughout *Mulan, Lilo and Stitch, Prince of Egypt,* and many

other films. Many "making-of" specials found on DVDs will show you how these shots were put together. You will have to use your well-developed eye to sort out more modern examples of 2D/3D multiplane with perspective usages, because most of these are found in short films. Some filmmakers, however, are kind enough to post their making-of videos on their websites. For example, take a look at the fabulous 2D/3D film titled *le Building* and its making-of video at www.le-building.com.

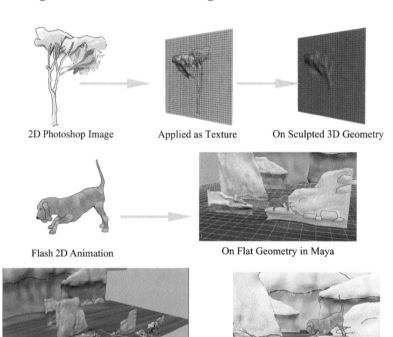

2D Photoshop Image Applied as Texture On Sculpted 3D Geometry

Flash 2D Animation On Flat Geometry in Maya

FIGURE 7.10 Multiplane with added perspective, by Jennifer Chandler, 2008, SCAD, 2D/3D Compositing course.

Camera Movement Applied in 3D Final Image

Fly-Through and Helicopter

We'll briefly discuss other types of camera moves that exploit the world in all axes. There are many ways to move the camera freely about the gravity-less world of a compositor or 3D Cartesian set. A fly-through is one way of exploring the set and is generally what it sounds like. The camera flies through the set, revealing parts of the environment. A great example of a 2D/3D fly-through is in the vine skateboarding sequences of *Tarzan*. Here, Tarzan leads the camera as he fleet-footedly barefoot skates through the vines of the jungle. The camera moves all throughout the environment as this 2D character moves through the 3D vines.

A helicopter shot is one where the camera revolves around the character in a circle, sometimes for the whole 360 degrees. The

focal point of the camera's movement remains the character for most or all of the scene. You have seen this shot in hundreds of films. In *Brother Bear*, for instance, there is a sequence where Koda and Kenai are sitting on a rock bluff. Kenai is about to break the news to Koda about the true reason for his mother's demise. The camera starts behind the bears and wheels around them. They are drawn in 2D and placed onto a background, which in my memory is a 3D rock. You can also see a great helicopter/360-degree shot of the horse in Dreamworks *Spirit*, and even a good showing of the 3D/2D in the making of feature on the DVD. That example is absolutely seamless.

FIGURE 7.11 A 360-degree shot or helicopter camera move.

Moving a camera around in a 3D world is easy and easily abused. In this chapter we will learn how to push a deep space shot using multiple media and adding perspective to what would traditionally be a flat plane.

Ambiguous Space

The following is a list of common attributes found in ambiguous space:
Character placement. Anything to make the subject unidentifiable or to unsettle the audience.
Camera movement. Anything to unsteady the audience: upside-down shots, reverse relationship to character movement.
Parallax between levels. Anything to create a space that is off kilter or indefinable.

Ambiguous space is often used or abused in horror films. It is hard to give it any other emotional center than that of confusing the audience, as it is mainly defined as a space in which the viewers do not know what they are looking at or where they are. Maintain a scene like this for too long, and the audience will lose interest. Use it sparingly, and you instantly increase the visual intensity.

There are varying degrees of ambiguous space, however. We'll put the zolly shot in the category of ambiguous space, because it is meant to be offsetting to the audience. It is a camera move that has a reverse relationship to the character's movement. A zolly is a zoom and a dolly combined. You have seen it used, surely. Pop quiz and extra credit to those that can name the person who first created the zolly camera move and what famous shot was it used for. To push the shot, you can also move the character away from the camera at the same time that it moves in and zooms in. You'll note in Figure 7.12 that the boy scales toward the camera while the background elements stay relatively the same size.

FIGURE 7.12 Zolly example.

All of the normal things to watch out for exist here: style matching, frame rate, timing, image sizes, and registration. Remember what we learned in Chapter 3? Show contact points judiciously, focus on those that further your emotional focus, and hide everything else. Feet contact points are usually not highly emotional, just gravity at work, so they can be hidden most of the time to avoid giving away any bad compositing. If your characters are sitting and the camera move is a helicopter shot, hide the point where they are seated on the ground. Put a bush in front of them, another rock, something. That type of contact point between 2D and 3D is one of the hardest to keep from giving itself away. Again, where buttock contacts ground is not highly emotional, just weight. Save the stress of getting contact points perfect for the moments that support the emotional center of your shot. Now, if the buttock contacting the ground is amazingly intricate to the story being told, because the character's life was just saved by a wedged rock and the camera moves around in a sweeping arc to show the gravity of the situation, then yes, show that contact point.

Hands-On Examples

Four examples will be used: example art will be used to walk the reader/student through using compositing packages to create a flat space, limited space shot, deep space shot, and a forced perspective shot.

Flat space. In the hands-on section, we will take a 3D world and compress it to create a flat space scene that has been inspired by the Cohen Brothers being inspired by Busby Berkeley a la *The Big Lebowski.*

Limited space. In the hands-on section, we will create a traditional multiplane scene using some wonderful imagery from a SCAD student's puppet theater.

Deep space. We will take a look in this chapter at how to push a deep space shot using multiple media and adding perspective to what would traditionally be a flat plane.

Occasionally, students in my class confuse the idea of medium with camera space. They think that flat space must be done in 2D and deep space must mean 3D. Just to prove the point that it is camera space we are dealing with and that deep space can be created with 2D and flat space can be created with 3D, we will do just that in our hands-on examples.

Flat Space

The files for this hands-on project can be found in the companion data. The files are as follows:

- Maya_Files/**FlatSpace_HatPinLadies.mb**
- Maya file with animated objects
- Maya_Files/2 psd textures
- Image_Sequence/pinGirls.[1-80].tga

If you open the **FlatSpace_HatPinLadies.mb** file in Maya, you will see that two cameras are set up for the scene. The **persp** camera is set up for the flat space shot. The **persp1** camera is set up for a deeper space shot. Let's look at what makes this scene flat space.

The points to remember when creating a flat space shot can be broken down into the following elements:

1. Camera: placement, lens, and movement
2. Lighting
3. Texture

In this project, you will note that the camera has been placed looking down directly at the characters. There are no perspective lines, and horizon lines are hidden or minimized. The camera lens

FIGURE 7.13 A flat space shot.

is an important aspect when planning a flat space shot. In Maya, the focal distance is what you would adjust to get a narrow or wider lens. A telephoto lens is simulated by having a large focal distance. A wide-angle lens is simulated by having a small focal distance. You have probably learned something about cameras and know that a wider-angle lens exaggerates your perspective and basically creates a deeper space in your shot, whereas a telephoto lens compresses space and minimizes the perspective shift in your shot.

In Figure 7.14, the original persp camera is looking down at the characters. The focal distance is a very large 197. In Figure 7.15, the second camera in the scene, persp1, is in a similar position, looking down at the characters, but this camera has a focal distance of an incredibly small 9. You can see the difference in the exaggerated perspective lines of the characters.

To make the shot as flat as possible, lighting should be used to limit the tonal range seen. In other words, you do not want a high level of contrast in the lighting. You do not want tones and shadows, or if they are present, they should be close in tonal range. I once saw a great example of a live-action set that looked like a Japanese pen-and-ink illustration except that there was a live model standing amidst the stylized set. The final image looked completely flat and lovely: a young woman in a kimono stood framed in pen-and-ink (at least in my memory they were pen-and-ink) cherry blossom trees and flowering bushes. However, a

FIGURE 7.14 Camera with focal length of 197.

FIGURE 7.15 Camera with focal length of 9.

picture taken from the side of the set showed exactly what was going on to accomplish this amazing flat image: the stage was tilted toward the camera, and there was indeed depth in the shot. However, there were *dozens* of lights positioned all around the stage to illuminate everything and absolutely abolish shadows. The result was a lovely flattened space. That model had to have been extremely hot under all of those lights.

The same is true in your digital 3D space. You will need to light to get rid of shadows and flatten the image out. Welcome your friend the ambient light. I know, I know. Students of mine have just raised their hands to state, "But you said never to use ambient lights." Yes, this is true. "But, you said they just washed out the scene." Yes, I admit it. This is *precisely* what we want for this type of shot. We want to wash out all darkness. We have ultimate control and do not get shadows unless we ask for them; try doing that on a live-action set. Yet we still need to make sure that the darker areas on an object's materials are minimized. Ambient light will help with this.

FIGURE 7.16 Ambient light added to the scene to flatten out the lighting.

For the material and texture aspect of flattening your scene, the first idea is that the levels of texture detail should be the same throughout the image. If textures lose detail as they fade in the distance, this is a depth cue and starts to deepen the space. You might become annoyed with any darkness in the material color. If you are not using toon shading (which we realize does not react to light and flattens the 3D character), you can adjust the ambient color in the material. Let's do this together:

1. Open the Maya file from the companion data: **FlatSpace_Hat-PinLadies.mb**.
2. Open the Hypershade window either by clicking the button on the toolbar or by going to **Window > Rendering Editors > Hypershade**.
3. Locate the **PinMaterial**. Middle-mouse-drag it into the **Work Area** tab of the **Hypershade**. With that node selected, click the

Input and Output Connections button. This will display the textures that are connected to the material node. You will see that a Photoshop file is being read into for the specular channel and color channel.

FIGURE 7.17 Seeing the input connections to the material node.

4. In the fold-down tab menus on the left of the Hypershade window, locate the **Color Utilities** fold-down tab. Click the **Blend Colors** node. This will add a blend colors node to your hypershade work area.

FIGURE 7.18 Adding a blend colors node.

We want to add the color texture to the ambient channel. However, if we add it straight in, it will *completely* wash out any 3D shading. That might not be what you want. Let's look at that possibility first before we continue with how we'll do it in this tutorial.

An easy way to hook up the texture directly to the ambient channel is to double-click on the **PinMaterial** node. This should open the Attribute Editor for the **PinMaterial**.

Then middle-mouse-drag the **color** texture on top of the **Ambient** color chip in the Attribute Editor. You will see the connection is automatically made in the Hypershade window's work area. Figure 7.19 presents an example of this connection. The images at the top of the figure show what the material looked like before the addition of the ambient texture and afterward. You can see that the shading is completely flat, maybe too flat for our needs.

FIGURE 7.19 Adding the color texture directly to the ambient color.

Instead we will carry on with our method. What we want to do is use the same color as the texture but knock it back a bit. In step 4 we created a blend colors node. We'll use it now.

5. **Click** the **Blend Colors** node so that it opens in the **Attribute Editor**. **Middle-mouse-drag** the **Color** texture to the Blend Colors node's **Color 1** color chip.

6. Add a **gray** color to the Blend Colors node's **Color 2** color chip.

FIGURE 7.20 Adding color texture to the Blend Colors node.

7. Click on the **PinMaterial** so that it appears in the Attribute Editor. **Middle-mouse-drag** the **Blend Colors** node to the **Ambient** color chip in the Attribute Editor. The connection will update in the Hypershade's Work Area tab. The image preview of the Attribute Editor shows a small amount of shading but not a lot.

FIGURE 7.21 Connecting the blend shape node to the ambient color.

8. Click on the **Blend Colors** node and adjust the **Blender** attribute in the Attribute Editor. A value of 0 will give an ambient color of gray (or whatever Color 2 is). A value of 1 will give the texture as the ambient color. Anything in between is a mixture of the two.

Figure 7.22 presents four material previews. The one in the top left is the original anisotropic material that we started with. The one in the top right is with the color texture used directly as the ambient color; it gave a completely flat look. The bottom chips use the Blend Colors node to blend between the color texture and a gray color. This allows some shading but still keeps the render looking flat.

FIGURE 7.22 Materials with and without ambient color.

The final project for this tutorial is saved in a file named **Flat-Space_HatPinLadies_v2.mb.** In this file, a similar Blend Colors node technique has been applied to the ladies as well.

FIGURE 7.23 Flat space scene with flat lighting.

LIMITED SPACE

Limited space is what you experience in theater and in 2D animation. Most equate this type of space with multiplane setups, where the background moves at a different rate from the middle ground, which moves at a different rate than the foreground. The levels can have parallax of movement, but to maintain limited space and not become deep space, there should be no movement toward the camera.

The points to remember when creating a limited space shot can be broken down into the following elements:

- Artwork placement in relation to the camera
- Movement of the artwork parallel to the camera
- Movement of the camera parallel to the artwork

The files for these hands-on projects can be found in the companion data. The files are as follows:

FIGURE 7.24 The main under-the-sea levels.

FIGURE 7.25 Character.

FIGURE 7.26 Character.

FIGURE 7.27 Character.

FIGURE 7.28 Character.

FIGURE 7.29 Character.

We will use the 3D camera in After Effects to set up the artwork into varying depths, then we will move the camera to show parallax between the levels: a basic mutliplane camera move. You can accomplish this move in software that does not have multiplaning capabilities by moving the artwork at different rates. We will also re-create this shot in Flash to show that technique. Once you see the two most common methods for accomplishing this type of shot, you should be able to re-create it in any software.

Using a Compositing System's 3D Camera

Shake, Nuke, After Effects, Toon Boom, and many proprietary software packages that I have worked on have implemented some type of 3D camera that figures out the depth of the artwork in relationship to the camera when either is moved. Most of the systems I have seen have been extremely similar. The only difference in the proprietary software packages that does not show up in off-the-shelf software is the capability to set the artwork scale relationship so that when a piece of artwork is moved back in depth, it automatically scales to visibly stay in the same scale relationship to the other drawings. I'll bet we could come up with an After Effects expression to do that. That can be something for the website. Last one to post is a rotten egg.

Our first example uses a normal 3D camera for multiplane setups in After Effects. In version CS3 of After Effects or later, you are able to bring in Photoshop files and maintain the layers. This is an extremely useful feature. Of course, if your production pipeline needs .tif files or tga, you can still use those individually. Using a psd file allows us to create the levels in Photoshop, see the relationship of the layers in their composition, and save them all in one file for safe transportation. It is up to you what your pipeline needs. For this example, our Photoshop file is a static image. There is no animation in these files.

As an aside, this is only one method for working on projects that use both After Effects and Photoshop, and as you have noticed, this text is not the end-all–be-all text on how to click every single button in these software packages. After Effects, Shake, Nuke, Photoshop, Illustrator, Flash, Corel Draw, Toon Boom, and any other packages we might have touched on are huge software packages. With hope, this text has been a great "getting your toes wet" opportunity, and you will be fearless in picking up some great texts that explore the packages in depth. There are even some great concepts in the help documentation, and if you read the documentation you will note that Adobe has some wonderful online video tutorials as well. How's that for information when you need it? For example, here is a great video to watch for more information on using Photoshop and After Effects together:

www.adobe.com/go/vid0252. This link can be found in the help documentation along with many others.

Follow these steps to create a multiplane shot in After Effects:

1. Click **File > Import File** (or double-click in the project tab).
2. In the file browser window, select the Photoshop file **sea_100dpi.psd**.
3. Select **Import as: Composition—Cropped Layers**. The default setting of Editable Layer Styles on is fine.

You might ask, what is the difference between the different import as options? The video link mentioned earlier actually explains it. Footage, you might be familiar with, merges the layers together as one image or you can choose which layer you want to use. We want to use all of the layers, so our choices are Composition or Composition with cropped layers. If you bring in the Photoshop file as composition, it will bring in each layer with the same size as the document. The pivot point will be at the center of the whole image. If you bring in the Photoshop file as composition with cropped layers—you guessed it—the layers are cropped and the pivot point is at the center of the layer itself. All of the layers are still positioned as they were originally created, only their cropped size and pivot point are different.

The layers are brought in and placed nicely in a folder, and a composition is automatically created. That saved many button clicks, didn't it? Anything that saves a click or two is great! Those clicks and drags add up to precious time saved.

FIGURE 7.30 Composition that was automatically created.

4. Double-click on the composition titled sea_100dpi to see the layers together.

5. To help remember what layer is what, take a moment to rename the layers in the composition. **Click** on the **layer** so that it highlights, and hit **Enter** on the keyboard to rename the layers.

6. To place these layers in depth, we will need to turn on the 3D icon. It is located on the layer itself and looks like a cube. Click each layer on. Please visit Chapter 7 in the Gallery section at www.hybridanimation.com for an example.

7. **Right-click** in the Composition tab and select **New > Camera**. For this hands-on project, we will use the default camera. Feel free to experiment on your own for the chapter assignment. Click **OK** in the camera options window. You will notice that a camera has been added to your composition. It doesn't matter where it is in the timeline. I prefer to have the camera at the top of the timeline for easy access. Please visit Chapter 7 in the Gallery section at www.hybridanimation.com for an example.

8. To make it easier to see what your camera is seeing and where the artwork is in front of the camera, change your viewport to have **two views**. Have the left view show a top orthographic view by clicking once in the left port, making it the active port (you will see yellow triangles at each corner), and then change the view drop-down to be **top**. Have the right view show what the camera is seeing by clicking once in the right port, making it the active port, and change the view drop-down to be **Camera 1**. See Figure 7.31 for an example.

FIGURE 7.31 Setting up a two-view panel with top and Camera 1 views.

You can reposition the image in the viewports by using the **space bar** and click (pan) or zooming in and out with the mouse's middle roller ball (should you have one) or using the hotkey **z** (zoom in) **alt + z** (zoom out).

Next, you will want to position the artwork in front of the camera.

We have turned each layer onto a 3D layer. This has added another dimension to the transform attributes. We can now simply move them back in Z-depth:

1. Select each layer, and locate the Position attributes. (You can show just the position attributes with the hotkey **p.**) Start by moving the **bg** layer back in Z away from the camera. You can drag on the Z attribute with your mouse button or in the preview window click and drag on the Z translate manipulator.

 You will notice that the background layer looks smaller now that it is moved back in space. Perhaps on the website we'll have a special trick on how to put in an expression to hook up scale to the z position so that it automatically scales. For now, follow this step.

2. Scale the **bg** layer so that it matches visually the size of the other layers when viewed through the **Camera 1**. You can show just the scaling attributes with the hotkey **s**. In our example, the bg image was moved back to about 4000 in Z, and the scale was adjusted to 200.

3. Repeat for the next layer. The Reeds layer, for example, has been moved in Z to 3500 and scaled to 190. In the Chapter 7 Gallery section on the companion website, you can see an image in which the reeds layer is a little bit in front of the background layer but still visibly the same size when seen through the camera. You'll note that the position and scale attributes are the only attributes visible. You can achieve this effect by using the hotkey **p** and then holding down **shift** and then the hotkey **s** to show the position attribute; then add the scale attribute. Thank you, Professor Burge, for your wonderful demonstrations of After Effects and this and many of the tips you see in this chapter.

4. Repeat for all of the layers. See Figure 7.32 for an example. You'll note that the way things are placed in the timeline has no correlation as to what is in front or behind another object in Z position. In fact, the boat and TopWave are at the bottom of the timeline yet closest to the camera in Z.

5. Make sure that you are on the first frame of the timeline and adjust the camera's zoom to get the opening view of the underwater stage. Please visit Chapter 7 in the Gallery section at www.hybridanimation.com for an example.

FIGURE 7.32 All levels moved in Z. The boat and TopWave are the closest to the camera.

After all of that, you are ready to set two keyframes to see the parallax magic. We'll move the camera up to reveal the boat. When you view the playback, you should be able to see the parallax between the layers. The closer the layers are to the camera, the faster they will move across the screen. The farther away the backgrounds, the more parallax (different rates of movement) you will have.

1. On frame 1, create a **keyframe** for the **position** *and* the **point of interest** for the camera by clicking on the stopwatch icon. If you only set a keyframe for the position, the camera will move up but pivot down to continue to look at the center of the images.
2. On the last frame, move the camera **position** and **point of interest** up in **Y** so that the boat is visible. A keyframe will automatically set.

Press play to play back a preview and notice the different rates of movement. Some touchups can still be done. You'll notice that the background layer is visible when you don't want it to be. Do not be afraid to move the artwork to exaggerate the parallax and use traveling garbage mattes to hide unwanted levels.

For the background and reed layers, we will add a mask to hide these levels when the camera moves above the sea level. For both levels, the same steps will go as follows:

1. Right-click on the Reed or BG level and select **Mask > New Mask**.

2. Under the image in the timeline there is now a Mask parameters area. Open this area, change the setting to **subtract**, and click on the **stopwatch** icon for **Mask Path**. This will allow us to animate the matte.

3. Make sure you have the selection tool active (or use the **v** hotkey). Go to frames midway through the camera move and at the end. It might be best to start at the end and work backward. Adjust the matte as needed to hide the reeds or background. Keyframes will automatically be set. In Figure 7.33, three keyframes were set to adjust the matte during the camera pan.

FIGURE 7.33 Moving the mask to hide the reeds and background levels during the camera movement.

4. To further tweak the animation, you can move/slide the image layers to get more parallax or a better composition. In Figure 7.34, a few keyframes were added to the position of the Front wave and TopWave images.

Take Note

You will note that the image size is very large. When exporting out movie files, it is important to watch your file size so that you maintain a good playback speed. In this book we have learned that the compression setting **animation** is not actually a compression at all. It is all of the frames in their full res state packed into one movie file. You will not receive a good playback rate with this. As an example, I have exported a movie file from this exercise. You will note that with a **Sorenson 3** compression, this **2400 × 2000** pixel movie is only **3 MB**.

FIGURE 7.34 Keyframes can be added to the artwork levels themselves to increase parallax or obtain a better composition.

MULTIPLANE IN FLASH

What if you are using a piece of software that does not have a 3D camera? Well, then you are going to have to simulate the experience the old-fashioned way: by moving the artwork itself at different ratios. The camera itself will not move, because there is no camera to move. Instead we will move the artwork. By moving the artwork at different rates, we can establish what the camera is focusing on, what is in the foreground and moves faster and what is in the background and moves slower. First, we'll choose the main 100% level that stays with the camera. Everything else either moves faster than that level or slower. For example, if it is in front of the 100% level, it can move 150% faster, or if it is in back of the main level, it can move 80% of the speed of the main level.

We will use the characters and some of the images we have already used in our hands-on exercise.

Open Flash and import the character assets:

1. Click File > Import to Library. Select sea01.psd, and click on open.
2. A window will open showing each layer in the Photoshop file. The character layer is selected. That is correct. Click OK.
3. This will create a folder and place the character inside of it. It will also load in a composited version of the character with the background. We do not need this image.
4. Do the same for the other characters. Because they are unnamed in Photoshop, we need to take a moment and name them appropriately here. Name the characters and organize your library.
5. Once again, click **File > Import to Library** and select the **sea_100dpi.psd** image. We'll only use layers 2, 4, 5, 6, and 7. You can bring them all in to experiment with.

6. Once the layers are imported to the stage, organize them as necessary.

FIGURE 7.35 Organized library with all assets loaded.

To animate these assets, we will have to turn each item into a symbol. While we are doing this, we will go ahead and load them into layers and scale them—they are huge images:

1. Rename the first level in the Flash timeline to **bg**.
2. Drag the blue square background into frame 1 of that layer. It will fill the screen.
3. With the bg selected, click **Modify > Convert to Symbol** or use the hotkey **f8**.
4. Name this symbol, and make sure it is a **graphic**.
5. Using the **Free Transform Tool** (hotkey **Q**), scale the background to be much longer than the Flash canvas is. In our animation we could move it slightly and need room to pan it under the camera. Please visit Chapter 7 in the Gallery section at www.hybridanimation.com for an example. In this example, the background is shown at the top of the image, and at the bottom it is shown in wire frame so that you can see its size in relationship to the canvas.
6. Repeat these steps to add a reed level, a character, and a wave. See Figure 7.36 for an example.

FIGURE 7.36 Symbols added to their own layer and scaled into place.

You might find it useful to lock layers when you are not working on them—anything to help avoid putting the symbols on the wrong layers. It is very important that each symbol be on its own layer. We are going to add motion tweens to these. If you have worked with Flash before, you may know that you can only have one pivot point per motion tween; each symbol or group of symbols has one pivot point. If you have any more than that, the motion tween will not work.

Instead of pulling out the mathematical formula, we are going to move these items using those pivot points to help us. First we'll start with the 100% layer, because this layer will be that basis by which all of the other layers will move. Although it is tempting to do this via action script (I'll leave that explanation to those who are bent that way to figure out), we'll do it by hand:

1. Select the character and on frame 1 place the character on the right-hand side of the screen.
2. Move the timeline to frame 70, and hit **f6** for a keyframe. Move that character to the **left-hand** side of the screen. To make things easier, do not add motion tweens yet.

FIGURE 7.37 Characters' animation keyframes set.

If we turn on onion skinning and show frames 1 through 70, we can see how far the character moved. The wave that is in front of the girl should move faster than she does—150% faster. If we click and move the wave from where the girl was in frame 1 and move it to where the girl moved to in frame 70 then keep moving it farther (about half that amount we have already traveled), we have 150% movement. It is easier to see this in an image. See Figure 7.38 for an example. The black arrow indicates the amount of the character's movement. The red arrow indicates the amount of movement for the front wave. In the accompanying Flash file, this is labeled as an OL. Anyone remember why? It is an overlay, meaning the front wave is lying overtop of the character.

FIGURE 7.38 Move the front layer 150% faster than the character.

1. Move the timeline to frame **70**, **select** the **wave** element that is in front of the character, and click **f6** for a new keyframe. Measuring as seen in the previous paragraph, move the wave farther to the left than the character moved.

 Again, use the trick of turning on onion skinning to see where the character was on frame 1 and where the character is on frame 70. This will help you judge how much to move the reeds level. The reeds level in the accompanying Flash file is labeled **ul_1**. Those keeping notes may remember that this is a UL, meaning it is an underlay. This level lies under the main character. It has a "1" next to it in case we were to add another underlay that would have a "2" behind it. The same can be done for overlays. The interesting thing about this naming convention is that it indicates the order of levels and

simplifies the constant questioning of "What was in front? Was it the waves or the reeds?" Imagine if this were 100 levels deep!

2. Still on frame 70, select the reeds element that is behind the character, and click **f6** for a new keyframe. This element will move only 50% of the character, half as much. Move the reeds level halfway to the left; see Figure 7.39 for an example. The black arrow indicates the amount of the character's movement. The red arrow indicates the amount of movement for the ul_1 reeds.

FIGURE 7.39 The ul_1 movement of 50% of the character's movement.

The bg does not have to move; we can add a little movement of 5% to see if it looks okay. Remember, if it looks right, it is right; hang the math. (Don't let my high school geometry/programming teacher read this.)

3. Go to frame **70,** select the **bg**, and hit **f6** for a keyframe. Once again, measure how much movement should be allotted to the bg. See Figure 7.40 for an example. The black arrow indicates the amount of the character's movement. The red arrow indicates the amount of movement for the bg, which is 5%.

FIGURE 7.40 The bg movement: 5% of the character's movement.

The last step is to add motion tweens to the symbols so that Flash inbetweens the movement of the elements across the canvas.

4. To make it easier to see just what the "camera" sees, select **View > Pasteboard** to hide everything outside of the canvas.

5. With the **left** mouse and **shift** key, **select keyframes one** of all the levels.

6. **Right-click** on any of the selected keyframes and select **Create Motion Tween**.

7. The inbetweens will turn blue and an arrow points from frame 1 to frame 70. Press the **enter** key to preview the motion.

Using this idea, you can continue assigning amounts of movement for levels that are farther behind the character or closer to the camera. This is the same concept as if you were traveling down a road in a car. Imagine that the cows in the pasture are the 100% level. (I grew up past a dairy farm that was also past the sausage factory. So you can also hold your nose while thinking of this picture. I could have my eyes closed as a kid and known when we were 5 miles from home by the smell.) The cows are the 100% level. The barbed-wire fence in front of them is moving 150% faster than the cows across your field of vision. The telephone poles in front of the fence are moving maybe 170% faster. The bicyclist on the road is the closest to the camera (your eye) and might be moving 200% faster. The barn in the back of the field is moving 50% slower than the cows and the mountain even farther back is barely moving at 10% the rate of the cows. The sun never seems to move. Thank heavens the stink is gone before we get to my house.

Go back to frame 70 and adjust the amounts of movement until the parallax feels right. The levels should all seem to move without any one level seeming to stick slower or slide faster than the others. Remember to show your friends and get their feedback. Sometimes you work on your shot so long and have so much emotional investment into it that you cannot see the errors. Your friends have no such emotional investment and it will not cost them any time to fix anything. So they are more likely to see the errors that your brain simply will not see because it wants the shot to be done.

An example of this exercise is presented in the companion data: **Multiplane.fla**.

DEEP SPACE

It should come as no surprise to you that deep space allows for the camera to move toward the shot elements and characters, or they move toward the camera. Perspective cues are used to help

deepen the space. These cues can include a one-, two-, or three-point perspective; vanishing points; and diffusion of textures as they diminish into the farthest reaches of the eye. (Of course, there are other symptoms of a deep space shot. You'll have to read *The Visual Story* to learn more.)

Deep space shots are "easy" in 3D. Pick the camera up and move it. It weighs nothing. You do not have to build a track for it. You do not have to strap it to you or others. You move the camera around the world and shoot what comes in front of it. Right?

My students know better, and they know a trick question when they hear one. Although you have a virtual 3D camera, you should maintain the idea that the camera is expected to behave like a physical camera. It can do fly-throughs and move places that a physical camera cannot. However, the camera should always move with slow ins and slow outs as if it had weight and needed to take effort to move and effort to stop. You have likely dug deeper by reading recommended cinematography books to understand why a camera would be placed at the floor versus at the ceiling or closer to an actor's field of view. You have read *The Visual Story* to understand how the camera setup in one shot relates to the story as a whole. If you have not, fear not. We can continue with these exercises to learn what buttons to push and what pipelines to use. However, make sure to gain more exposure to reasons for moving the camera. I'm putting the soapbox away (apparently, I have a closet full of them).

2D CHARACTERS IN A 3D CAMERA MOVE

So far in this chapter, we have just been talking about 3D characters in a 3D world and 2D characters in a 2D world; for a few pages, we did not talk about 2D/3D. Of course, any medium or mixture of media could have been used in the previous exercises. Now we return to our originally scheduled program of 2D and 3D media.

In all of the previous chapters, we purposefully held the camera still. What happens if you want to use 2D characters in a 3D camera move? When you have a 2D character in a 3D world and have a 3D camera move, the concept of registration becomes extremely tricky. You can use the pipelines that we have explored, create the 3D first, then animate the 2D to match. Maintaining good contact points will be difficult, yet it can be done. Drawing the 2D to match the 3D either digitally or using print and peg pipelines will require studious attention to matching those contact points. To that idea, we have also explored the concept of always hiding the contact points unless they are absolutely tied into the key emotion and storybead of the shot. Keep that in mind as we go through this next exercise.

This exercise is basically a multiplane setup, except that it is in 3D. Also, instead of having flat planes, they will be in a sphere. In class I have lovingly called this a multisphere setup. This type of a camera move starts to edge us into a deep space world.

You have possibly seen something similar to this before. In *Tarzan*, when Jane, the Professor, and Clayton follow Tarzan to the gorillas for the first time, there is a realization shot where the characters recognize that they are surrounded by gorillas. Jane stands up, and the camera shows the gorillas in the trees around her.

If you watch the extra content on the DVD, you will learn about Deep Canvas, a software program that allowed the background painters to paint their canvases in 3D. Most might confuse this with typical texture painting or 3D paint systems like ZBrush or Mudbox (great tools to learn, by the way). You might know how to texture paint or use ZBrush already. Deep Canvas differed from 3D paint packages. It held each paint stroke in space, layered the paint strokes on top of each other (much like painting on glass, except in 3D), and then allowed those paint strokes to respond to the scene's lighting. It was a wonderful piece of engineering that was truly remarkable and different. I've never seen anything like it since. The software was originally created for *Tarzan*, then it was used for *Treasure Planet* and even on *Brother Bear.*

Besides the use of Deep Canvas, the biggest thing to note is that the gorilla realization shot (among others) is a great example of a deep space shot with 2D characters in 3D worlds. You will note that the gorillas in the trees are all 2D. Of course, Jane and company are 2D as well. The environment itself is 3D painted with Deep Canvas. The 2D gorillas are perched in the tree with their contact points hidden as the camera moves in 3D space to reveal them.

When faced with a problem such as this, it is probably best to bring the 2D artwork into the 3D system and composite it there. We will use the mermaid characters from before as an example and set up a multisphere shot. This is a quick exercise; feel free to expand on it for the project portion of this chapter.

Our Assets

For this shot we will take the output of our Photoshop characters that have been quickly animated in Flash (as an example of using animation, not as an example of animation), create image sequences, map those sequences as textures inside of Maya, and do our camera move there.

We've already covered the process of bringing the characters from Photoshop into Flash. Just as a review, we'll make a .tif sequence with alpha channels.

In Flash

1. Export a swf file by selecting **File > Export Movie**.

FIGURE 7.41 Exporting a swf of the characters.

In the companion data you will find a swf for each of the characters. The animation is minimal. These would be great candidates for taking into Flash CS4 and adding IK (inverse kinematis) to. Extra credit goes to the students who do this in their project.

You could export out a gif sequence directly from Flash; it would maintain the alpha channel that you need. However, compression is not your friend. So we will use After Effects to create the image sequence. There are other ways to do this. You can have scripts that do this automatically for you. Obviously, this is a step that is done often. Maintain a lossless compression and keep your alpha channels. A subject we have not even discussed in this book is that of look up tables and color space. That topic is beyond the scope of this book.

In After Effects

1. Select File > Export > Image Sequence ….
2. Choose the .tif file format, and uncheck "insert space before number."
3. When you type in the base name of the image sequence, add in three zeros: "000." This will add zero padding. See Figure 7.42 for an example.

crabKidooo

FIGURE 7.42 Exporting an image sequence with an alpha channel from After Effects.

Now, we are going to want to bring this image sequence into Maya as a texture. However, Maya will not read anything unless it has a Name.#.extension. We need a period between the name and the number. Using whatever means you have, you will want to change the name of the sequence.

We have used Adobe Bridge previously in this book. We'll use it again. You could use Shake or even script shake to do this. (See www.fundza.com for information on that process, and thank Professor Kesson for his selfless contributions to better the lives of would-be technical directors everywhere.)

In Adobe Bridge

1. Select all of the images (from 1 to 19) by clicking on image 1, holding shift, and clicking on image 19.
2. Right-click on any of the images and select Batch Rename.
3. Entered in the text to get a basename a "." and start the numbering at 1.

Now, we are ready to begin putting our 2D animation into Maya. A note to mention here is to remember resolution. When you bring images into Maya and are going to render them, you will want to keep in mind how big those characters are going to be on screen and how big your final render is going to be. If you are rendering a high-definition 720 image and these characters are going to fill the screen, you will want to make sure they are at a high enough resolution (have enough pixels) to be viewed well.

In Maya

The object is to position your levels inside of Maya, move the camera in Maya (as well as the artwork), then render out the final image. You can also render out multiple passes of precomps and composite them together in your compositing package of choice. It doesn't have to be one final render—whatever makes the shot.

Let us remember alpha channels for a moment. In order to have anything seem see-through, you must have an alpha channel. By this chapter, this step should be routine, but you would be surprised how it can still trip you up if not reminded. Figure 7.43 shows that the wave level from sea_100dpi.psd has been saved out as a stand-alone .tif image. The actual image itself has transparency around it in Photoshop. You are able to see the checkerboards around the wave. However, Maya will not know this is suppose to be an alpha channel unless an alpha channel is specifically created. In many cases you will need to select the image with the magic wand tool (or select the empty space then go to **select > invert selection**). In the channels tab, you can see that an alpha channel exists. If you do not have one, you can create one from

the selection by clicking on the **save selection as channel** button at the bottom of the tab.

FIGURE 7.43 Alpha channel in Photoshop for the Wave element.

At first it was hard for me to remember which was the alpha channel and which was where the pixels would show up. Maybe this will help: the color black has a value of 0. If you think of a zero value as nothing, then that means nothing shows: alpha. The color white has a value of 1 (on); everything shows. That is only when you are looking at the alpha itself. Just when you think you have it, remember that in some cases in this book we have created mattes in the RGB channels. When using RGB mattes, it is just the opposite—create an opposite alpha channel. If in doubt: test. The image in Figure 7.44 shows a plain white canvas in Photoshop with an alpha channel. If this were brought into Maya and placed as a texture, it would show up as a circle, shown in the insert. As a note, the file is brought into the color attribute and the transparency attribute of the material. This is usually done automatically. However, sometimes you have to do it manually.

> **Take Note**
> Make sure that your Photoshop texture is saved as an RGB and not CMYK. If it is saved as CMYK, the fourth channel will be read as the alpha channel; which more than likely will lead to undesired results.

FIGURE 7.44 Alpha channel in Photoshop with RGB shown as plain white.

The wave texture has been cropped to a square size. Why a square? This is now going to be used as a texture. Texture space is defined in a square that is numbered from 0 to 1 across the top and down the length of the image. This is how textures are used in almost all packages. While on the subject of UVs, because this is now using our 2D images inside of a 3D space, you will need to become familiar with UV unwrapping. We'll look at examples together.

You can follow along in Maya with the file **MultiSphere_setup .mb**. Inside this file, a sample scene has been created that has a few textures already loaded and properly using alpha channels. We will create geometry to hold our animated character textures and make sure that those texture planes face the camera for the final render.

First, let's examine the spheres with textures already applied. The out sphere, labeled "OuterSphere," is the background level and it has a background texture applied. The next sphere in is labeled "MiddleSphere" and has the reeds texture applied to it. You can see that the alpha channel of the reeds texture is being read in, and you can see through that sphere to the background sphere—hemispheres actually; to better show what is going on the spheres have been reduced to hemispheres. Your project can have spheres or any type of geometry that wraps around the camera.

The next sphere in is a CharacterSphere and it has been hidden for the moment. We will come back to it.

The smallest sphere has been adjusted to hold the wave textures. It has been labeled "WaveSphere." You will note that the WaveSphere has been broken up to hold the wave texture in two different ways. One is the normal use of UVing in the hemisphere to apply the wave texture (Figure 7.46).

The second way that the texture has been applied is to what is now a separate piece of geometry. A section of the sphere was extruded. That extruded section was extracted and then separated into its own object. (History, of course, was deleted.) This way the

FIGURE 7.45 MultiSphere_
setup.mb.

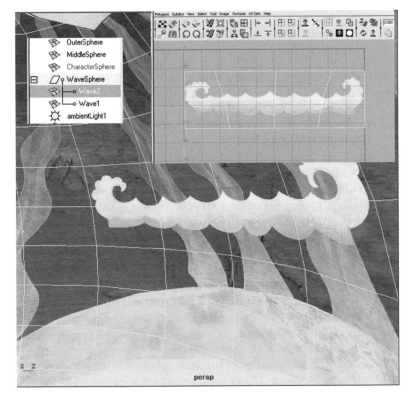

FIGURE 7.46 Wave texture
applied to a polygon hemisphere.

object itself can hold the texture but still maintains the curvature of the sphere. It was important in the UVing process to make sure that the tops and sides were UVed to be in the right quadrant of the UV editor so that they received the alpha channel information to become transparent. If the UV gets to the edge or outside of the texture, gray will show up in the rendered image. You might see a small bit of that in the example file. To fix this problem, open the UV texture editor and move the UVs to be inside the quadrant. If we had U and V wrap turned on in the texture placement node, it would not be an issue. However, usually in cases like this we do not want texture wrap on.

We have kept everything in a sphere shape so that it wraps around the camera much like an IMAX screen wraps around the audience. It doesn't have to be in a sphere, but in this case we will keep the sphere shape in order to push the fisheye lens appearance of the levels.

> **Take Note**
> As you orbit the camera around to look at the spheres, you might notice that the wave level appears to go behind the reed level. This is only a hardware shading (viewport preview) issue and will not show up in the renders. However, to make the transparency sorting work correctly, in the viewport select **Shading > Polygon Transparency Sorting** so that it is on.

To create geometry planes for the characters, we will select an area of the CharacterSphere and create it into its own piece of geometry:

1. In the outliner, select **CharacterSphere** and turn its visibility **ON** in the channel box.
2. Use your favorite method of selection to select a rectangle of faces behind one of the waves.
3. In the Polygons area, select **Option Box** next to **Mesh > Extract**. Make sure that **Separate Extracted Faces** is turned **off**. (If it is left on, every face you selected will be divided from each other.) This has put the group of selected faces into its own "list," but it is not separated from the object yet. You will note that in the outliner there is still only one object named CharacterSphere.
4. Next, select **Mesh > Separate**. This should separate the extracted polygons into their own named object in the outliner. However, there is still history attaching them to the main CharacterSphere.

 Note: Depending on your version of Maya, you may receive an error: *Separate works on selected objects or on faces from one single object.* This message may appear even if you do have faces selected, just not exactly what Maya wants. To get

to the faces that Maya wants selected, **right-click** in the view-port window and hold down the **CNTRL** key. This will open a hot box window. Select from the bottom hot box: **To Face Path**. This will select the faces correctly and you can continue with step 5.

5. Make sure to delete the history by clicking **Edit > Delete by Type > History**. You will know you were successful when that pesky Transform node is gone from your outliner.

Now that the plane for the character is ready, apply a material and the texture by doing the following:

1. Select the newly extracted plane. In the figure ours is renamed to **CrabKid**. Apply a lambert material to the plane. One way is to **right-click** on the plane and select from the hot box menu **Assign New Material > Lambert**.
2. In the Attribute Editor, select the **checkerboard** button next to the **color** chip and add a **file** node.
3. For that file node, in the Attribute Editor click the **browse** button and find the first frame of the crabkid image sequence, **crabKid.0001.tif**, and click **open**.
4. In the Attribute Editor, make sure to click on the **use image sequence button**. This will automatically read in an image to match the frame that the timeline is on. (Why, back in my day we had to write an expression for that.)

If you look back at the material node, you will note that the transparency has automatically been loaded from the alpha channel for you. If not, you'll have to do that manually in the hypershade.

Some things can go wrong when you do this on your own:

- If you use a CMYK image instead of an RGB image, alpha reads it incorrectly.
- If you use a naming convention that Maya cannot understand like crab0001.tif or crab_0001.tif, you will get a purple message about a node not existing.
- You will have problems if you forgot to have an alpha channel.
- You will have problems if you saved the image as a jpg or in a format that does not hold alpha channels.

Now, as you look at your CharacterSphere you will think some-thing has gone terribly wrong and you might start thinking of the items in the preceding list as possible candidates. There is nothing wrong, only something that has not been done: UV mapping. If you open the UV Editor by selecting **Window > UV Texture Editor**, the problem should become apparent. The UVs are nowhere near the image of the crabkid's smiling face.

FIGURE 7.47 UVs are not correctly mapped to show character texture.

If you are unused to UVing, it is small tasks like these that will help you gain confidence in the fine art. In an example on the companion website, the UVs have been moved around (by selecting them and using the move and scale tool) until they fit within the upper right quadrant and display the character. Also, the U wrapping and V wrapping have been turned off inside of the file 2D texture placement node. You can locate these nodes in the hypershade window.

Repeat these steps to create texture planes for the other animated textures. My students, remember to name as you go. In Figure 7.48, the merman image sequence has been loaded onto a small polygon area behind the other wave element.

FIGURE 7.48 Two characters loaded as textures.

> **Take Note**
> Take note: You want to make sure that you have enough 2D images to match the time in your Maya timeline. If you advance past frame 15 in our example file, the crabkid texture does not have any more images. It either will go blank or, oddly enough, load in a different texture! Oops. That is going to be a gotcha at render time if you don't plan for it now!

The last step is to place a camera in the scene by clicking **Create > Cameras > Camera** or whatever type of camera you prefer. Then animate the camera as desired. Please visit Chapter 7 in the Gallery section at www.hybridanimation.com for an example in which a camera has been placed at the base of the spheres looking up at these god-like merfolk.

Very important: You will notice that the lighting in this scene is **ambient** to make everything appear flat and the materials are **lambert** so that there is **no specular highlight**. Of course, you could add in 3D objects that have their own type of lighting. You'll want to use light linking to make sure that the 3D lighting does not affect the 2D imagery and vice versa. Extra effort points to the students who include that step in their final project. You can find more information on light linking in the Maya help documentation.

FORCED PERSPECTIVE

What if you wanted to add a little more dimension to your scene? There are two things you can do. One is to have the character's plane follow the camera. Doing this will enable you to move the camera without giving away the secret: that the character is only a pixel deep. Another thing you can do is much like the idea we explored by creating spheres. You can add dimension to your texture planes, push perspective, and force more parallax to happen.

First, having your character planes face the camera is a useful technique to know. Because we created these characters as spheres, it may not be necessary. But if the camera were to move or if the character were, say, a driver in a UFO that moved past the camera, you would want the character to always face the camera. To accomplish this, do the following:

1. Select the Camera and then the character's plane. This is a driver/driven relationship, so it is important that the camera is selected first.
2. Under Animation, select the **option box** for **Constraint > Aim**.

3. You want the aim vector to match the axis you want to point toward the camera. In our example on the companion website, the X axis is pointing away from the camera. Therefore, the aim vector is set to **−1** in the **x** box. (You might have assumed that the three unmarked boxes stand for X, Y, and Z.) Then click **Add**.

4. If you want to adjust the offsets in any way, select the object, locate the aim constraint in the inputs area of the channel box, and adjust the offsets to get the positioning you desire. In Figure 7.49, the clouds are being adjusted to be framed better in the camera view.

FIGURE 7.49 Adjusting the Aim constraint offset as needed.

Things to watch out for when using aim constraints:

- Make sure that the constraint is added correctly. The camera should not whiz away. If it does, you have constrained the camera to the character. Oops.

- Make sure that your planes are getting enough ambient lighting. They may turn from the light and become dark in your render. You may want to parent constrain an ambient light to follow along with your camera to always illuminate the characters.

- Remember, if it looks good in the final render camera, that is all you care about. Move things, scale things; it is okay. If you are working for an art director, though, that person might change his or her mind about the camera move. If that happens, then you have some extra work to do.

To push the idea of adjusting these levels even more, look for opportunities to create more parallax by adding dimension to the texture planes themselves. Newer releases of Toon Boom are marketed as having a feature that allows bending of texture planes. Higher-end compositing packages have some capabilities like this. However, in our classroom experiences it is easier to get exactly what we need in 3D by simply extruding geometry. If you have a great example of forced perspective, share it on our website!

Using our current example, we added a slight extrusion to the MiddleSphere so that the bottom portion of the texture would have parallax with itself during the camera move. For this process, you would do the following:

1. Select **Edit Mesh > Split Polygon Tool** in the Polygon area and click on the edges of the MiddleSphere to cut a line running along the bottom blue area of the texture. (The default settings for the Split Polygon Tool are fine for this step.)
2. Use your favorite selection method to select the bottom area of the texture plane that corresponds with the blue ocean floor.
3. Select **Mesh > Extrude**, and extrude the features so that the element juts out from the rest of the texture.
4. Place your camera and move it. You should see parallax of the texture plane with itself and other elements.

FIGURE 7.50 Adding dimension to the texture plane.

This technique was actually used in *Mulan* and *Atlantis* among others. You can see it in *Mulan*'s opening shot of the Great Wall of China, after the wonderful painting with animated mattes and compositing tricks fades into the actual animated shot of the Great Wall. As the camera pulls back to show the wall, you might notice parallax going on between the segments of the wall itself. A technique of forced perspective and a lot of creative compositing was used to create that shot. I believe that was when Maya was available as a beta. This method of creating deep space with 2D artwork was used throughout the film with varying degrees of deep space. A more notable shot would be from sequence 19 shot 24, where Mulan runs into the crowd and the camera booms up to show fireworks bursting in the sky. That is a 3D shot full of 2D

imagery with forced perspective on many of the palace elements, and don't forget crowds and particle fireworks.

Well students, this has been quite a chapter. Now you are ready for this chapter's project.

PROJECT: CAMERA SPACE

Due: _____

Readers/students will be encouraged to create their own example of a limited space, deep space, or forced perspective shot with a chosen visual target. The tree used for images in this chapter can be found in the companion data in the **Tree** Maya project folder.

FIGURE 7.51 Tree with tire swing, by Brent Morris, 2009, SCAD alum.

You are assessed on the following skills:

1. Ability to create a camera move with a clear understanding of animation principles
2. Ability to create a camera move with a clear understanding of flat, deep, or limited space
3. Technical use of animation tools
4. Technical use of compositing tools
5. Overall appeal of the shot
6. Matching of style
7. Problem solving

FURTHER READING

Blain Brown, *Cinematography: Image Making for Cinematographers, Directors, and Videographers. Directors and Videographers.* Oxford: Focal, 2002.

Hollywood Camera Work, www.hollywoodcamerawork.us.

Joseph LeDoux. *Synaptic Self: How Our Brains Become Who We Are.* New York: Viking, 2002.

Little Shop of Horrors. Ashman, Howard, et al. *Little shop of horrors*, Burbank, CA: Warner Home Video, 2000.

Ron Brinkmann. *The Art and Science of Digital Compositing*, Amsterdam: Morgan Kaufmann Publishers/Elsevier, 2008.

Tom Schroeppel. *The Bare Bone Camera Course for Film and Video*, Coral Gables, Fla: Schroeppel, 1980.

STUDENT CONTRIBUTORS

Yossaya Aisiri
Jennifer Chandler
Brent Morris
Daniel Tiesling

CLAIRE ALMON

ANIMATOR

Radical Axis, Inc.

Three Magicians (2D/3D test)

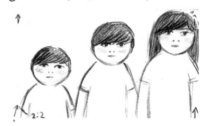

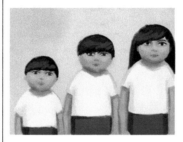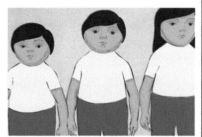

What were the lessons learned on your 2D/3D project?

In this project I learned the importance of planning the shots ahead and breaking them up into 2D and 3D elements before hand. This makes it easier going forward, instead of blindly guessing at what should be 2D or 3D.

Did your project use 2D on paper or use Cintiq/Wacoms etc.?

For my 2D elements I used Photoshop and Flash on a Cintiq.

What was the biggest challenge you or your team had to overcome using 2D and 3D?

The biggest challenge was managing time and really trying to seamlessly integrate the elements into one cohesive piece.

Why did you or your team choose to use 2D and 3D?

I chose to use 2D for the stylistic quality and art direction and 3D to help with camera moves or props that would be otherwise difficult and time consuming to do in 2D.

Is there anything you would like to share with the readers?

I like the idea of thinking of animation as animation and 2D and 3D as tools that can be used in any way to get the end product, instead of two different styles on their own.

WHAT NEXT? COMPANION WEBSITE

Opening to Poison Tree, SCAD Group Project 2008.

Well everyone, we have reached the end of our printed journey. Surely, as you have read this book you have thought of different ways to approach the problems we have faced. Maybe there are different methods you have used or want to test out. There will be new software, new versions, scripts, and methods to be explored. On top of it all, there will be examples of animation that we all want to look at to learn or be inspired. To help us on this journey, there is a website companion to this book (www.hybridanimation.com).

This is not a static website meant only to convey the data from this book. It is a forum where readers just like you can share their observations, work, techniques, and knowledge.

Please, join us on the forum to see what new looks we have come up with and how we did it.

I look forward to seeing you there and hope that you have found this book useful. While making beautiful art, I hope you keep fearlessly asking, "What does this button do?"

DOI: 10.1016/B978-0-240-81205-2.00008-X

APPENDIX

STUDENT CONTRIBUTORS

If you thought to yourself at any point while reading this book that those are neat images, then you must know who the creators were. My students have been so very helpful and enthusiastic during the creation of this book. They have taken little direction, sometimes no more than a "make it look like XXXX," and delivered, on time, exactly what I had envisioned. They have tested this book during class, and their homework assignments have populated some of these pages as well as the website.

I can't thank them enough, so I will try by listing their names, interests, and websites. If you like their work, look them up and tell them so.

SCAD Student Contributors

Yossaya Aisiri
http://yossaya.com
MFA, Illustration
Interests: Illustration

Claire Almon
www.clairealmon.com
MFA, Animation
Interests: Animation

Dianna Bedell
http://diannabedell.com, animationecstacy@gmail.com
BFA, Animation; Sequential Art minor
Interests: Preproduction, 2D visual effects

Candice Ciesla
www.candiceciesla.cc
BFA, Animation
Interests: Animation

Sandee Chamberlain
smc.animation@gmail.com
MFA, Illustration; MA, Animation
Interests: Concept art and character design

Jennifer Chandler
chandleranimation.com, jchand22@gmail.com
BFA, Animation
Interests: Story development, character animation

Chelsey L. Cline
http://underlockandkeyfish.blogspot.com, keyfish@live.com
Animation major, Sequential Art minor
Interests: Character animation (2D/3D), concept development,
 character design, storyboards

Clint Donaldson
http://clintdonaldson.blogspot.com
MFA, Animation
Interests: Character animation

Chris Ellis
Interests: Animation

Loraine Howard III
www.lorainehowardiii.blogspot.com, rainclev81@hotmail.com
BFA, Animation, Painting
Interests: 3D modeling

Jessica Huang
www.shavingsheep.net, jessicazh09@gmail.com
MA, Animation

Alton Jones
MFA, Animation

John-Michael Kirkconnell
Kirkanimation.com, jmkirkcon@gmail.com
BA, Film, Television and Theater: Univesity of Notre Dame
MFA, Animation

Mark Montgomery
markmont.net
BFA, Animation, Graphic Design (double major)
Interests: Animation cycles

Brent Morris
brentmorris85.blogspot.com, Brentmorris85@gmail.com
BFA, Animation
Interests: Storyboarding, character design

Dan Murdock
BFA, Animation

Amanda Powell
BFA, Animation

Daniel Tiesling
www.danieltiesling.com, tiesling@gmail.com
BFA, Animation
Interests: Character setup/rigging

Jessica Toedt
Stitch21z@hotmail.com
BFA, Animation
Interests: 2D and 3D animator and compositor

Shani Vargo
BFA, Animation

John T. Vu
BFA, Animation

Jason Walling
jwalling101@yahoo.com
BFA, Animation
Interests: Character animation

INDEX